D0996632

C3

C9

COLLINS

WATERCOLOUR WORKSHOP

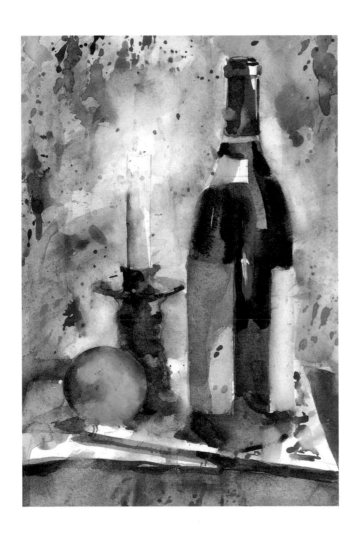

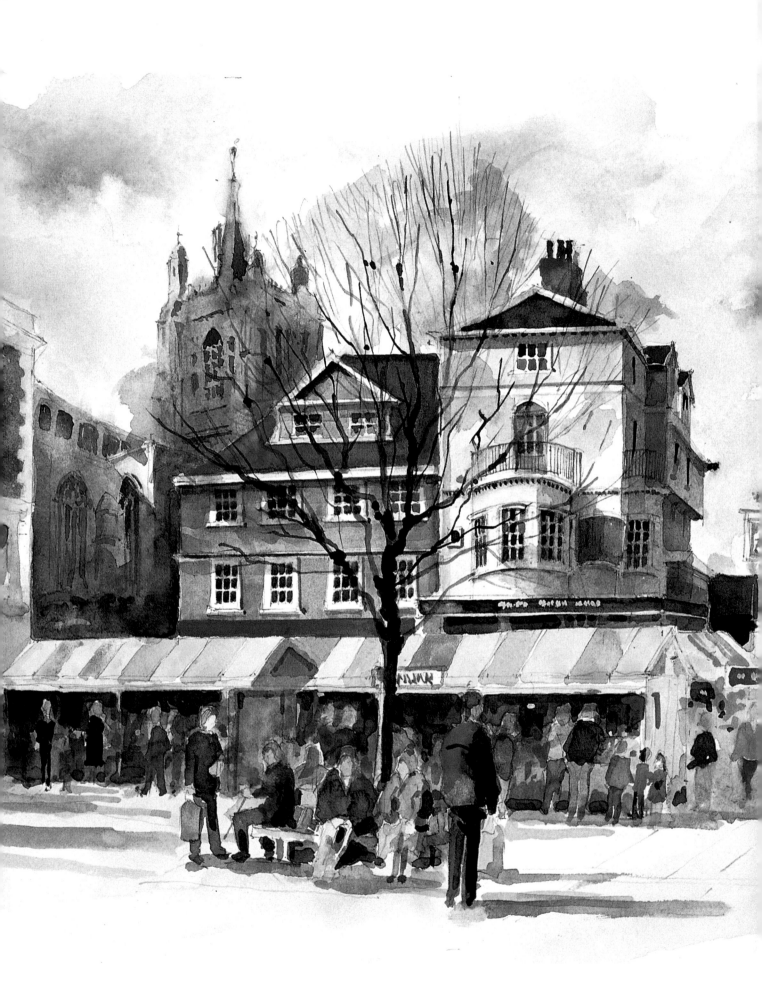

WATERCOLOUR WORKSHOP

A PRACTICAL COURSE IN WATERCOLOUR PAINTING TO DEVELOP SKILLS AND CONFIDENCE

John Lidzey

HarperCollins*Publishers*

DEDICATION

For David and Anna

ACKNOWLEDGEMENTS

Many thanks to all the people who helped me
with this book, too numerous to mention;
but special thanks
to Cathy Gosling, Caroline Churton
and Caroline Hill of HarperCollins
for their ability to turn chaos into order;
to Douglas Atfield and Ed Barber
for their splendid photography;
to Patsy North for her editorial skills;
and finally, to my wife for her help,
encouragement and word-processing wizardry.

*All paintings are by John Lidzey
unless stated otherwise.*

First published in 1995 by
HarperCollins Publishers, London

© John Lidzey, 1995

John Lidzey asserts the moral right to be identified
as the author of this work.

All rights reserved. No part of this publication may be reproduced,
stored in a retrieval system, or transmitted, in any form or by any
means, electronic, mechanical, photocopying, recording or
otherwise, without the prior written permission of the publishers.

**A catalogue record for this book is available from the
British Library**

*Editor: Patsy North
Design Manager: Caroline Hill*

*Photography by Douglas Atfield (pp. 12, 13, 21, 26, 27,
29, 31, 35, 44–5, 56–7, 102, 106–9, 124–5, 134–5),
Ed Barber (pp. 15, 17, 19, 64, 65) and
Paul Millichip (p. 18)*

ISBN 0 00 412929 6

Set in Palatino and Futura
by Wearset, Boldon, Tyne and Wear
Colour origination in Singapore, by Colourscan
Produced by HarperCollins Hong Kong

PAGE 1:
John Lidzey,
*Still Life with
Candlestick,*
29 x 20.5 cm
(11½ x 8 in)

PAGE 2:
John Lidzey,
Market Scene,
35.5 x 38 cm
(14 x 15 in)

CONTENTS

ABOUT THIS BOOK

The aim of this book is to encourage you to learn by doing, just as you would in a practical painting workshop led by a tutor. Along with instructional teaching and general guidelines in the text, you will find practical exercises and projects for you to do, designed to help you to develop as an artist. As you practise and become more visually receptive and perceptive about the world around you, your own ideas, and personal style, will begin to emerge.

Most of the chapters contain one main project and, in some cases, a number of exercises. If you carry out all of these before moving on, they will effectively help you to understand and practise the teaching.

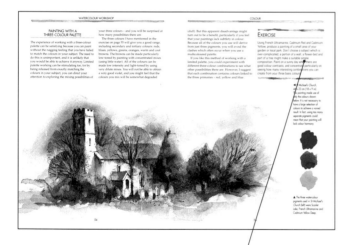

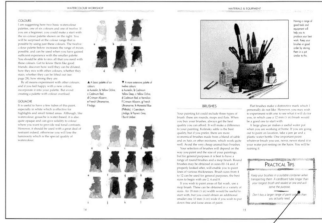

EXERCISES
These are designed to complement the teaching contained in each chapter. Some of the exercises are quite short and should not take too long to do; others may require a little more time. Their aim is to get you painting and thinking for yourself.

PRACTICAL TIPS
Throughout the book you'll also come across practical tips. These highlight some useful hints about working methods and provide a few solutions to everyday painting problems.

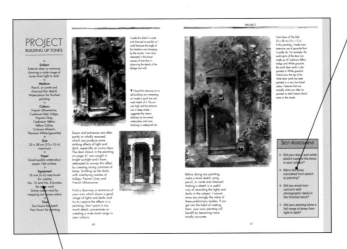

SELF-ASSESSMENTS

At the end of each project, you'll find a number of self-assessment questions relating to the work you have just completed; these are intended to draw your attention to particular aspects of your painting, in the same way that a professional tutor might help you to assess your work in a practical workshop.

PROJECTS

The projects, of varying degrees of difficulty, concentrate on more specific aspects of painting, with a view to sparking off ideas which you can then try to interpret in your own way.

You should take your time with the projects and be prepared to reread relevant sections of the text as often as you need to enable you to tackle them successfully. After all, there are no short cuts to learning to paint well!

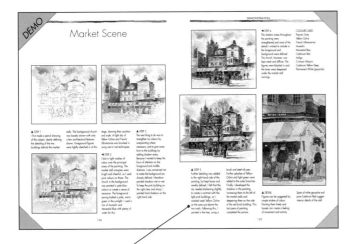

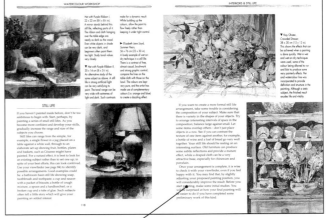

DEMONSTRATIONS

Because you can learn a great deal by watching professionals at work, several demonstrations by the author are included in the book. These show how a painting is developed from the initial drawing to the finished work, and you are taken step-by-step through each stage so that you will understand what techniques are used and how particular effects are created. Details from the finished paintings are included to highlight specific areas of interest.

IDEAS & INSPIRATION

The paintings in the book, by the author and other well-known contemporary artists, cover a wide range of different subject matter. Some of these paintings are meant to complement and clarify points explained in the text, but others are included to show how style and technique vary from one artist to another, emphasizing the importance of being original in your creative work. They can help you to extend your attitudes and horizons – and fire your enthusiasm. They are there for you to enjoy!

THE MEDIUM OF WATERCOLOUR

For more years than I care to remember, I have attempted to achieve control of the watercolour process – and I am still working at it. The fact that the medium is so wilful makes it particularly exciting for me. Also, watercolour is a beautiful medium, and when the colours go down on the paper they can be a joy to behold. The effects that can be achieved with the medium are many; one colour overlaying another, for example, will bring a third colour shining through where the two overlap. Water dropped into pigment can produce on a miniature scale exquisite unrepeatable shapes which could never be painted with a brush. It is this unpredictability which makes watercolour unique among painting media. If used with imagination and flair, it is able to create many wonderful effects which can turn an ordinary subject into a thrilling painting.

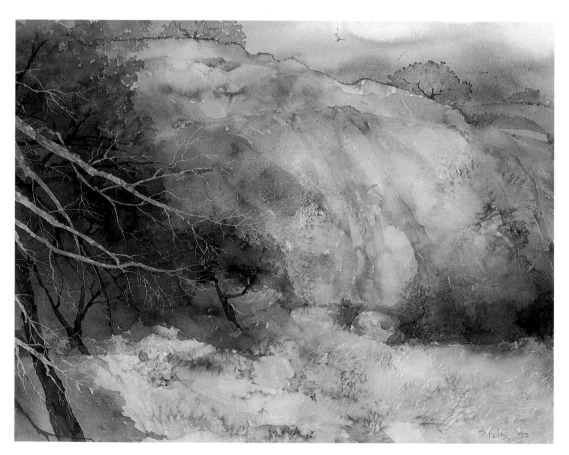

Shirley Felts,
Enchanted Rock,
Texas,
55 x 74 cm
(21½ x 29 in)

*Anna Playing
the Cello,
56 x 40 cm
(22 x 16 in)*

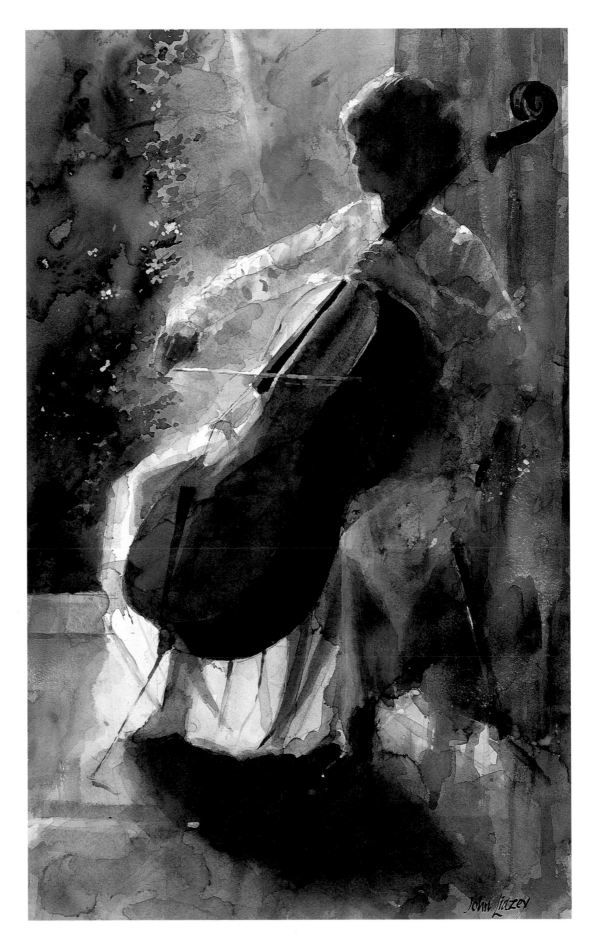

RICHNESS OF COLOUR

It is often said that watercolour has no tonal qualities. Certainly, it is easy enough to find in galleries many examples of thin and weak paintings. But anaemia need not be a characteristic of the medium. Many painters have realized that watercolour can be rich and vibrant in colour as well as light and delicate. By overlaying colours and building them up, it is possible to a achieve a tonal depth to rival any other medium. There are also unconventional methods, viewed with disfavour by purists – for example, the use of conté crayon as a shading medium – which can extend the tonal range of colours, making the lighter hues sing out.

WATERCOLOUR SUBJECTS

The qualities of watercolour make it particularly suited to many types of subject matter, only a few of which I can mention here. All outdoor water scenes are natural subjects for the medium. The reflections of the sky on a calm sea can be exactly caught by pale washes of colour and subtle changes of tone. Fast-running inland water needs a hard-edged treatment with sudden transitions of brilliant light and dark. Watercolour is ideal for this, too.

Skies can be perfectly represented by the medium. The delicate tints and shades which are a feature of watercolour can bring out the luminosity of summer cumulus clouds and late winter sunsets. On a smaller scale, many studies of botanical subjects are painted in watercolour. No other medium can suggest with such feeling the delicate colouring of wild flowers.

In domestic interiors, glass is particularly appropriate to watercolour as it shares similar characteristics, being transparent and reflective. Delicate patterns on furnishing fabrics or curtains can be accurately described and their pure colours reproduced with ease. Finally, no other medium creates so well the mysterious nature of interior light as it shines through fabrics or reflects on polished surfaces.

DEVELOP YOUR OWN STYLE

The secret of watercolour painting is to relax and not worry too much about the problems involved in producing a painting. I have often

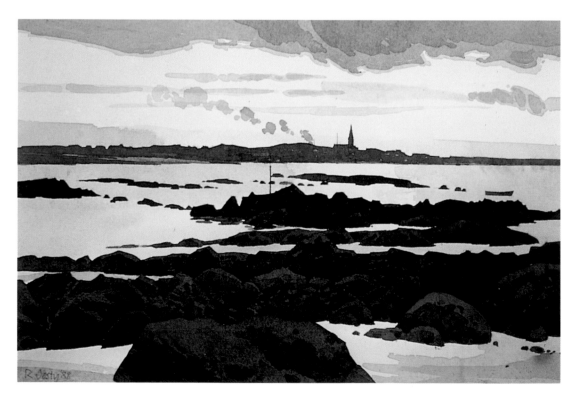

Ronald Jesty,
*Grand Havre,
Guernsey,*
23 x 34 cm
(9 x 13½ in)

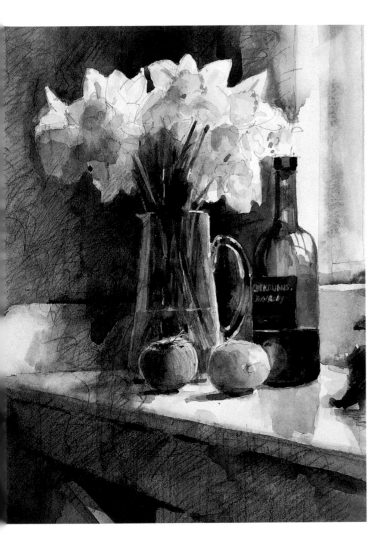

Still Life with Daffodils,
41 x 29 cm
(16 x 11½ in)

Early Morning at The Dell,
36 x 24 cm
(14½ x 9½ in)

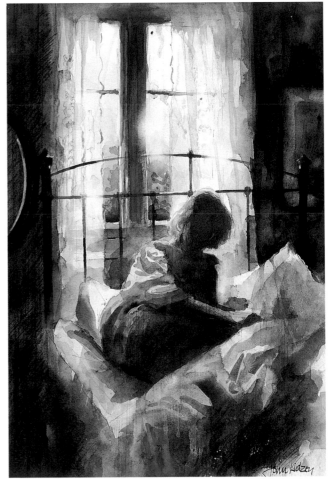

felt that creating successful watercolours is as much about an attitude of mind as anything else. Rigid thinking and fixed ideas are the enemy of personal development.

The great English painter, Turner, filled his sketchbooks and notebooks with countless experiments in the watercolour medium. Some he called 'colour beginnings'. The range and power of his watercolours when viewed today are astonishing, and many of the techniques he used were first developed in his sketchbooks.

If you want to produce exciting watercolours, keep a sketchbook for your own experimental work. Try out some of the techniques I outline in Chapter Three. Collect ideas from other books on paintings, too, and note them down. Study the work of professional artists, so that you can learn from them. Gradually, all your research will bear fruit and you will begin to achieve your own distinctive style.

CHAPTER TWO

MATERIALS &
EQUIPMENT

Good art materials are expensive, and it can be tempting to save money by purchasing cheaper goods. This is a temptation which should be resisted. No matter whether you are a beginner or more advanced, you will not be able to produce good work with poor materials.

When it comes to purchasing equipment, however, it is certainly possible to make economies. Painters are usually very resourceful, often finding ways in which they can either adapt equipment made for other uses or make their own, especially palettes, drawing boards and paintboxes.

Most of the items in this section can be bought from an art shop, although I do suggest some alternatives. As you become more involved with the actual application of paint to paper, you will begin to find uses for materials and equipment obtained from other places. For example, pieces of scrap metal or wire mesh can create textures you would never be able to achieve with a brush. But, for the moment, concentrate on developing your skills with a range of traditional materials and equipment. If you use your imagination, you can produce outstanding paintings with only a fairly modest kit.

This is one of my paintboxes – a replica of one made at the end of the eighteenth century. It contains twelve whole pans of colour, enough for most uses. When a pan is used up, I will often replenish it from a tube of the same colour.

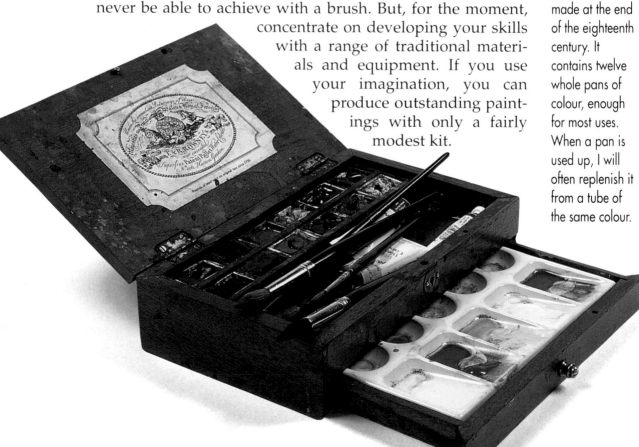

PAINTS

Watercolours are available in pans or in tubes. If you normally need to cover large areas of paper with colour washes, it is best to buy tubes of paint, but for general work, pans are more convenient. Whole pans are better than half pans for everyday painting. When buying your colours, make sure that you buy the best-quality artists' paints rather than student quality.

PAINTBOX AND PALETTE

A paintbox is a convenient way of keeping your colours organized, but it isn't essential. If you use tubes of paint, they can be contained in a small tool-box which can also hold your brushes and any other painting materials you have. You can make up dividing units which provide a place for everything.

Don't buy a paintbox with a greasy plastic palette incorporated into it. Mixing paints in these is never satisfactory. The best palette materials are metal or china. Besides palettes with small wells, have available larger containers for mixing greater quantities of paint. I have a china photographic developing dish, but a china butcher's tray or any flat china tray would do perfectly well.

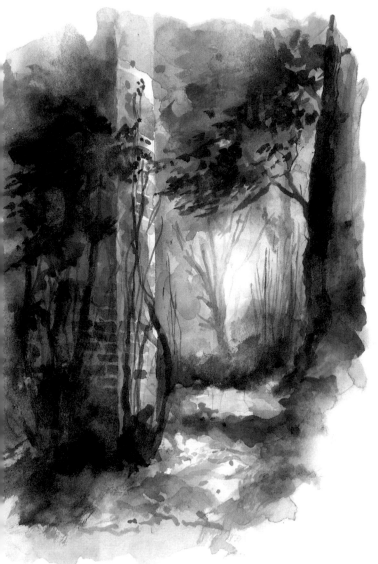

▲ *Early Morning Sunlight,*
28 x 22 cm (11 x 8½ in).
I took less than an hour to paint this picture quickly and freely. Try working at this speed; ignore the details and just capture the general effect.

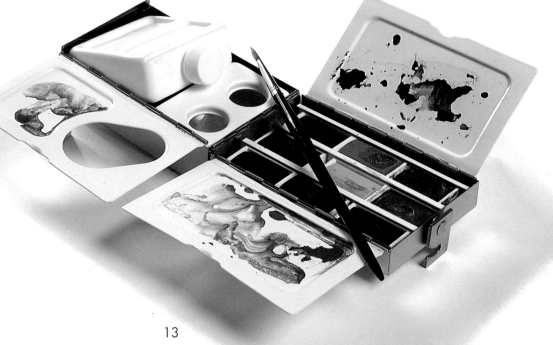

This small paintbox is handy to keep in your pocket, and is suitable for sketching purposes and for painters who wish to travel light.

COLOURS

I am suggesting here two basic watercolour palettes, one of six colours and one of twelve. If you are a beginner, you could make a start with the six-colour palette shown on the right. You will be surprised at the colour range that is possible by using just these colours. The twelve-colour palette below increases the range of mixes possible, and can be used when you have gained sufficient experience with the smaller palette. You should be able to mix all that you need with these colours. Get to know them like good friends: discover how well they can be diluted; how they mix with other colours; whether they stain; whether they can be lifted out (see page 28); how strong they are.

By all means experiment with other colours, and if you feel happy with a new colour, incorporate it into your palette. But avoid creating a palette with colour overload.

GOUACHE

It is useful to have a few tubes of this paint, especially in white which is effective for highlights and small tinted areas. Although, like watercolour, gouache is water-based, it is also quite opaque and can give solidity to colour where you want to provide real tonal contrasts. However, it should be used with a great deal of restraint indeed, otherwise you will lose the luminosity which is the special quality of watercolour.

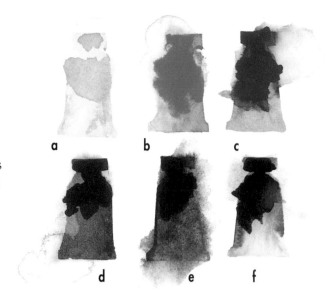

▲ A basic palette of six colours:
a Aureolin, **b** Yellow Ochre, **c** Cadmium Red, **d** Crimson Alizarin, **e** French Ultramarine, **f** Indigo.

▼ A more extensive palette of twelve colours:
a Aureolin, **b** Cadmium Yellow Deep, **c** Yellow Ochre, **d** Cadmium Red, **e** Vermilion, **f** Crimson Alizarin, **g** French Ultramarine, **h** Monestial Blue (Phthalo), **i** Coeruleum, **j** Indigo, **k** Payne's Grey, **l** Burnt Umber.

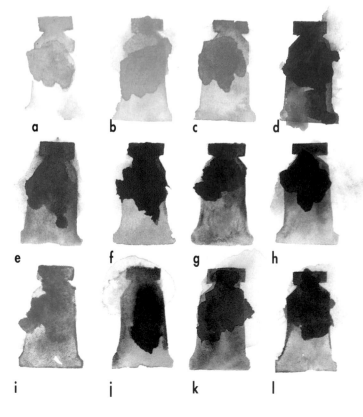

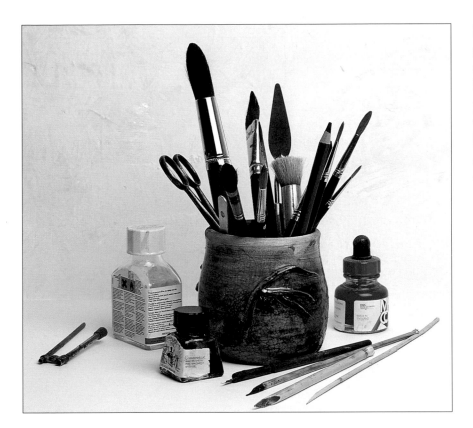

Having a range of good tools and equipment will help you to produce your best work. Keep your brushes in good order by storing them in a pot similar to this.

BRUSHES

Your painting kit could include three types of brush: these are rounds, mops and flats. When you buy your brushes, always get the best quality you can afford. It will make a difference to your painting. Kolinsky sable is the best quality, but if you prefer, there are more economical brushes made from a blend of sable and ox hair, or other mixtures, which work quite well. Avoid the very cheap animal-hair brushes.

Your selection of brushes will depend on the way you paint and the size of your paintings, but for general purposes it is best to have a range of round brushes and a mop brush. Round brushes may be obtained in sizes 00–14 and, if properly looked after, will enable you to paint lines of various thicknesses. Brush sizes from 4 to 12 can be used for general purposes; the best sizes to begin with are 2, 4 and 8.

If you wish to paint areas of flat wash, use a mop brush. These can be obtained in a variety of sizes. An 18 mm (¾ in) width would be useful to start with, but you could obtain an additional smaller one 10 mm (⅜ in) wide if you wish to put down free and loose areas of paint.

Flat brushes make a distinctive mark which I personally do not like. However, you may wish to experiment with one to see what it will do for you, in which case a 12 mm (½ in) brush would be a good one to start with.

A large glass jar makes a useful water pot when you are working at home. If you are going out to paint on location, take a jam jar and a plastic water bottle. One important point: whatever brush you use, never, never stand it in your water pot resting on the hairs. You will be ruining it.

PRACTICAL TIPS

Keep your brushes in a suitable container when transporting them. A cardboard tube longer than your longest brush and sealed at one end will serve the purpose.

Don't buy a larger range of paint colours than you actually need.

PAPER

When you buy paper for working in watercolour, always ask for watercolour paper, not cartridge paper which is mainly intended for drawing. But do keep some cartridge paper for making pencil or conté tonal studies.

There are many types of machine-made watercolour paper. Some are made from 100 per cent rag, normally cotton, which I always use for my own work. Others are made from materials such as wood pulp and come in a range of tints which you might find interesting to try. Watercolour paper is mostly available in sheets measuring 56 × 76 cm (22 × 30 in).

THICKNESS

Papers may be bought in various thicknesses, actually expressed as weight. A middle-of-the-range paper would be 300 gsm (140 lb), and it is this weight that you would normally use. In a half-sheet size of 38 × 56 cm (15 × 22 in), it will usually need stretching (see page 18), but in a smaller size than this, it will not. A 200 gsm (90 lb) paper is light and thin and will always need stretching. At the other end of the scale, 600 gsm (300 lb) paper is heavy and thick and will not need stretching. It will also take the heavy punishment sometimes required of watercolour papers. The catch is that 600 gsm (300 lb) paper is more expensive!

SURFACE

In buying paper, you have a choice of surfaces: Hot Pressed, Not (or Cold Pressed), and Rough. The best surfaces to use if you are a beginner are Hot Pressed or Not, as they are easier to work with. Not means 'not smooth and not rough' and is certainly the most popular with painters. Rough surface papers are useful for obtaining certain textural effects, but should be experimented with only when you have gained experience of the other two. Fine, detailed work is not recommended with rough surface paper.

PADS

Pads provide a useful and convenient way of working on watercolour paper, and can be

300 gsm (140 lb) Hot Pressed watercolour paper. A smooth-surfaced paper, useful for fine work. If paint is applied very wet, it will show interesting effects.

300 gsm (140 lb) Rough surface watercolour paper. If paint is dragged over this paper with a large brush, the texture of the paper produces a dappled effect.

300 gsm (140 lb) Not surface watercolour paper. This is a good paper for beginners to use. It will show a certain amount of texture through the paint.

300 gsm (140 lb) grey-tinted watercolour paper. Papers are available in various colours which show through the paint and create atmosphere.

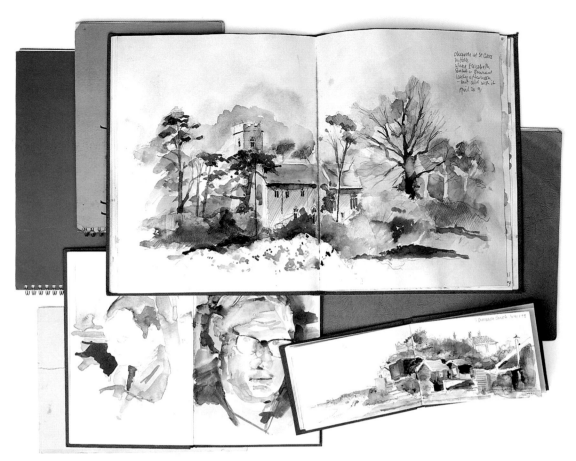

Sketchbooks are very useful for working on location. For the dedicated sketcher, a small book can be kept permanently in a coat pocket ready for use whenever the opportunity presents itself. A hardback cover will ensure that the paper in your sketchbook will not become damaged.

obtained in a variety of sizes. One manufacturer makes them in a range starting at 17.5 × 12.5 cm (7 × 5 in) and increasing in size to 40 × 50 cm (16 × 20 in). Don't be tempted to use only small pads. Do some work on at least a 25 × 35 cm (10 × 14 in) pad and give yourself room to spread. If you become a serious watercolourist, you will probably want to work on sheets of paper rather than using pads, except when you are sketching.

SKETCHBOOKS

These often contain types of paper other than watercolour paper and are intended for sketching on location where the achievement of high-quality results are not necessarily intended. Sketchbooks are available in many sizes and can be quite small. I have a 15 × 10 cm (6 × 4 in) book which fits nicely into my coat pocket. Many books can be obtained with a conventional sewn binding rather than wire binding, making it possible to draw and paint using two pages across the fold.

DRAWING BOARDS & EASELS

You can make your own drawing board from either 6 mm (¼ in) plywood, hardboard or medium-density fibre board. This will be light in weight and easy to carry to sketching class or on location. Cut your board 5 cm (2 in) larger in both directions than the paper you normally use. Don't use a board with a shiny melamine surface; if you use gumstrip on this to stretch your paper, it will soon peel off.

If you like to work at an easel, make sure that you choose one that is firm and solid. Personally, I do not use an easel as it then becomes difficult to tilt the board this way and that to control the flow of paint.

STRETCHING PAPER

To prevent the lighter weights of watercolour paper from cockling when wet, it is best to stretch them before you begin painting. This is not difficult to do.

First, cut your paper to size so that it is at least 5 cm (2 in) smaller in both directions than the drawing board. Cut 5 cm (2 in) wide gumstrip paper to lengths slightly longer than the dimensions of the paper.

Immerse your paper in water (in the bath is best) for about half a minute. Ensure that the paper is thoroughly soaked. Lay the paper on the board and smooth it flat.

Wet your gumstrip paper with a damp sponge and position a length along each of the sides of the watercolour paper. Half of the tape should overlap onto the board. Smooth the tape flat and ensure that it is adhering firmly both to the paper and to the board. Trim the corners off square with scissors or a sharp knife.

Stand the board upright (not by a radiator) until the paper is dry. It should then be stretched tight and absolutely flat.

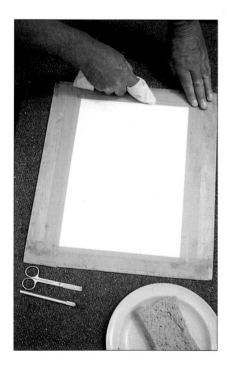

Stretching paper
ready for
painting.

OTHER USEFUL ITEMS

You may find it useful to keep in your kit a range of the following items:

Pencils These can be obtained in degrees of softness, from 6H through to 6B. For general use, you should have H, 2B and 4B pencils, and a 6B if you like good heavy darks in your drawing. A 2B pencil should be used for drawing on watercolour paper. Softer grades should be used only for free-hand drawing studies.

Eraser A pencil eraser is essential. There are various types available, but the best is a putty eraser. This will not damage your watercolour paper, whereas harder ones will.

Conté Black conté crayon is very effective for making studies, and can be used in conjunction with stick charcoal for some lovely results. Your finished drawing will need fixing to prevent it from becoming smudged, so it is essential that you obtain an aerosol can of colourless fixative.

Pastels If you want to sketch on location, yet prefer to travel light, a small box of coloured pastels can be carried around in your pocket. Remember, however, to take the can of fixative with you or your work may be ruined on the way home.

Pens Pens can be very useful for the watercolourist. It is best to obtain a simple pen holder which will take a range of drawing nib sizes. If you like working with pens, you can sometimes buy bamboo or reed pens from art shops. Alternatively, if you can get hold of the raw materials, you could try making this type of pen yourself.

Cotton wool Cheap to buy, cotton wool is easy to use for mopping out and correcting mistakes. It is better than using a sponge, which over time tends to become dirty.

Scalpel or craft knife A sharp knife is indispensible for the watercolourist, both for keeping a good point on your pencil and for adding highlights to your painting. If you keep a sharp knife loose in your kit, protect the blade (and yourself) by sticking it into a piece of cork.

Sponge Use only natural sponge, which can be effective for creating certain textures. It is particularly helpful for suggesting foliage.

Blotting paper can be very useful, particularly if you are lifting out small areas of colour.

50 mm (2 in) brown gumstrip paper This is the kind of tape you need when you are stretching paper. Never use masking tape for (see page 18) this purpose.

25 mm (1 in) masking tape This is useful in lots of ways, but particularly for holding paper onto your board when you are working on unstretched paper.

Indian (fixed) ink When dry, indian ink will not run if you paint in watercolour over the top. It is best to use this before you start experimenting with other, less stable, inks.

Masking fluid This will blot out areas that you do not wish to receive paint. When you buy it, make sure that it is in a liquid state and not hardened off. Masking fluid can be used with pen or brush. However, don't use your best brush to apply it, and make sure you wash the brush in soapy water before and after use.

UNORTHODOX ITEMS

If you have some experience in watercolour, you might find it interesting to add the following items to your painting kit for experimental purposes. Make test pieces for future reference.

Comb A comb is useful for giving an area of paint a linear texture. Draw it across the paper while the paint is wet.

Palette knife You can produce some unusual effects by scraping out areas of paint, while still wet, with a palette knife.

Toothbrush or stencil brush Stiff bristle brushes may be used to achieve spatter effects.

Wire mesh See what happens when you apply paint through a thin wire mesh. Some interesting textures can result.

Metal shapes Anything when coated with paint and pressed onto paper will make its own distinctive mark. Some painters keep items such as washers, nuts and screws for this purpose.

The author at work in his studio. The best light to work by is north light. Strong sunlight in the studio can be very inconvenient and cause colour misjudgments. If you sit by a window, position yourself so that the light casts a shadow away from your painting.

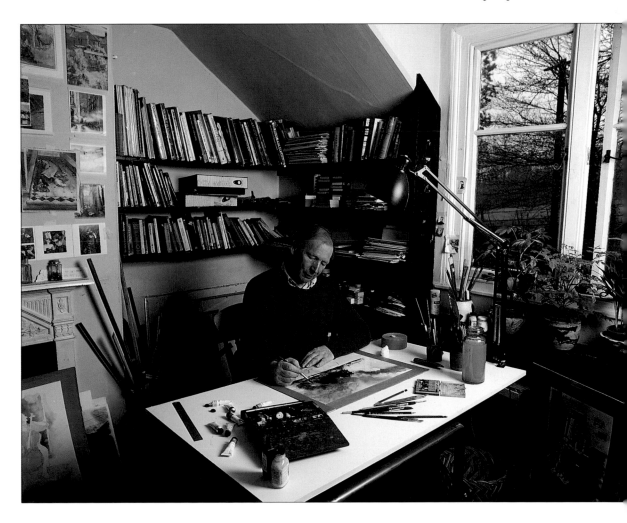

WATERCOLOUR TECHNIQUES

When you begin to paint in watercolour, it is best to start simply. The most basic method of all is just the act of using a brush to put the paint down onto paper. The way in which your paint is applied to the paper will determine the look of your work. So, before you start experimenting with the more exotic or unusual methods of working, spend most of your time simply painting.

Good paint handling technique, like good handwriting, can be satisfying to look at, and you can teach yourself how

Kay Ohsten, *Farm Buildings*, 44 x 35 cm (17½ x 14 in). A good example of free and loose watercolour techniques in action.

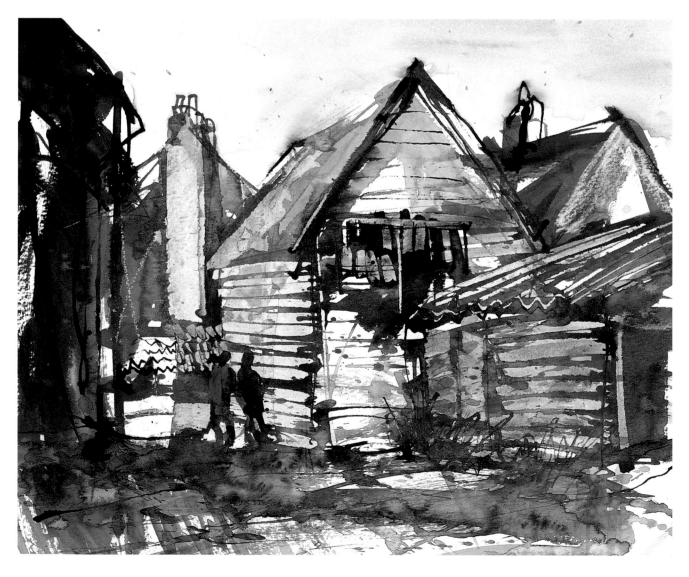

to do it. Look at the paint handling of good watercolourists, and make studies from their work. Work every day if you can; don't bother to stretch paper. Paint quickly. Paint on both sides of the paper. Paint at the same time every day, even if you don't feel like it. Don't worry about whether the painting is good or bad. What will happen is that you will start to relax. Your work will improve and you will begin to develop an exciting basic watercolour technique.

When you feel confident that your work is beginning to develop, then perhaps you should consider trying different techniques. By this time you may feel that you don't need them, but, nevertheless, you may find some of the methods outlined on the following pages useful and want to incorporate them into your painting. However, don't think that acquiring techniques is what painting is all about. Remember that you don't learn the techniques of painting first and then go on to be a painter. The techniques arise out of the process of painting.

APPLYING PAINT TO PAPER

Most watercolours are painted with a brush. The size and type you use for any purpose is very important. Get to know brush characteristics, and don't try to make a brush do what it is not designed for. Beginners often use brushes which are far too small. The result can be crabbed, fiddly paintings.

Gradually start experimenting with other methods of putting paint on paper, or manipulating it once it is there. The use of unconventional painting tools can introduce variety and interest in your work.

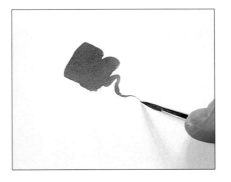

A small brush should only be used for detailed work. Most beginners paint with brushes too small in size.

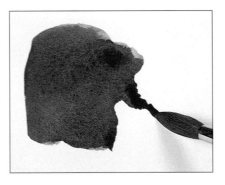

Always use a big brush to cover large areas of paper with paint. Even small details can be made with these. An 18 mm (¾ in) mop brush is a good size.

Even an old comb has its uses for producing special effects.

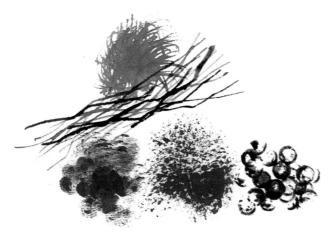

Marks made by the handle of a paintbrush, a reed pen, a finger-tip, a stencil brush and the end of a pencil.

USING WATER

The use of water to dilute paint affects the lightness or darkness of colour on paper. A weak mixture will spread the pigment thinly over the paper surface, allowing its whiteness to show through. It will also affect colours previously painted; for example, blue over yellow can show as green. A strong mix with little water will present a darker colour with no transparency. In some cases, if the mix is too strong, the result will be that the paint on the paper will have a rather unpleasant shine. A good painting will show a variety of colour dilutions.

Water added to hard edges of painted areas will make the paint bleed slightly. This will reduce the sharpness of forms and provide a softer, watery look.

The amount of water you mix with your paint controls the density of the paint on the paper. The darks and lights in this picture show the tonal extremes that can be achieved.

Experiment with paint and water. Dilute your paint on the paper surface, rather than in the palette. See what delicate, translucent effects you can achieve.

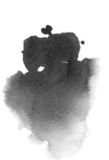

Areas of paint, when dry, can be lightened with clean water and cotton wool. In this way, you can soften edges and achieve 'soft focus' effects.

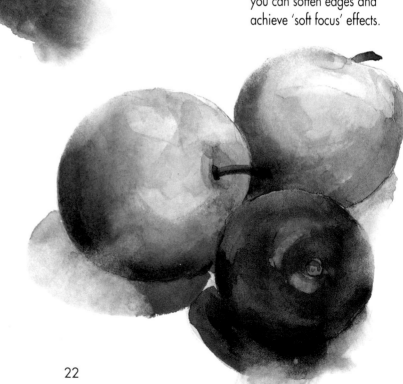

22

Water dropped into wet Indigo has produced an effect which would be difficult to achieve with a brush. Water added to a wet painted area can produce some lovely painterly effects.

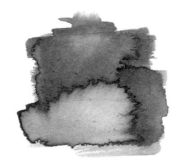

▶ A strong mix of Scarlet Lake dropped into weak wash of Aureolin gives this sunburst effect. Many otherwise dull areas of paint can be made interesting by similar methods of working.

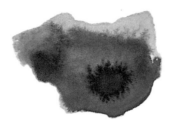

WET-IN-WET

With this technique an area of paint is laid down and, while it is still wet, more of the same or a different colour is added. Painting in this way often produces extremely interesting and unrepeatable effects. For example, by dropping a strong mixture of colour into an already wet, weak wash and then tilting the drawing board about, a colour can be persuaded to change subtly in tone and texture over its surface area. One of the problems can be the capacity of the paint to form runbacks, or 'cauliflowers' as they are sometimes called. These may appear just when you don't want them, perhaps when you are laying a wash, but at other times the shapes and patterns they produce can make a painting come very much alive.

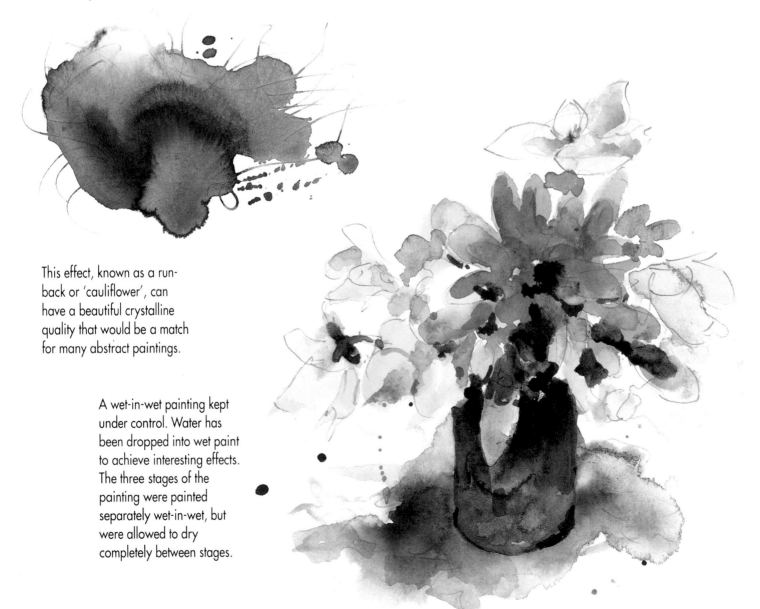

This effect, known as a run-back or 'cauliflower', can have a beautiful crystalline quality that would be a match for many abstract paintings.

A wet-in-wet painting kept under control. Water has been dropped into wet paint to achieve interesting effects. The three stages of the painting were painted separately wet-in-wet, but were allowed to dry completely between stages.

WET-ON-DRY

Painting by this method means that you keep the colours under control. As the term implies, colours are allowed to dry before any other paint is applied. The colours do not run into one another but remain separate. The beauty of this way of working is that colours can be separately painted over each other; where they overlap, another colour is shown which is a mixture of the two. For example, where blue and yellow overlap, the colour green can be seen. The effect can be like pieces of stained glass overlaying one another. In your paintings you can mix wet-on-dry with wet-in-wet methods to produce some interesting and varied effects.

The translucent, glass-like nature of watercolour can be seen when paint is laid wet-on-dry. Painting by this method can produce beautiful glowing results of great accuracy.

Hard-edged, reflective forms or subjects which require clear definition are best painted wet-on-dry.

Shirley Felts, *Plums, Apricots and Peaches*, 36 x 46 cm (14 x 18 in). A beautiful, luminous painting making extensive use of wet-on-dry methods. The dark colours, while retaining their depth of tone, have not been allowed to become muddy. The fruit and bowl have been sharply defined, only possible with the wet-on-dry technique.

▲ Tonal depth can be built up by overlaying colours. Begin with weak washes, but make successive applications less dilute to finish with a rich dark tone.

◄ As tonal depth is built up, a range of colours might be used. This can result in an interesting, variegated surface which suggests different textures.

BUILDING UP COLOUR

Watercolour paint is semi-transparent. This means that if dark (low) tones are required, paint must be built up, allowing each layer of paint to dry before the next is applied. In some circumstances, different colours of paint can be applied, producing a low tone but with slight variations of hue.

The usual practice in watercolour is to lay down the lightest colours first and then to paint successively darker colours as the painting proceeds. My own preference is to paint the light and some dark colours first to establish the tonal range of the painting. Intermediate tones are put in as the need of the painting dictates.

▼ *Topcroft Church,* 40 x 46 cm (16 x 18 in). The tones here have been built up in the shadow under the trees with blues, violets and reds suggesting colour in an area of deep shade. Five layers of paint were applied for the darkest sections.

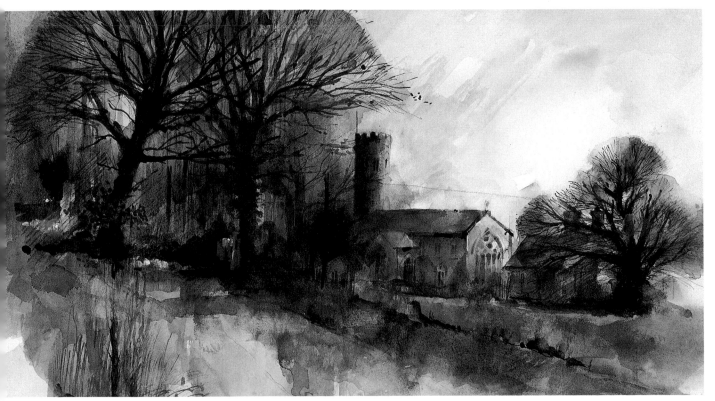

Laying a wash is best done on previously stretched paper. Mix plenty of colour before commencing. Tilt the board slightly and apply the paint in broad horizontal strokes with a large, soft, round brush. Join one strip of colour to the next as you work down the paper. Very slightly damping the paper can help to achieve an even finish. Any brushmarks will disappear as the paint dries.

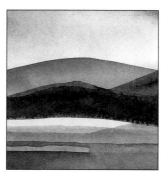

A wash can be as small as a single strip of paint. Slightly overlaying washes, wet-on-dry, can produce interesting results. The example on the far left, when masked, produces the stylized hill and field scene shown here.

LAYING A WASH

The term 'flat wash' usually refers to a relatively large area of paint applied absolutely flat so that the finished result might have the effect of coloured paper. I personally feel that a perfectly flat single-colour wash can look rather artificial, although it can be useful in some circumstances, for example, to suggest calm, still water. However, it is possible when laying a wash to achieve more natural effects by changing the depth of tone or the actual hue of the wash over its total area.

If you want a completely flat result, apply your wash quickly on dampened paper and always have enough paint to cover. Don't be discouraged by early failures – with practice, it is possible to achieve perfect results.

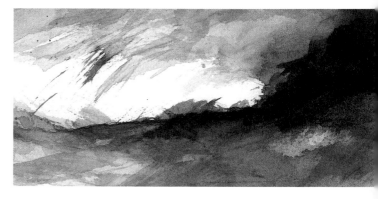

Washes do not need to be tight and disciplined – try working freely instead. Paint thin washes, letting them dry before applying darker washes, then scratch and scrape the paint whilst wet.

MASKING FLUID

Use masking fluid when you wish to leave certain areas (usually small ones) of your paper protected from the paint. Masking fluid can be applied with a pen or a brush, so that it is possible to draw or paint intricate shapes which will show up as white paper once the masking fluid is removed. If you want other colours to show through, it is possible to lay a flat wash in colour first and then apply masking fluid after the paint has dried. Use masking fluid with moderation. Over-application often makes the finished painting look false.

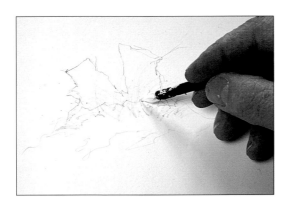

▶ After the watercolour has completely dried, the masking fluid is rubbed off with a finger tip. The grass will now show as white on a coloured background.

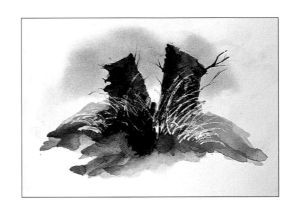

▲ In this example, masking fluid is used to suggest coarse grass at the foot of a tree stump. After the initial drawing, a broad-nibbed pen is used to apply the masking fluid with quick, slightly curved strokes. When the fluid is dry, the painting is commenced using medium to dark tones over the masked areas.

▶ Yellow or green can now be washed over this area to suggest the colour of grass.

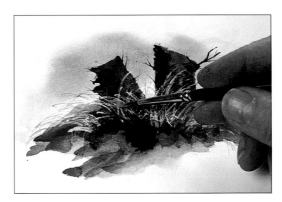

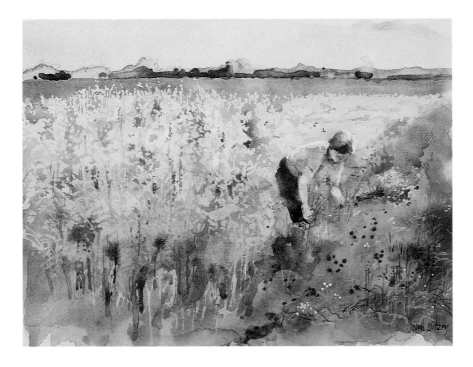

Picking Wild Flowers, 34 x 50 cm (13½ x 20 in). Flowers and grasses were suggested by painting shapes in masking fluid and laying washes on top. After the masking fluid was removed, further washes were added, but some parts were left totally unpainted.

This small example shows the lifting out technique. After painting the foliage and shadowy base in Indigo and Aureolin, the paint was allowed to dry. Clear water was applied with a brush to the parts where the trunk and lower branches were to be. Using damp cotton wool and blotting paper, the paint was then lifted. Subsidiary dark branches were added after the lifted areas were dry.

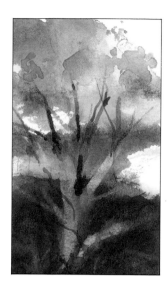

The brick wall was suggested here by scraping out damp paint with a 6 mm (¼ in) strip of metal. Before painting, very faint guidelines were drawn in so that the alignment of the bricks could be achieved. Varying pressure on the metal strip produced a textured effect.

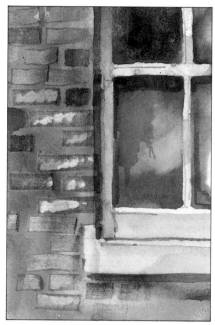

► The effects of scraping out, lifting out and the use of masking fluid are shown in this painting. The sun was achieved by cutting a circular hole in a piece of cartridge paper, placing it in position and lifting out the paint by gently rubbing with damp cotton wool. The effects of scraping out can be seen at bottom right and the use of masking fluid at bottom left.

SCRAPING OUT & LIFTING OUT

Watercolour paint can be removed from the paper by scraping with a very sharp palette knife or other implement when it is wet, or lifting it out with a wet brush when it is dry. When scraping out, take care that you do not damage the paper. This technique is not recommended for papers of weights less than 300 gsm (140 lb). The effect will be determined by the amount of paint on the paper surface. It works better with more, rather than less, paint.

An area which is to be lifted out is first wetted, normally with a water-saturated brush. This dissolves the paint, which can then be blotted off with damp cotton wool or blotting paper. Certain colours will lift more easily than others, and very thin layers of paint are less easy to lift than thick layers.

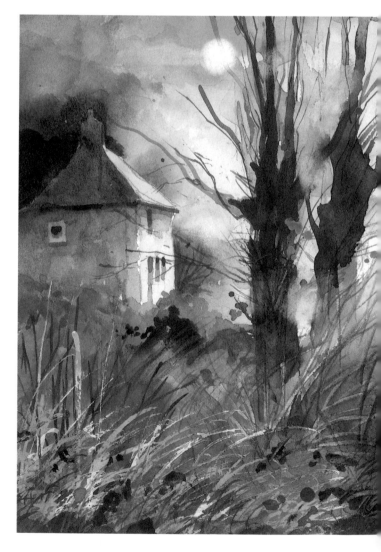

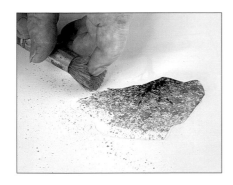

Any short bristle brush can be used to create a fine spray of paint. A stencil brush is being used here, but a discarded toothbrush will do just as well. It is a good idea to shield with paper any areas not to be treated to avoid accidental marks on your painting.

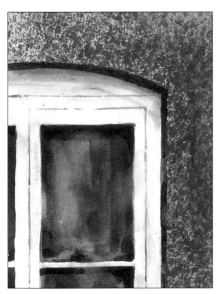

Spattering can suggest a coarse-grained wall texture very successfully. The appropriate area was first washed over with Yellow Ochre and left to dry. Burnt Umber, Cadmium Red and Yellow Ochre paints were then spattered over from a variety of distances to achieve large and small blot sizes. Once these were dry, a very weak wash of Ultramarine was applied over parts of the spattered area.

This tree foliage has been created with spatter effects. A mask was cut from cartridge paper to show just the foliage. Spattering was done in three successive stages, allowing the paint to dry each time. The mask was moved slightly to soften the outline. Branches, tree trunk and grass were then added.

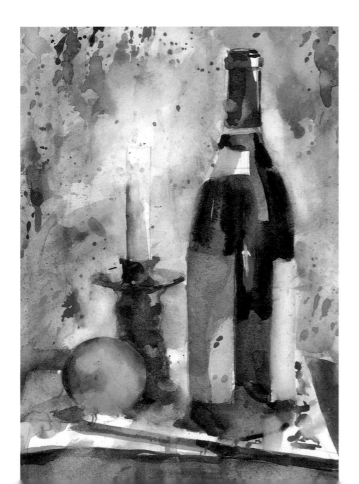

SPATTER EFFECTS

Spattering or flicking paint can be used to create certain painted textures; it can be used to suggest very fine detail or it can be used on a somewhat grander scale to give the impression of spontaneity in the painting process.

Paint on a bristle brush can be spattered over the paper giving a fine spray, or it can be flicked using a large, soft brush. You will need to experiment with various brushes to find the one that suits your purpose. The two that I have found most useful are a discarded toothbrush and a 12 mm (½ in) stencil brush.

A pattern of flicked paint can provide a festive effect. In this case, an 18 mm (¾ in) brush was loaded with various paint colours in succession.

Each paint colour was flicked and dropped onto the paper. Cotton wool and clean water were used to mop out unwanted blots of paint.

◄ Candle wax can be used to provide a paint resist. The paint will just slide off the waxed areas. A candle end is easy to use and can cover a large area quickly.

◄ Worked into wet areas of paint, candle wax will give a variety of textures. With appropriate colours, this technique could be used to suggest rock-like surfaces or tree bark.

► Where small areas of paper need masking, white wax crayon can be used. The wax resist technique produces distinctive marks on the non-painted parts.

WAX RESIST

Wax resist in the form of a household candle or children's wax crayons can be used to create a variety of interesting effects. You can apply the resist before you begin painting, or even while the paint is still wet. Candle wax rubbed on paper under the paint will provide textures which can describe such things as a weathered wall, flowing water or even a distant field of corn. Coloured wax crayons may be used with watercolour in mixed media form. The combination can create unusual effects of bright colour and stippled paint.

The paper surface you use will play a part in the wax-watercolour technique, rough paper giving you a coarser-grained texture than smooth paper. Before you use any wax in a painting, do some trials on spare pieces of paper to see if you can achieve your desired result.

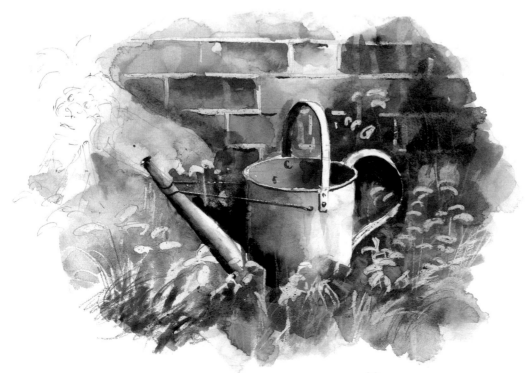

This study of a watering-can makes use of white and coloured wax crayons. The mortar in the brickwork was achieved with white wax crayon, and the same method was used on the handles of the watering can. Candle wax suggests foliage in the grass. Coloured wax crayon was added over the watercolour when the paint had dried.

The house walls are sketched and the ground area drawn in. Beeswax is then applied inside the masked area with thick card.

The paint for the background and foreground is liberally applied. Beeswax is worked into the foreground for broken texture.

The paint is allowed to dry and further applications of colour are added to the painting with pen and brush.

BEESWAX

A paste can be made from an equal mix of beeswax and turpentine by melting the two together in a glass jar immersed in water and bringing to the boil. When cooled, the paste can be used as a powerful resist. You can apply the wax with a spatula to cover large areas or mix it into the wet paint on the paper to produce unusual painterly effects. It is very effective for describing mountains, rocks and rough terrain. On completion of the painting, the wax can be removed with brown paper and a hot iron.

▼ In the finished picture, the broken paint suggests weathered house walls and a wild terrain of rocks and coarse grass.

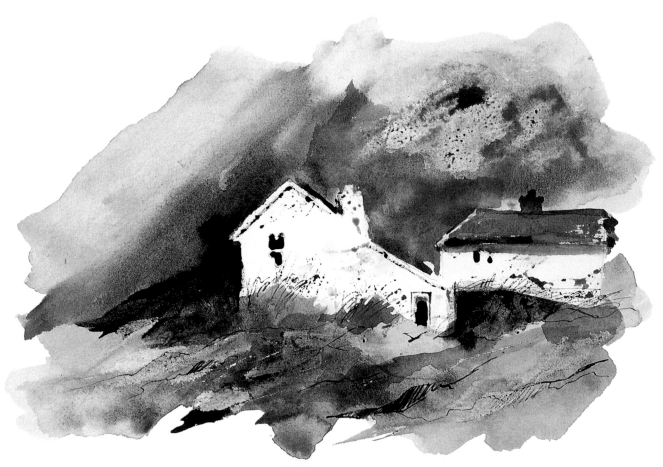

A comparison of watercolour (above left) and gouache (above right). Watercolour produces more transparent tints than gouache. Paintings worked entirely in gouache, because of the greater density of the paint, can have a somewhat milky or pasty effect.

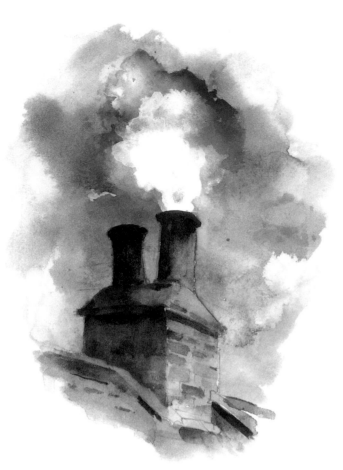

White gouache can suggest smoke or steam effectively and can be useful in sky studies to suggest cumulus clouds. To simulate a smoke effect, apply the gouache thickly and dilute the edges with clean water. A cloudy effect is produced which can be controlled with damp cotton wool.

GOUACHE

This paint, sometimes referred to as body colour, has many of the characteristics of watercolour but with the difference that it is much more opaque. Used as a paint medium in its own right, it produces a denser and less translucent result than watercolour.

Because of its greater density of colour, gouache can be helpful in strengthening the low tones of watercolour. White gouache can be used to lighten watercolours, which can then be applied over previously-painted dark tones. White gouache can also be used on its own to paint in highlights, for example, where sunlight might catch the edge of a window frame.

While gouache can sometimes be valuable in the above cases, you should be wary of over-using it, otherwise your painting could lose its watercolour look.

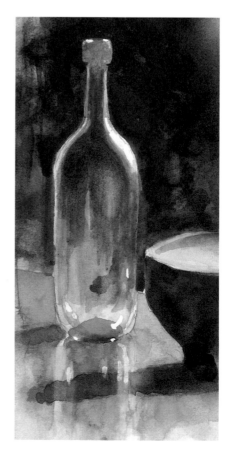

Leaving unpainted paper to suggest small highlights is usually difficult to do. An easier way can be to add highlights in white gouache after the painting is completed. Use a small brush to apply the paint. Weaker highlights can be painted in dilute gouache.

LINE & WASH

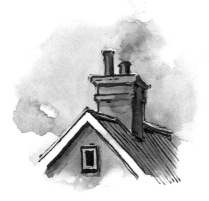

▲ When using waterproof indian ink, the drawing is usually made first and watercolour washed over it when dry.

This technique is very popular with many commercial illustrators and cartoonists. The usual method of working is to begin with a drawing in fixed (water resistant) ink, followed by washes of watercolour. There are, however, other ways of working: the drawing can be made on top of colour washes, or the lines can be drawn in unfixed ink or even in watercolour itself. The line work is usually drawn with a pen, but some artists occasionally draw with a small stick dipped in ink. There is plenty of room for experimentation with the line and wash method. But to begin with, I suggest that you use the basic method outlined above, making sure that the ink you use will not run in water.

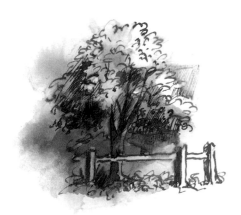

◄ If watercolour is painted over the top of a drawing made in non-waterproof black ink, it will cause the ink to run slightly. The drawing can be softened as a result.

◄ Watercolour paint can be fed into a pen with a brush, so lines can be drawn in any colour. Here, watercolour washes were applied first, with colour penwork on top.

▲ Waterproof indian ink was used for the basic drawing in this landscape. When it was dry, watercolour washes were applied over the top. Working in this way produces harder

and sharper results than working with watercolour alone. The use of line and wash in landscapes can give the effect of a windy day.

Conté crayon can be used on its own for quick sketches and studies. Strong, sharp lines can be drawn, with soft tones suggested by rubbing the crayon with a fingertip.

CONTÉ & PASTEL

Both of these media can be very effective with watercolour. They can be added sparingly to liven up parts of a watercolour sketch or applied extensively to a finished painting to produce a real mixed media effect.

Conté is a synthetic chalk available in various colours. It can be used to make a loose underdrawing for a watercolour and for deepening the tone in shadow or other dark areas. Black or grey conté can effectively strengthen the tonal contrast in watercolour, giving the medium a powerful quality.

Pastel, available in many colours, normally gives a more intense result than watercolour. Used on its own, it can produce some lovely work, but used with restraint, it can also brighten parts of a watercolour where the colour needs to be particularly strong, for example, the flowers in a floral still life.

Use soft pastel over watercolour to provide bright colours in dark areas. It can be used extensively to provide mixed media effects. Soft pastel should be applied when the watercolour is completed and should be fixed to avoid smudging.

Soft pastel (left) and conté (right) compared.

In this painting, the blind was painted too high.

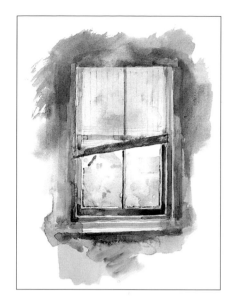

While the paint was wet, it was removed with damp cotton wool.

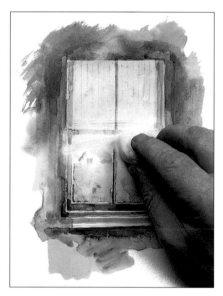

The damp area was allowed to dry and the blind was repainted in its new position.

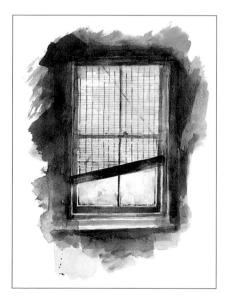

CORRECTING MISTAKES

It is commonly said of watercolour that painting errors cannot be corrected; that once colour has been laid down, no alterations are possible. This idea is only partially true. In some cases, drastic revisions can be made to a painting, either while the paint is wet or sometimes when it is dry.

Most watercolours nowadays are produced on well-sized papers which do not totally absorb the paint. Where this is the case, it is certainly possible to remove paint while it is still wet. The use of cotton wool and plenty of water will in most cases do this quite effectively. However, you will find in practice that some colours are easier to remove than others.

Even after paint has dried, alterations are possible by gently wiping the paint off with cotton wool and water, and painting revisions over the top when dry. To avoid damage to the paper, do not rub too vigorously over the area to be corrected. Accidental small blots of paint and similar marks can usually be removed with a sharp craft knife or razor blade. However, this tends to disturb the paper surface, and painting over the scraped area is not recommended.

▶ This tree is painted in line and wash, and the paint has dried. To effect any changes, the paint must be removed with clean water and cotton wool.

▶ Most of the branches have been gently wiped off and the foliage painted on without the underlying structure of the tree showing.

TONE

One of my main preoccupations as a painter is the study of light. I find it fascinating to see how light and shade can reveal forms, sometimes highlighted and at other times lost in darkness. In a still life, for example, the light might catch the edge of a vase, throwing it into sharp relief against a dark background, while the shadowed side of the same vase might be obscured. The vase might be identified only by its illuminated side. To record this subject effectively, I must translate light and shadow into a range of painted tones.

In landscapes, tonal considerations also arise. Take a tree when its leaves are beginning to change colour. It is quite possible to identify which parts of the foliage are yellow and which are green. It is often more difficult to see which is the darker shade, or, indeed, if there is any difference between the shades at all. When you are out walking or sitting at home, look at what is before your eyes. Your field of vision presents itself as a series of tones. Try to analyse what is dark and what is light. Arrange what you see in some kind of tonal order. Such practice will surely help you when you come to pick up your brushes.

▶ *Snowdrops and Bamboo*, 40 x 28 cm (16 x 11 in). Strong tonal contrasts give this still life an effect of light and shade. In your own painting, exaggerate these features. Also, allow your tones to merge into one another as has happened here. Parts of the bottle and jug share the same tonal value.

◀ *A Farmhouse*, 30 x 48 cm (12 x 19 in). This farmhouse, painted in winter, was bathed in early morning light. To capture this effect, it was necessary to use a maximum range of tones. Notice how the light-toned tree on the right recedes into the distance.

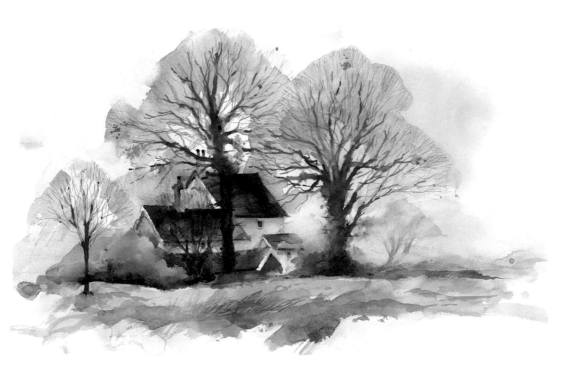

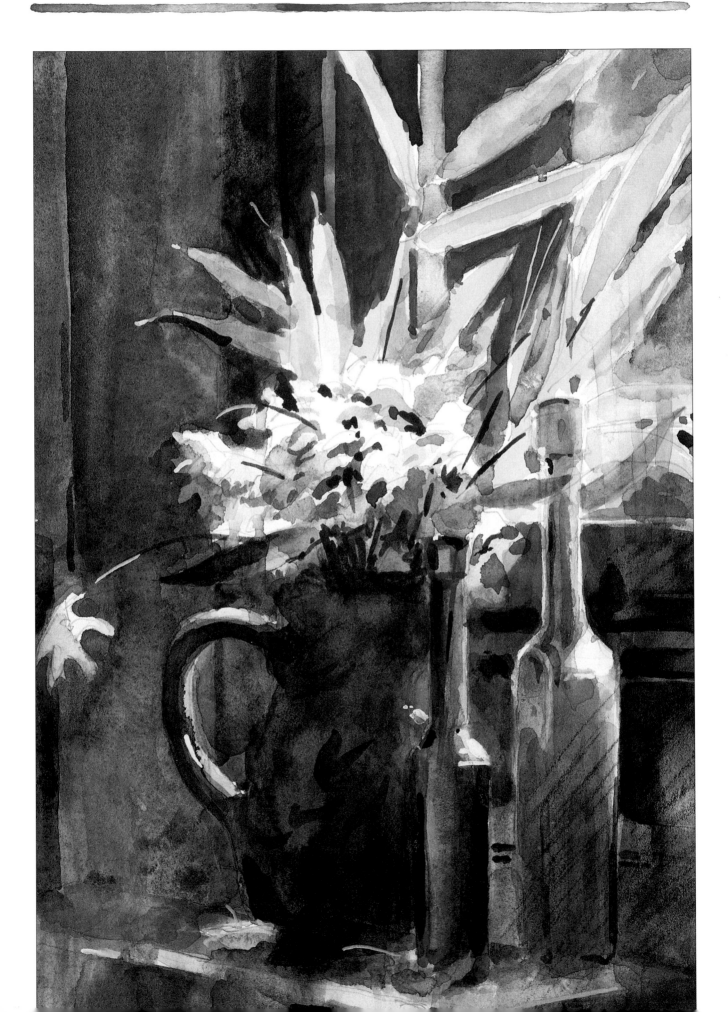

HOW TO SEE TONAL VALUES

The identification of tonal values has for long been a problem in painting and not only in landscape work; painters of interiors often have critical tonal problems to solve. A very good method of judging the lightness or darkness of a colour, either inside or outside, is to view the subject through half-closed eyes. This process of squinting lowers the amount of light entering the eye, enabling you to concentrate on purely tonal values more easily.

MAKING TONAL SKETCHES

Instead of launching into a finished painting, it is very sound practice to do some sketches in

pencil or conté first. Your tonal studies will often help you to make your paintings work. Look at your subject in terms of tones, rather than as a series of separate items, all of which have to be drawn individually. You will often find that one tone runs into another.

Try to ignore details; look instead for flat masses of tone. A house and tree might merge into one another, forming a continuous shape, or a figure in a room could be simplified down to a limited series of tones, light against dark. The tonal studies made by the French painter, Seurat, are interesting in this context and can be seen as marvellous works in their own right.

WORKING IN A SINGLE COLOUR

It can also be helpful to prepare painted single-colour studies before beginning a finished painting. Identify the tones by squinting at your subject and recording them in your sketchbook. Use just one colour or maybe two mixed together: Ultramarine and Yellow Ochre would be fine. Some pure colours on their own produce bright, high-intensity results; it is more effective to keep your colours subdued.

Don't work on too large a scale – 15 cm (6 in) maximum in either direction would be appropriate. Suggest your tonal values by

Make pencil sketches of possible subjects. In this pencil drawing, the interest was mainly focused on the arrangement and tonal qualities of the scene.

This study was done with a mixture of Ultramarine and Yellow Ochre. The tonal values have been retained, but the arrangement has been slightly changed. The areas of tone at top and bottom right have been completely wiped out.

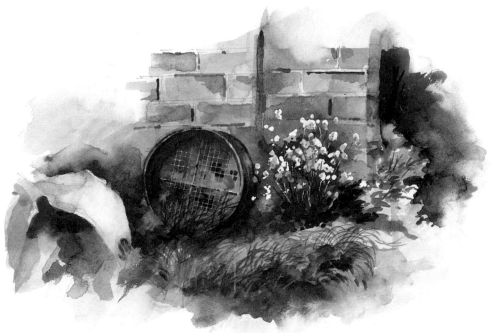

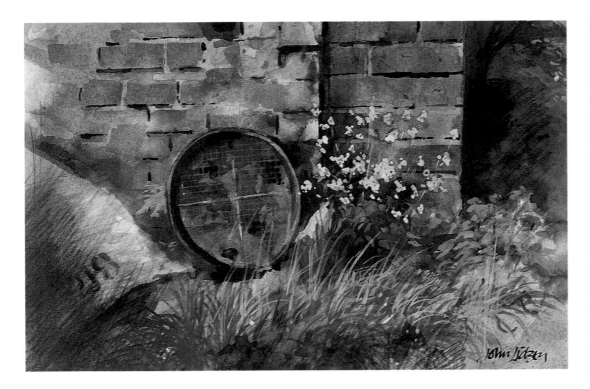

*Garden Sieve,
20 x 30 cm
(8 x 12 in).
In this full-colour
version, the
second set of
ideas was
abandoned.
Notice how tones
have been
lowered around
the forget-me-nots
to bring out the
colour of the
flowers. Always
consider how
tonal values can
give your painting
shape and form.*

progressively increasing the paint-to-water
content of your mix – a weak wash for your light
tones, a really strong, soupy mix for your darks.
It may, or probably will, be necessary to
intensify your dark tones by laying more colour
over your first application after it has dried.

TONE IN THE FINISHED PAINTING

While working on your finished painting, keep
your tonal sketch or your one-colour study
beside you and refer to it often. Try to maintain a
full range of tones in your colours. Your light
tones can be pure, pale washes, allowing the
white of the paper to come through. Your dark
tones can be deep and vibrant. Try not to let
them become muddy. If you don't use too many
colours in your mixture and keep to a minimum
the amount of water you use, you should find
that you avoid this problem.

To build up your tones, overlay paint on the
appropriate areas wet-on-dry. For a very dark
value, gouache paint can be effective; it will
provide a really opaque colour. Keep your use of
gouache paint to a minimum, however; if it is
over-used, you will lose the translucent quality
of your watercolour.

EXERCISES

1 Practise developing a tonal range by painting a
series of colour patches in Ultramarine and Yellow
Ochre mixed. Start with the lightest tone you can
achieve with plenty of water. Finish with the darkest
tone possible, overlaying the colours if necessary.
Don't make more than ten separate patches.

2 Prepare a small interior study of a lighted candle
beside a wine bottle set against a pale background.
Observe the complete range of tones from light to dark
and see if you can capture all these tones in a colour
sketch. Use a full range of colours, too.

3 Paint an open domestic window in sunshine, from
the outside looking in. Try to convey the relative
darkness of the interior against the brightness of the
exterior with some of the strong tones you used in the
previous exercise. Work only with the following
colours: French Ultramarine and Yellow Ochre.

PROJECT
BUILDING UP TONES

❖
Subject
Exterior door or entrance
showing a wide range of
tones from light to dark
❖
Medium
Pencil, or conté and
charcoal (for sketch)
Watercolour for finished
painting
❖
Colours
French Ultramarine,
Cadmium Red, Indigo,
Payne's Grey,
Cadmium Yellow,
Yellow Ochre,
Crimson Alizarin,
Titanium White (gouache)
❖
Size
25 x 38 cm (10 x 15 in)
maximum
❖
Paper
Good quality watercolour
paper, Not surface.
❖
Equipment
18 mm (¾ in) mop brush
for washes
No. 12 and No. 8 brushes
for other work
Damp cotton wool for
mopping out excess colour
❖
Time
Two hours for sketch
Four hours for painting

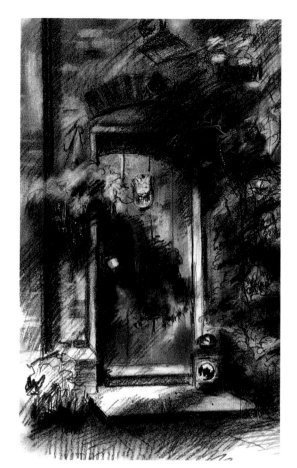

I made this sketch in conté
and charcoal as quickly as I
could because the angle of
the shadows was changing
by the minute. I was more
interested in the broad
masses of tone than in
observing the details of the
foliage and wall.

▼ I found this doorway to an
old building very interesting,
so I made a quick line and
wash sketch of it. The sun
was high and the entrance
was in deep shade. I
suggested the interior
darkness by low-toned
watercolour and cross-
hatching in waterproof ink.

Doors and entrances are often
partly or wholly recessed,
which can produce some
striking effects of light and
dark, especially on sunny days.
The door shown in the painting
on page 41 was caught in
bright sunlight and I have
attempted to convey this effect
by creating strong contrasts of
tones, building up the darks
with overlaying washes of
Indigo, Payne's Grey and
French Ultramarine.

Find a doorway or entrance of
your own which shows a good
range of lights and darks and
try to capture the effects in a
painting. Don't paint in too
much detail; concentrate on
creating a wide tonal range in
your colours.

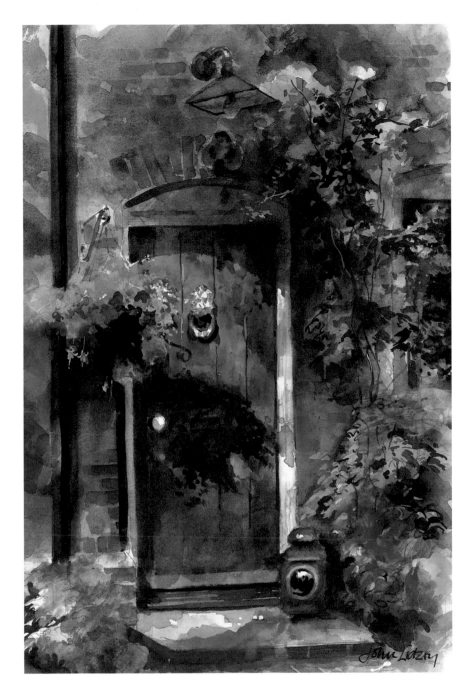

Front Door of The Dell, 25 x 38 cm (10 x 15 in). In this painting, I made more extensive use of gouache than I usually do. For example, the sunlit parts of the door are made up of Cadmium Yellow, Indigo and White gouache; the sunlit door jamb is also painted in White gouache. Notice how the top of the white door jamb has been painted in a very low-toned colour. Features that are actually white can often be painted as dark (nearly black) tones in the shade.

Before doing any painting, make a tonal sketch using pencil, or conté and charcoal. Making a sketch is a useful way of recording the lights and darks in the subject. I cannot stress too strongly the value of these preliminary studies. If you get into the habit of making them, your own painting will benefit by becoming more tonally accurate.

SELF-ASSESSMENT

✧ *Did your black-and-white sketch capture the tones in your subject?*

✧ *Were the tones translated from sketch to painting?*

✧ *Did you avoid over-concern with photographic detail in the finished result?*

✧ *Did your painting show a full range of tones from light to dark?*

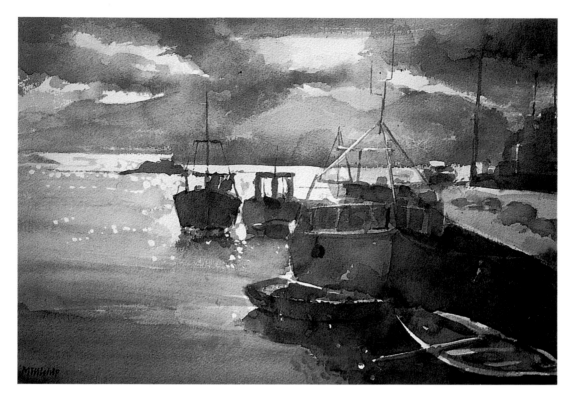

Paul Millichip, *Connemara Harbour*, 38 x 56 cm (15 x 22 in). Tonal values play a major part in the composition of this painting, which was painted against the light. The dark shapes at the bottom right-hand side lead the eye into the upper centre of the painting to where the light flows on the water.

USING TONE TO DESCRIBE LIGHT

Watercolour is not generally considered to be a tonal medium; indeed, it can sometimes achieve considerable delicacy without any tonal contrasts at all. However, if you wish to suggest interesting effects of light and shade, often referred to as chiaroscuro, you will need to make use of the full tonal range which the medium can offer. Strong light will normally cast shadows in which details can be lost. Experiment with subjects which contain strong lighting contrasts. Paint against the light, observe shadows, study reflections; record what you see in your sketchbook.

LIGHT AND SHADE IN LANDSCAPES

On a good, sunny day, make a note of how the sun produces totally different lighting effects at midday and at twilight. In the evening, look at the possibility of painting trees against a setting sun. See how tonal values widen and create a sense of light at this time of day. If the sun is low enough and bright enough, the light might actually appear to bend round the tree trunks or branches. Watercolour can capture this quality extremely effectively.

CREATING LUMINOUS INTERIORS

Sun plays a vital part in painting landscapes, but many interiors may be painted when there is no sun. Artificial light can provide interesting effects of light and shade. A table lamp could be used as part of a still life set up, and candles and oil lamps make fascinating subjects for painting.

In daylight, try painting from the inside looking towards an open window. Observe the way light behaves on the curtains moving gently in the wind. Look for the lights and darks on the window frame, and notice how the window itself is the source of light during daylight. If you study the way light falls and modulate your tonal values successfully, you will be able to create a magical effect with light.

PRACTICAL TIPS

While painting your light tones, paint an area of your darkest tone, too, to establish a contrast.

Don't produce a painting in which all the tonal values are the same.

Lamp and Bottles,
56 x 33 cm
(22 x 13 in).
A dark corner of
a room. If the
items in a still life
are chosen
carefully, it is
possible to create
a satisfying range
of tones. The cup
in the foreground
is made to seem
especially white
by its contrast
with the darker
elements behind
it. Notice how
shadows can
create interest.

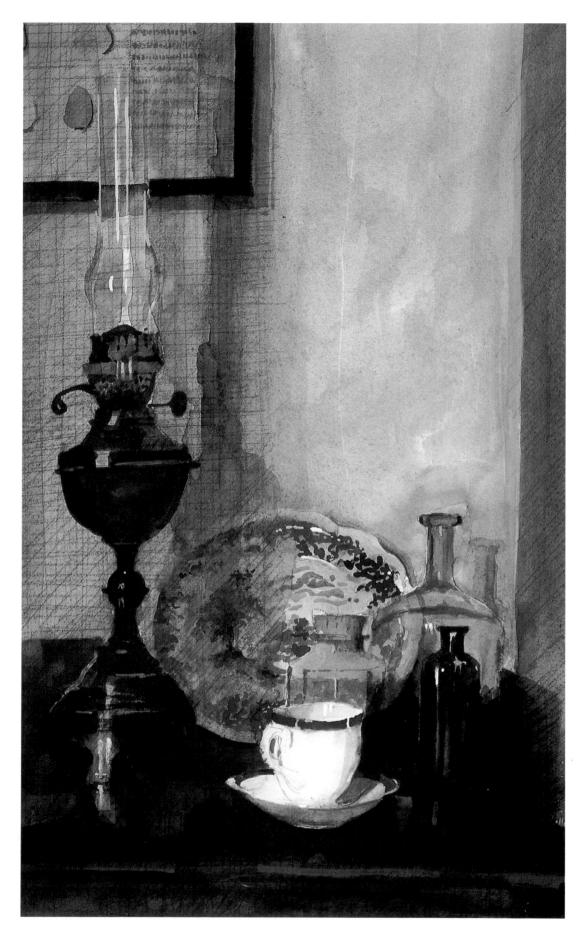

Still Life with Lamp and Jug

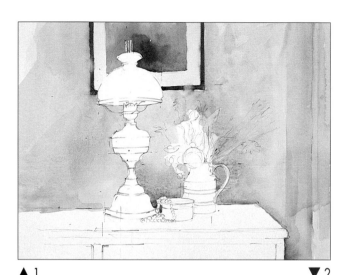 ▲ 1

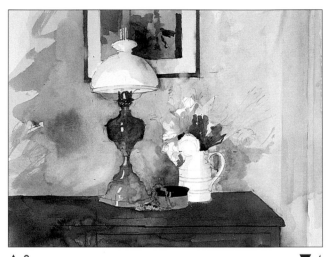 ▼ 2

▲ 3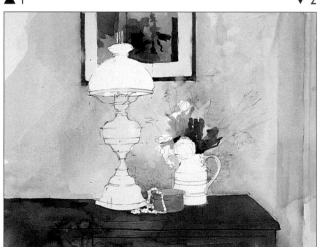

▼ 4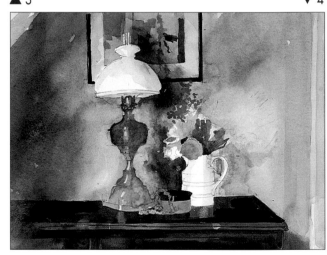

STEP 1
My initial drawing was carefully done, but only the general shape of the dried flowers was indicated; I prefer to paint details of leaves and flowers directly at the painting stage. The first washes of colour I applied only indicated the warm and cool areas of the painting.

These were kept very light in tone and intensity.

STEP 2
A flat wash was laid in next for the cupboard top, using Cadmium Red and French Ultramarine. The left-hand side extends into shadow, so I brushed some pure French Ultramarine wet-in-wet into

the wash on this side. I began my painting for the lamp base by a flat application of weak Aureolin. I also painted the area around the top of the jug to establish one of the darkest darks.

STEP 3
I now began the process of building up my colours. You

can see how I have laid a new wash over the previous one on the left-hand side. My washes are not kept even in areas like this. If you look carefully at an area of shadow, you will see that there are often subtle variations of light and dark. The red beads were painted in a light Crimson Alizarin,

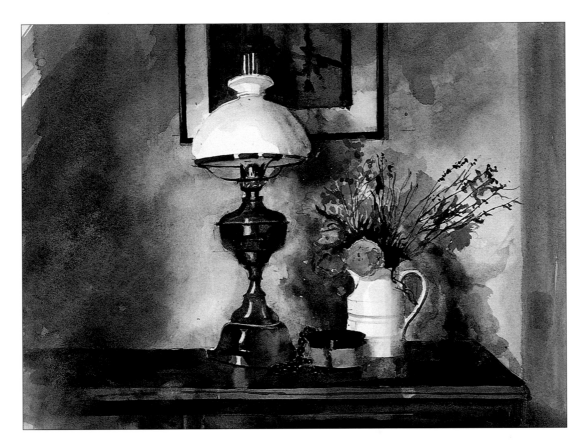

and some modelling was given to the lampshade and jug by light applications of French Ultramarine and Yellow Ochre.

STEP 4
The light was coming from the front and slightly from the left which meant that the lamp cast a shadow on the wall behind the flowers and onto the picture. This shadow was painted in Indigo and French Ultramarine. Further tone was added to the left-hand side of the lamp. I also needed to build up tones on the cupboard top and the right-hand side of the wall. In most cases, the painted shadow areas were partially mopped out with damp cotton wool in order to achieve a soft-edged result.

▲ STEP 5
The painting is now complete. I have slightly darkened some areas still further, and lightened others. By using strong changes in tone, I have created an effect of light and given a shape to the rounded items in the painting. A tonally weak painting would have created these effects far less successfully.

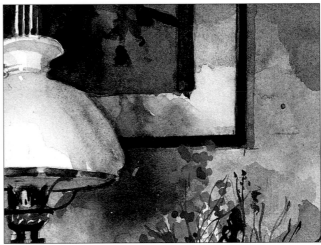

▲ DETAIL
Here you can see how I have avoided completely flat areas of tone. By gradually building up colour, it is possible to achieve very painterly results. Small subjects, like this detail, can be very useful for you to work on as experiments in tone and paint-handling techniques.

COLOURS USED:
Indigo
Aureolin
Yellow Ochre
French Ultramarine
Cadmium Red
Payne's Grey
Carmine
Cadmium Yellow Deep
Permanent White (gouache)

COLOUR

You could be an expert on colour theory and yet be a poor painter. An academic knowledge of colour can only be a small help in painting. You will find that there is no substitute for the practical experience of mixing and matching. Watercolour paints seldom behave as one would expect, as you may already have found out; red and blue when mixed do not always make violet.

Colour is often at the root of painting failures, and an understanding of what has gone wrong can be of great benefit in putting things right. The act of seeing a colour and identifying it is not the simple process it may seem. When you are painting, you can often be surprised to find that a colour turns out to be quite different from what you might initially have expected.

▼ *Butterfly Collection*, 42 x 29 cm (16½ x 11½ in). In subjects like this one, exaggerate the colours. The wall was actually white, but shadows and reflections turned it green in the light and indigo in the shadow.

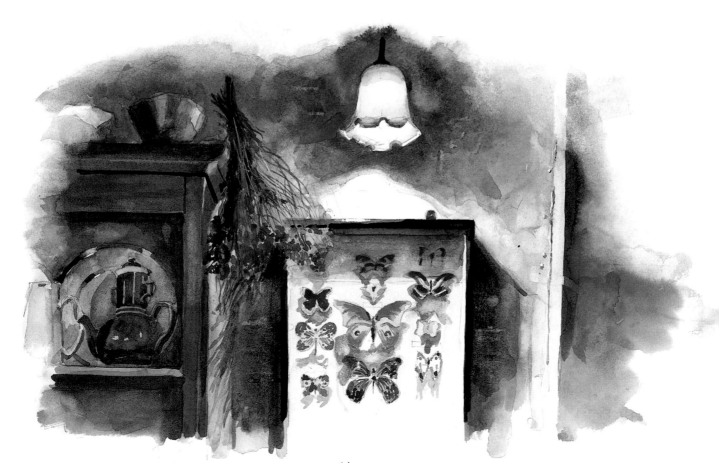

Elsie in the Poppy Field, 48 x 29 cm (19 x 11½ in). The low angle from which the figure is painted, framed against the sky, creates a colour contrast between the top and bottom halves of the painting. The attention is focused down from the figure to the poppies and white flowers below it.

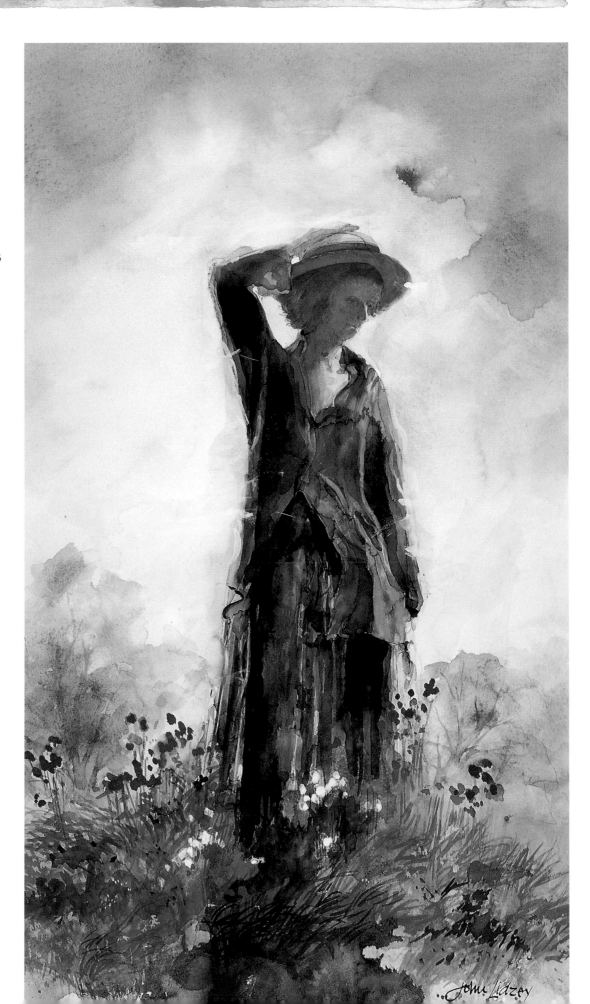

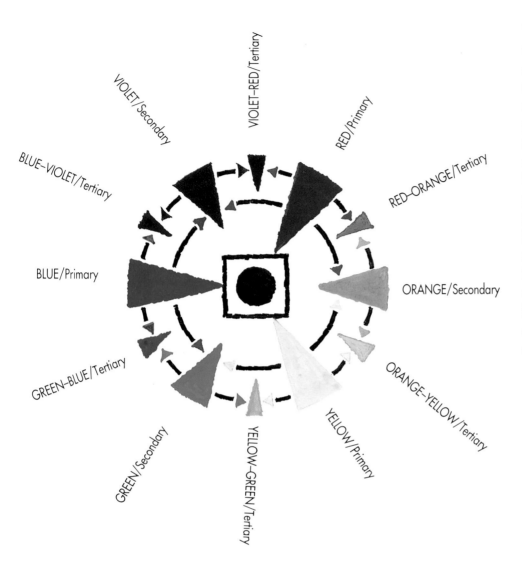

VIOLET/Secondary

VIOLET–RED/Tertiary

RED/Primary

BLUE–VIOLET/Tertiary

RED–ORANGE/Tertiary

BLUE/Primary

ORANGE/Secondary

GREEN–BLUE/Tertiary

ORANGE–YELLOW/Tertiary

GREEN/Secondary

YELLOW–GREEN/Tertiary

YELLOW/Primary

This colour wheel shows the three primary colours, the secondary colours and the tertiary colours. It clearly demonstrates how mixing two primaries will produce a secondary colour (e.g. yellow and red make orange). It also illustrates how mixing a primary and a secondary will produce a tertiary colour (e.g. red and orange make red-orange). The colour in the centre square is the kind of colour which will result from the mixture of two colours from either side of the colour wheel.

COLOUR TERMS

It is useful to know something about the characteristics of colour and to be aware of the correct technical language when describing it. There are, in fact, many terms associated with colour, but I am restricting myself here to the terms I use in this book.

PRIMARY COLOURS
These are red, blue and yellow. Mix any two of these colours together and you arrive at the complementary of the third colour (see page 49). For example, red and blue mixed together make violet, the complementary of yellow. In many cases, however, watercolour paint does not behave according to the theory. You can test colour theory in practice by using gouache in primary red, blue and yellow.

SECONDARY COLOURS
These are colours which can result from the mixing of two primary colours (see the colour wheel). Green, violet and orange are secondary colours. You will need to experiment over a period of time to find out how the pigments behave when mixed together. A secondary colour produced as a mixture of two primaries will often not possess the intensity of a proprietary secondary colour.

TERTIARY COLOURS
These come from mixing primary and secondary colours together, with the same qualification as that which applied to secondary colours.

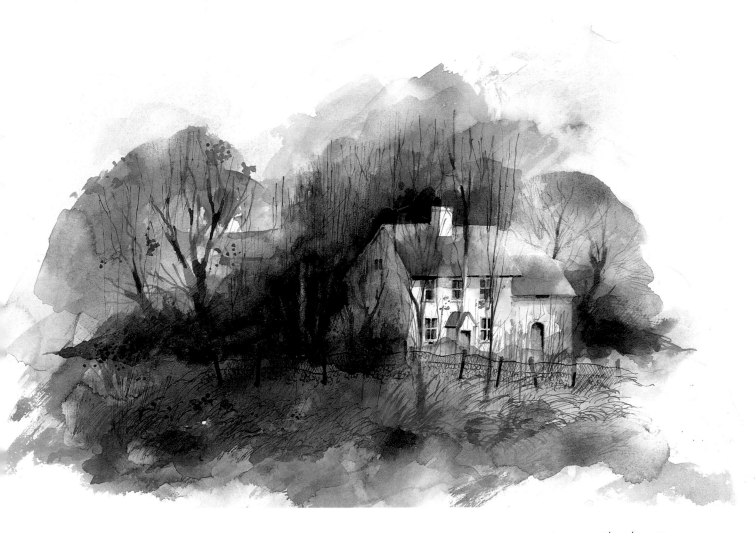

COMPLEMENTARY COLOUR

This refers to the colour opposite another on the colour wheel (see opposite). For example, red is the complementary of green. Each colour will reduce the intensity of the other if they are mixed together.

The Impressionist theory holds that every primary colour has its complementary colour in its own cast shadow. Thus, a yellow object will have violet in its shadow. As a watercolourist, this effect is something you could experiment with in your own work.

Cottage at Thornham Magna, 20 x 36 cm (8 x 14 in). Colour contrasts in the form of complementary colours are used here to produce a bright painting. Blues, oranges, reds and greens are juxtaposed. Normally this would create a discordant effect, but in this case most of the colours have been very slightly neutralized so that they can live together.

ANALAGOUS COLOURS

This term describes colours which are next to each other on the colour wheel: blue and green, red and orange, and so on. A painting produced with an extensive use of analagous colours gives a very harmonious and pleasing result. In my own painting, I will often turn one colour into another, similar, colour by adding an analagous colour to the mix; I then continue altering this mix with further additions of analagous colours. Rather than looking for fresh colours in your paintbox, try manipulating your paints like this.

NEUTRAL COLOURS

These are normally black, white and grey. A colour can be neutralized by adding a little black or grey to it. When you do this, you are in effect reducing its intensity (see below).

HUE

This term means pure colour, independent of any other qualities which might be ascribed to it. I can talk about green grass, but if I want to say anything about the kind of green, I must use some of the other terms that follow.

TONE

This was the subject of the last chapter and it means, of course, the lightness or darkness of a colour independent of its hue. Some colours, like sepia, are naturally dark in tone; some, like lemon yellow, are light in tone. You can lighten a tone by adding water or Chinese White. It is normally possible to make a colour darker by adding Neutral Tint, Payne's Grey or black, although by doing this you will lose some of the intensity of the hue and possibly alter it.

INTENSITY

This term refers to the brightness of a colour. Some colours like Cadmium Scarlet are naturally

The blue and green patches are analagous colours. Analagous, or harmonious, colours can suggest repose and peace.

If you mix all the colours in your palette, you may well arrive at a neutral colour similar to this.

Colours can be described in terms of their tonal value. Here, Payne's Grey, Cadmium Red and Lemon Yellow have been tinted out with water to give a scale of tones. A dark colour has a greater tonal range than a light one. In your paintings, see if you can make full use of the tonal range of your colours.

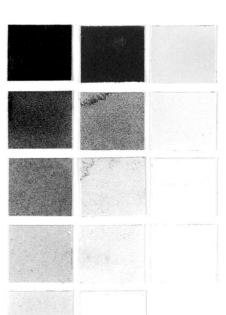

An example of a warm colour, orange, and a cool colour, blue.

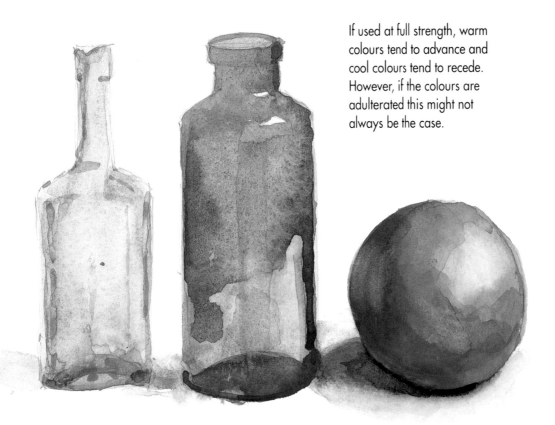

If used at full strength, warm colours tend to advance and cool colours tend to recede. However, if the colours are adulterated this might not always be the case.

intense. Others, such as Vandyke Brown, have little or no intensity. In order to reduce the intensity of a bright colour, either add in some grey of the same tone as the colour you wish to reduce or add some of its complementary colour (see page 49).

LOCAL COLOUR

This term describes the actual colour of something independent of the effect of the light source or reflected colour. Thus, the local colour of tree foliage might be green, but the effect of sunlight could make parts of it look pale yellow.

WARM AND COOL COLOURS

The temperature of a colour can be judged by its closeness to or distance from red/orange (warm), or blue/green (cold). It is important to remember that warm colours will vary in their colour temperature when compared with others in a similar temperature range. For example, Crimson Alizarin is colder than Vermilion even though they might both be called warm colours. The same case applies to cold colours: Monestial Blue is colder than French Ultramarine.

ADVANCING AND RECEDING COLOURS

As a general rule, warm colours advance while cool colours recede. It is particularly important to remember this when painting out-of-doors. Pale, cool colours slightly neutralized (see page 50) will recede the most. Conversely, hot colours used at full strength will advance.

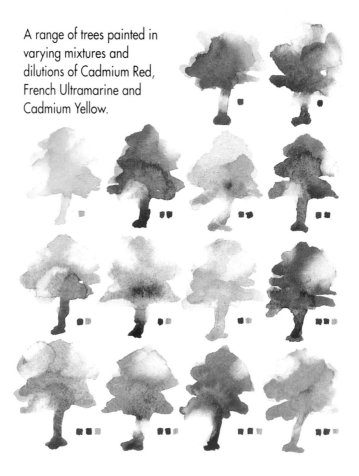

A range of trees painted in varying mixtures and dilutions of Cadmium Red, French Ultramarine and Cadmium Yellow.

MIXING COLOUR

It would be a good idea for you to experiment with your paints to see what colours may be mixed from your range of pigments. Try mixes of three colours at first. Take a simple shape and repeat it as often as necessary. In my colour chart I have chosen tree shapes. See what you can achieve with your three colours. After this, take another three colours and repeat the process. You could make an interesting chart to hang on your wall. Having all your colour variations on view would be a permanent reminder of the possible colours available to you.

If you are using pans of colour, you may find that, in the process of working, your colours will adulterate one another. This will have the effect of slightly neutralizing them. Although one colour will often get into another, this is not always a problem; in fact, this slight neutralizing of colours can benefit your painting. A fault I have often found with beginners' work is that it is too bright. They manage to apply a succession of pure colours to the paper, producing a painting that has the subtlety of a paint manufacturer's colour chart! If you study your environment you will see that powerful colours do not predominate. You can produce paintings of great beauty which consist of soft graduations of low-intensity colours (not muddy ones) contrasted with small areas of bright colour.

PRACTICAL TIPS

Don't mix separate colours on a small palette, as one will often run into another.

Remember to change your painting water often while you work.

Avoid mixing a lot of black with your colours, as this tends to make them dull and muddy.

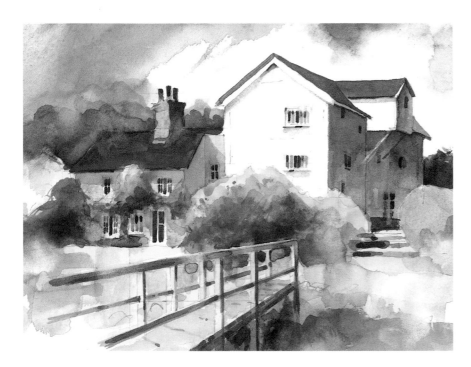

◄ A common fault made by beginners is to use their colours at full strength. I painted our local watermill in colours 'straight from the tube'. The result gives me the horrors!

▼ *Suffolk Water Mill*, 25 x 38 cm (10 x 15 in). In this painting I have lowered the intensity of my colours with greater use of water and by neutralizing them slightly with complementaries. A more realistic and pleasing effect is obtained. In your own paintings, keep your colours under control in the same way.

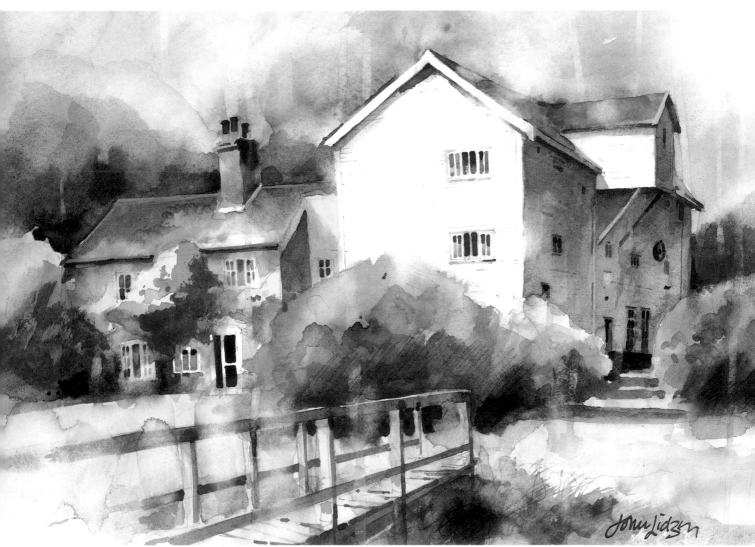

PAINTING WITH A THREE-COLOUR PALETTE

The experience of working with a three-colour palette can be satisfying because you can paint without the nagging feeling that you have failed to match the colours in your subject. The need to do this is unimportant, and it is unlikely that you would be able to achieve it anyway. Limited palette working can be stimulating too, for by being released from exactly matching the colours in your subject, you can direct your attention to exploring the mixing possibilities of your three colours – and you will be surprised at how many possibilities there are.

The three colours I have mentioned in the exercise on page 55 will give you a good range, including secondary and tertiary colours: reds, blues, yellows, greens, oranges, warm and cool browns. The browns can be made particularly low-toned by painting with concentrated mixes (using little water). All of the colours can be made low intensity and light-toned by using very dilute mixes. You will not be able to obtain a very good violet, and you might feel that the colours you mix will be somewhat degraded

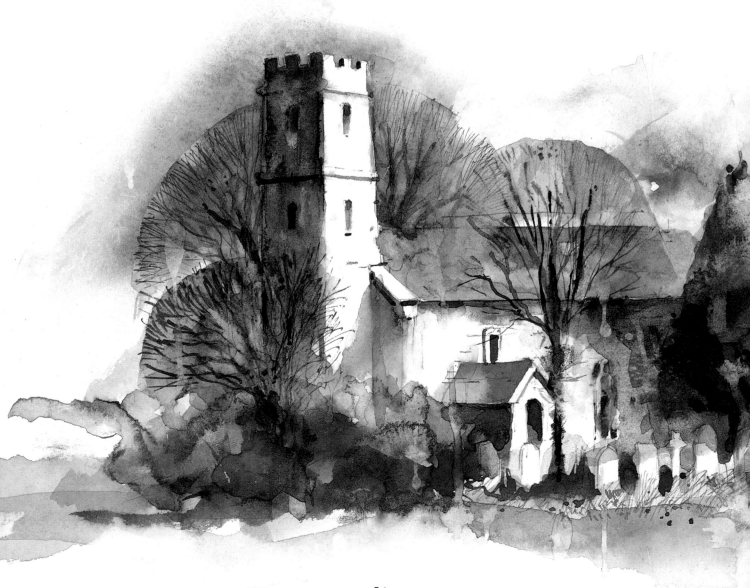

(dull). But this apparent disadvantage might turn out to be a benefit, particularly if you feel that your paintings lack subtlety in colour. Because all of the colours you use will derive from just three pigments, you will avoid the clashes which often occur when you use a multicoloured palette.

If you like this method of working with a limited palette, you could experiment with different three-colour combinations to see what other possibilities there are. However, I suggest that each combination contains colours linked to the three primaries – red, yellow and blue.

EXERCISE

Using French Ultramarine, Cadmium Red and Cadmium Yellow, produce a painting of a small area of your garden or local park. Don't choose a subject which is over-complicated; a portion of a wall, a flower-bed and part of a tree might make a suitable simple composition. Paint on a sunny day when there are good colour contrasts, and concentrate particularly on seeing how many interesting combinations you can create from your three basic colours.

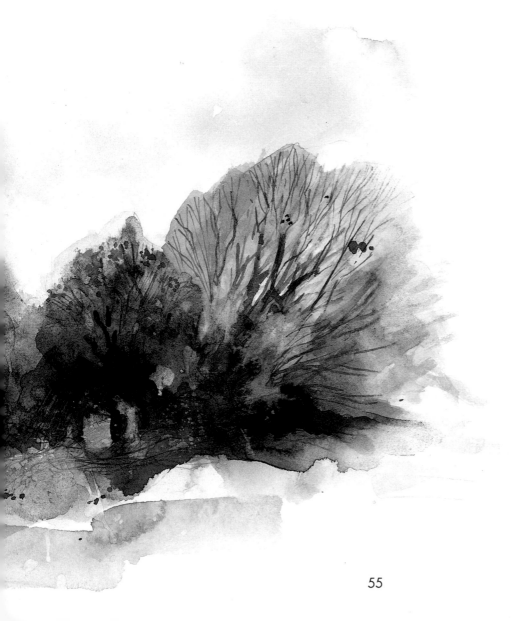

◄ *St Michael's Church,* 46 x 23 cm (18 x 9 in). This painting made use of only the colours shown below. It is not necessary to have a large selection of colours to achieve a varied result. In fact, using too many separate pigments could mean that your painting will lack colour harmony.

▲ The three watercolour pigments used in *St Michael's Church* (left) were Scarlet Lake, French Ultramarine and Cadmium Yellow Deep.

Old Country House

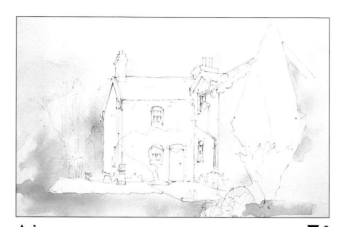

▲ 1

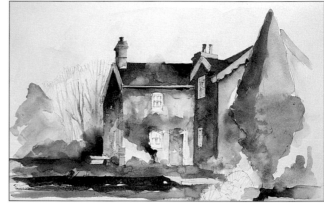

▼ 2

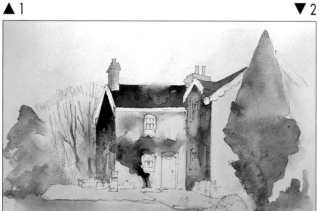

STEP 1

I drew the house, detailing the doors and windows, but I only outlined the trees and foliage. Notice that I made no attempt to draw individual bricks in the house wall. Such fine detail as this is unnecessary. The first step in painting was the laying of basic washes. I used heavily diluted paint as follows: Yellow Ochre for the sky, blotted out in places with damp cotton wool; Aureolin and Indigo for the foreground grass; Cadmium Yellow Deep for the middle-distance shrubs; pale Cadmium Red and Cadmium Yellow for the right-hand wall.

STEP 2

To give the wall a sunlit effect, I kept my colours very light and dilute. Shadow areas are sometimes a problem, and it is often tempting to paint them in a neutral grey. However, I painted these areas in mixes of blues and violets to provide a sense of light even in shadow. Really intense small areas of shadow can be painted in a true neutral colour. In this case, I painted the areas under the eves in a strong Payne's Grey.

For the foliage and grass, I kept the greens very pale at this stage. I wanted the final result to show a full range of greens from dark, cold greens through to light, warm, yellow-green tints.

▲ STEP 3

I now began to build up my colours. Colour usually looks more interesting when it is broken. For this reason, I avoid absolutely flat washes of colour, preferring to make them vary in hue, tone and intensity over the picture surface. Additional thin washes were laid over the sunlit house wall, and I mixed some very dark greens for the foreground grass. By darkening the shadows on the foreground tree and to the left of the house, I began to give the painting a feeling of depth.

▶ STEP 4
Although the house wall was in shadow here, I wanted to contrast it with a really deep-coloured shadow in the bush beyond. For this, I used Indigo and Payne's Grey mixed to a thick consistency. This also had the effect of making the Cadmium Yellow Deep to the left stand out even more strongly.

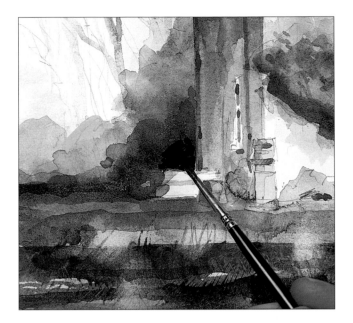

▼ STEP 5
I strengthened the shadows on the house to make the sunlit wall seem brighter. To give the distant trees an overall shape, I brushed a flat blue wash over them. The foreground needed warm colour, so in spite of the fact that the low bush was green, I changed its colour to a Vermilion and Yellow Ochre mix. The final stage was to add some detail.

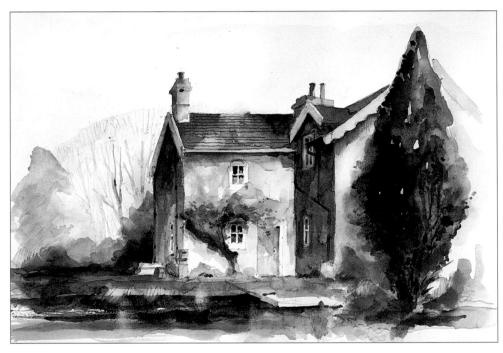

COLOURS USED:
Cadmium Red
Vermilion
Yellow Ochre
Cadmium Yellow Deep
French Ultramarine
Crimson Alizarin
Payne's Grey
Indigo
Aureolin

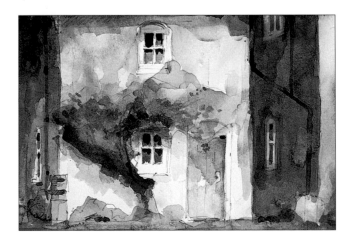

◀ DETAIL
The sunlit character of the wall is emphasized by the use of warm reds and yellows – watery Vermilion brushed over a Yellow Ochre wash. Cadmium Yellow Deep was used for the door. Even the shadows under the eaves and the shrub were painted in French Ultramarine – the warmest blue.

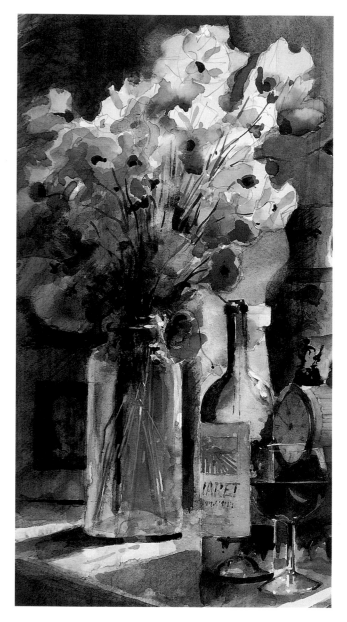

MAKING COLOURS SING OUT

Juxtapose your high-intensity colours with others of low intensity. Bright, colourful flowers in the sun, for example, will jump out of the painting if set against an area of shade. Try creating this effect by lowering the intensity and tone of all the colours in the background. You can achieve a marvellous impression of sunshine and shadow by using high-intensity oranges, pinks and violets against heavily neutralized browns, greens and greys.

COLOUR IN SHADOWS

If you are working in strong sunlight or in artificial light, it is possible that shadows will feature strongly in the painting. You could, of course, paint the shadows in black or a pale neutralized grey, but these colours rarely correspond with the colours that shadows tend to be. There is invariably a colour in a shadow.

An easy way to study the colour of shadows is to shine an Anglepoise lamp onto white paper

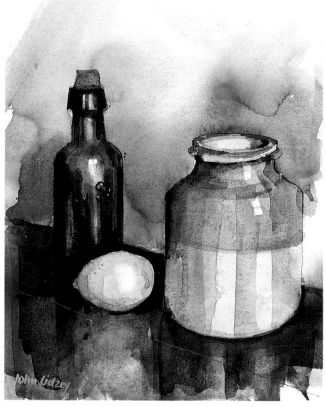

Still Life with Poppies,
36 x 18 cm (14 x 7 in).
If you want certain colours to shine, you can achieve this by keeping all the other hues very much under control, either by weakening them with water or degrading them with complementary colours. In order to bring the poppies forward here, some conté was used to dampen down the background.

Still Life with Bottle, Lemon and Jar,
36 x 20 cm (14 x 8 in).
Colour can be reflected into other surfaces. Here, the colour of the lemon is reflected into dark shadow areas on the jar and table. When arranging your own still lifes, juxtapose colourful objects with dull ones. The contrasts can bring a painting alive. If necessary, emphasize the tonal values to achieve a greater effect.

from about 30 cm (12 in) away. Take a coloured pencil and place it close to the paper so that it throws a sharp shadow. The shadow will take on the colour of the pencil. As you withdraw the pencil away from the paper and bring it closer to the light, watch the shadow colour change.

Study the colour in shadows carefully. Put colour into the shadows in your own paintings, whether they are still lifes, landscapes, interiors or townscapes. The results of doing so can be very effective indeed.

COLOUR & MOOD

With colour you can create an atmosphere of calm and serenity or one of vibrant activity. The same subject, painted once in low-intensity, cool colours and then again in high-intensity, warm colours, will evoke quite different responses in the viewer.

One of the big problems in painting is that of freeing oneself from a literal transcription of the colours in the subject matter. Look at the paintings of Van Gogh, not just his watercolours but his oils as well. You can see how he conveyed his inner feelings through colour. Of his *Night Café* (1888) he wrote, 'I have tried to express through reds and greens the awful passions of human nature.' Try to use colour to say something about your own feelings. In this way your paintings can have meaning as well as being original works.

EXERCISE

Investigate the psychological effect of colour. Take a subject comprising a wine bottle, an apple, a coloured cloth and some flowers in a vase, arranging these items as a still life. Produce two paintings, not necessarily highly finished. Ignoring the actual colours of the items themselves, first paint them in warm colours such as reds, yellows, browns, ochres. Then paint them again, this time using cool colours such as blues, greens, blue-violets. Make sure that you show a good range of lights and darks in your paintings.

Consider whether the moods of your two paintings differ from one another.

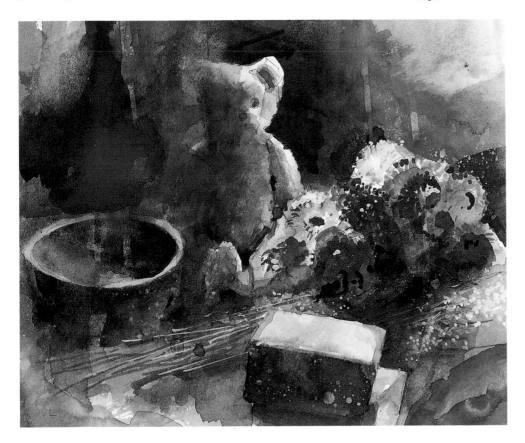

Just a Few Objects, 30 x 25 cm (12 x 10 in). Although there are some colourful objects in this painting, the mood is somewhat sombre. This is because most of the colours have been neutralized. Colourful forms have also been lost in shadow. There are some reds, but cool blues and greys predominate.

PROJECT
USING ALTERNATIVE COLOURS

✦
Subject
Simple landscape (two paintings of same scene)
✦
Medium
Watercolour
✦
Colours
Painting 1:
Cadmium Yellow Deep,
Cadmium Red, Crimson
Alizarin, Monestial Blue,
Indigo, Burnt Umber
Painting 2:
Aureolin, Yellow Ochre,
Vermilion,
French Ultramarine,
Coeruleum, Payne's Grey
✦
Size
28 x 20 cm (11 x 8 in)
✦
Paper
Good quality watercolour
paper, H.P. surface
✦
Equipment
Your usual brushes, with an
18 mm (¾ in) mop brush
for washes
Damp cotton wool for
mopping out excess colour
✦
Time
Approximately three hours
for each painting

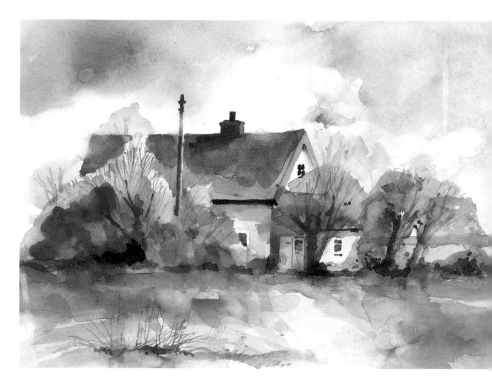

For this project I would like you to find a scene and paint it twice in completely different colours each time, using those shown in the list on the left. See if you can obtain alternative colour effects in each painting. Don't desperately strive to copy the colours you see in nature; be creative. For example, if, in the scene before you, the field of grass is a pale, cool green, paint it in a warm green. The sky might suggest Coeruleum as an appropriate colour; try mixing a blue/green, perhaps.

Cottage near Mellis 1,
28 x 20 cm (11 x 8 in).
Lemon Yellow and Monestial Blue together make fresh luminous greens, useful for paintings made in spring. Some of the yellow used for the foliage 'escaped' into the sky; I let it remain there. Although green is not a colour usually associated with summer skies, the result does not look totally false.

These colours were used for the painting above (left to right):
Lemon Yellow, Indian Red, Crimson Alizarin, Burnt Umber, Monestial Blue, Payne's Grey.

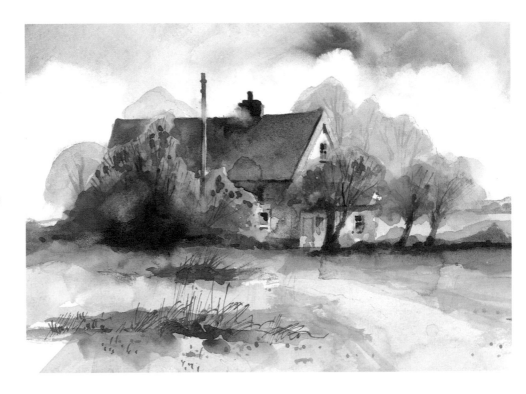

Cottage near Mellis 2,
28 x 20 cm (11 x 8 in).
In this version of the same
scene, I have used Cadmium
Yellow and Yellow Ochre in
the foreground, which gives
the painting a warm, mid-
summer look. The house
shadows are in Indigo and
French Ultramarine and give
the effect of cool shade.

For the painting here, the
colours were changed to the
following (left to right):
Cadmium Yellow, Aureolin,
Yellow Ochre, Cadmium Red,
French Ultramarine, Indigo.

The use of different colours for
each painting will help you to
achieve two completely
different results. In one painting
you could perhaps let cool hues
predominate, mixing varying
amounts of French Ultramarine
into your colours. In the other,
a much hotter result might be
achieved by adding Cadmium
Red and Cadmium Yellow to
mixes. If you make it a practice
to paint in alternative palettes,
it will help your development
as a painter.

SELF-ASSESSMENT

✦ *Were you creative or did
you only attempt to copy
the colours you saw in
nature?*

✦ *Have you really achieved
alternative colour effects
in each painting?*

✦ *Check to see if your
paintings can be
described as warm, cool
or just neutral.*

✦ *Have you kept your
colours clean?*

DRAWING FOR WATERCOLOUR

You may be passionately interested in drawing and see it as having a strong part to play in the look of your finished painting, or you might merely see drawing as a means of fixing an image down on paper before beginning to paint. Either way, if you are concerned about producing a drawing which is faithful to the subject, you will need to find a method which enables you to do this. Many, but by no means all, artists will produce drawings based on careful measuring techniques. Others appear to use no measuring techniques at all but work by means of comparing one object against another or against a background.

Drawing directly from the subject is a pleasurable and rewarding occupation, but, more than this, it is the foundation of good painting. Practise as often as you can, drawing every day if possible. You will be surprised how quickly you improve if you manage to work regularly.

▶ Kay Ohsten, *La Rouen*, 50 x 40 cm (20 x 16 in). Although this is a painting rather than a drawing, the good draughtsmanship shines through. Notice how perspective has been used to create a sense of the scale of the building.

◀ *River Waveney*, 30 x 40 cm (12 x 16 in), conté and charcoal. In this drawing, conté provided the hard lines and shadows while charcoal defined the softer areas.

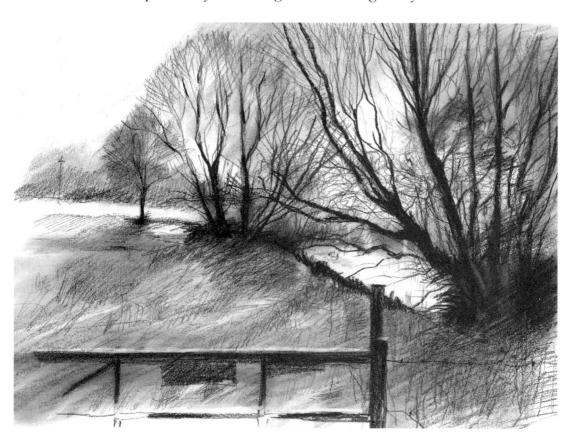

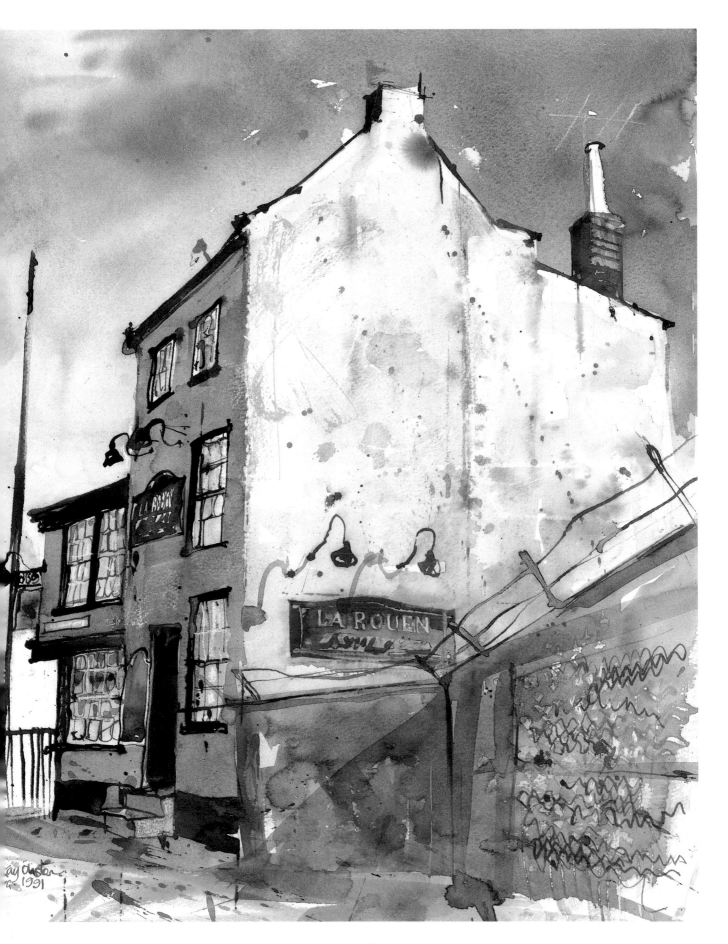

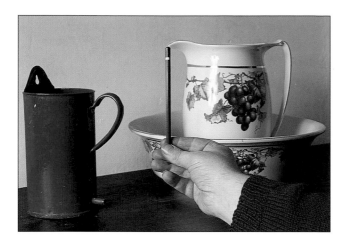

MEASURING DISTANCES

This method of drawing involves using your pencil to take measurements from the subject and to transfer them to the paper. For the purposes of working, you will need a new or fairly new pencil of good length.

If you haven't worked in this way before, I suggest you take as your subject a simple arrangement of items in your own home. You could use a wall with some pictures on it, a window and perhaps an item of furniture. Position yourself squarely in front of the subject between two and three metres (6–10 feet) away from it. You will find that you need to close one eye for measuring, otherwise it becomes impossible. Take care when measuring horizontally and vertically to keep the pencil absolutely parallel to the subject and a constant distance from the eye. To do this, it is vital to keep your arm absolutely straight and rigid. In the case of angles and slopes, align your pencil with the angle you wish to measure and imagine it as the hand of a clock. By identifying the 'hour' this points to, you can make the correctly angled line on your drawing.

Having secured your measurement, it is then necessary to transfer this to paper. At this stage you only need to make a suggestion of the outline of your subject. As your measuring marks become more numerous, you can begin almost to 'assemble' the drawing. As you progress, check your measurements. Correct any errors by redrawing over them; do not rub out the original marks. Many good and interesting drawings show corrections and alterations quite clearly, which makes possible an understanding of the artist's working process.

▲ Either thumb or forefinger can be used for measuring. Hold the pencil in front of you at arm's length, exactly parallel to the subject. You will see that the length and depth of objects can be measured by moving your thumb or forefinger along the pencil. You can measure the spaces between objects, too. When you have made a measurement, keep your finger firmly in position on the pencil.

▼ Keeping your finger in position, transfer your measurement onto paper by laying your pencil on the paper and making marks to correspond with the end of the pencil and your finger or thumb. A drawing done in this way is called a 'sight-sized' drawing. Larger drawings can be made in the same way, this time by using your pencil to compare the relative sizes of objects to each other.

USING BACKGROUND FEATURES

Drawing the background first can often help you when it comes to drawing foreground subject matter. You might wish to draw a still life on a window-sill. The window-frame or mullions, if drawn first, will help you to plot the contours of your still life and make the drawing much easier.

Similarly, a figure drawn against a background of a door, or even a piece of furniture, will be easier to structure. What is important, however, is that you draw your background with as much care as you can.

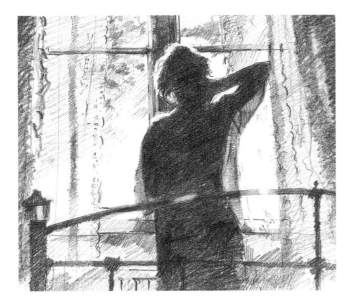

Use the background (and sometimes, as here, the foreground too) to help you draw a figure. In this case, the window and the rails of the bed were drawn first. The figure could be plotted against these more easily drawn items. You can often use the background in the same way as you use a grid of squares behind the subject.

USING A GRID

Grids have been used by artists in their work for centuries. Traditionally, they have been a means of sizing drawings up or down or merely making copies. But it is quite possible to employ this method to make a drawing from a photograph.

SQUARING UP FROM A PHOTOGRAPH

The technique is quite simple. A grid of squares is drawn over a photograph. (Take a photocopy if you don't want to spoil the photograph.) Each line along the top can be allocated a letter and each line down the side given a number. A similar grid of the same number of lines is drawn on the watercolour paper, lettered and numbered in the same way. This grid may be larger or smaller as desired, thus enabling you to enlarge or reduce the size of the photograph as necessary. The procedure entails drawing from square to square on your paper, copying exactly from the photograph. You will, of course, need to erase the grid lines when you have completed your drawing.

The photocopier as a drawing aid

If you find drawing a struggle, you could turn to the photocopier as an aid. With the modern photocopier you can enlarge photographs quite easily. By covering the back of the photocopy with 6B pencil scribble, you can then transfer the image merely by drawing over the photocopy while it is in firm and stationary contact with your watercolour paper. Use masking tape to hold your photocopy in position when working.

A DRAWN BACKGROUND GRID

You can also use a grid as an aid to drawing from the subject. If you are a beginner, this method might be a useful way of starting. The technique involves plotting the contours of the foreground objects against a backgound grid previously drawn onto cartridge paper. Working in this way ensures that the basic shapes can be drawn accurately.

A still life may be set up in front of a grid drawn onto cartridge paper; rule 5 cm (2 in) squares extending to the height and width of the subject. Your drawing is made on a piece of paper which shows an identical grid. Having completed the drawing, remove the background grid of squares and erase the grid on the drawing. You can then draw any further details within the outlines of the drawing.

PERSPECTIVE

If you want to make convincing drawings from life, a knowledge of perspective is of great value. For the beginner, the subject can be very complicated, not to say daunting, but an understanding of even the fundamentals can make drawing much easier with far more satisfactory results.

VANISHING POINT

The basic assumption of perspective is that parallel lines appear to meet at a single point on the horizon; this point is known as the 'vanishing point'. Imagine yourself standing in the middle of a straight railway track, looking at the rails receding into the distance; this provides a striking example of lines meeting on the horizon at a central vanishing point. If you stood a wooden box in the middle of the track parallel with the railway lines, the same principles of converging lines would apply to the box.

Horizon

You may wonder exactly where the horizon is, or if there is a special rule which tells you where it is, even if you can't see it (in a town, for example). The answer is that the horizon is at your own eye-level. The horizon level will change according to whether you are sitting down or standing up, or even standing on top of a high building. Always remember that, wherever you are, the horizon is directly in front of your eyes. As or if you become more interested in perspective, you will find that it is possible for there to be more than one horizon line in a single picture, for example, where sloping surfaces like pitched roofs occur.

ONE- AND TWO-POINT PERSPECTIVE

One-point perspective refers to a situation where there is only one vanishing point at the centre of the line of vision. However, objects are mostly viewed from an oblique angle, and if this is the case, there would be two vanishing points on the horizon. In this situation, the term 'two-point perspective' is used. A good example of this is if you were drawing the corner of a square office

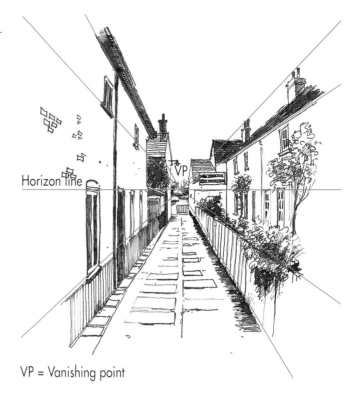

VP = Vanishing point

An example of one-point perspective. The horizon line is at eye-level. The vanishing point is directly in front of the viewer in the centre of the picture. All receding lines converge to meet at this point. This is the simplest kind of perspective.

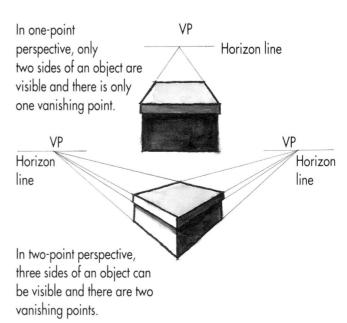

In one-point perspective, only two sides of an object are visible and there is only one vanishing point.

In two-point perspective, three sides of an object can be visible and there are two vanishing points.

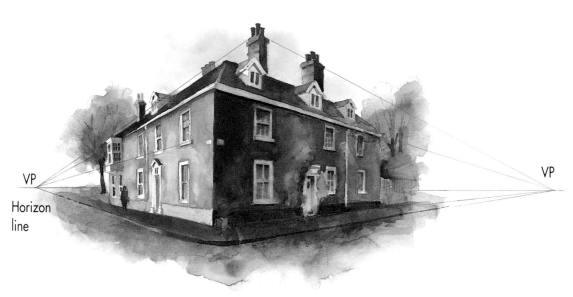

VP

Horizon
line

VP

This is an
example of two-
point perspective.
The lines on both
sides of the
building converge
at two separate
vanishing points.
Remember that
the vanishing
point is at your
own eye-level.
Lines at this level
run parallel to the
bottom of the
picture.

block. You would need two vanishing points at
which the converging lines of each side of the
building meet.

DRAWING ELLIPSES

The top of a circular bowl, plate or glass is
foreshortened if it is viewed from an oblique
angle; this foreshortened circle is known as an
ellipse. The rules of perspective can be applied
to circles drawn from an angle just as they can to
straight-sided objects. If you can draw a circle in
a square and a square in perspective, you can
draw an ellipse. Try this method out. You could
find that it will help you in your drawing of
bowls, cups and saucers, and dishes.

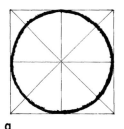
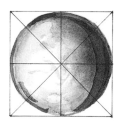

a

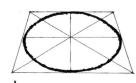

b

c

EXERCISE

Draw and then paint the simple objects listed below.
Use loose and free techniques in applying the paint,
concentrating on making the paint itself look
interesting. Accurate reproduction is not an important
factor here. Use paper no larger than 28 x 38 cm
(11 x 15 in).
1 A white cup and saucer on a black surface.
2 A light switch painted twice life-size.
3 An apple on white paper.

Try these exercises to practise
drawing foreshortened circles
or ellipses.
a Draw a square and mark
in the diagonal, upright and
horizontal lines. Practise
drawing a circle within the
square.
b Draw a square in one-point
perspective. Draw in the
other lines as before,

diagonals first, then vertical
and horizontal. Practise
drawing an ellipse within this
foreshortened square.
c Considerably increase the
angle of foreshortening and
draw the ellipse as before.
The relationship between the
depth of the bowl and the
depth of the ellipse can be
determined by measuring.

PROJECT
DRAWING AND PAINTING A STILL LIFE

✧

Subject
An arrangement of chinaware

✧

Medium
Pencil (for drawing)
Watercolour

✧

Colours
Either a six- or twelve-colour palette as suggested on page 14

✧

Size
23 x 28 cm (9 x 11 in)

✧

Paper
Good-quality watercolour paper, H.P. surface (stretched)

✧

Equipment
New 4B pencil
Putty eraser
18 mm (¾ in) mop brush for washes
Brushes no smaller than No. 6 for other work
Damp cotton wool for mopping out excess colour
Conté

✧

Time
One-and-a-half hours for the drawing
One-and-a-half hours for the painting

My drawing begins with marks rather than images. Using a pencil, I measure the width and depth of the main shapes. Some outlines are drawn in, but no details are included.

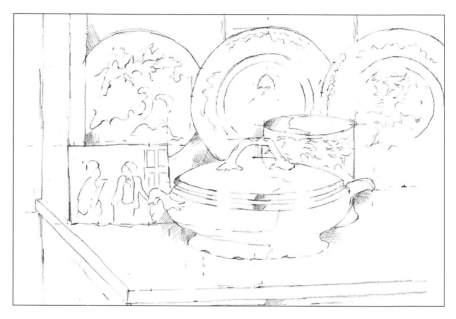

In this project I would like you to produce a measured drawing using the method suggested on page 64. You can then go on to make this drawing a foundation for a finished painting.

My own usual procedure when painting is to make a careful drawing and then to paint freely over this. Working in this way usually means that, although the painting technique is loose, the finished result is under control and well structured. An accurate drawing is always a good basis for a finished painting.

The drawing is completed. Some of the details are included, but I am careful not to over-elaborate. The measuring marks I made when starting the drawing are erased as necessary, but many will be covered by the build-up of paint as the watercolour proceeds.

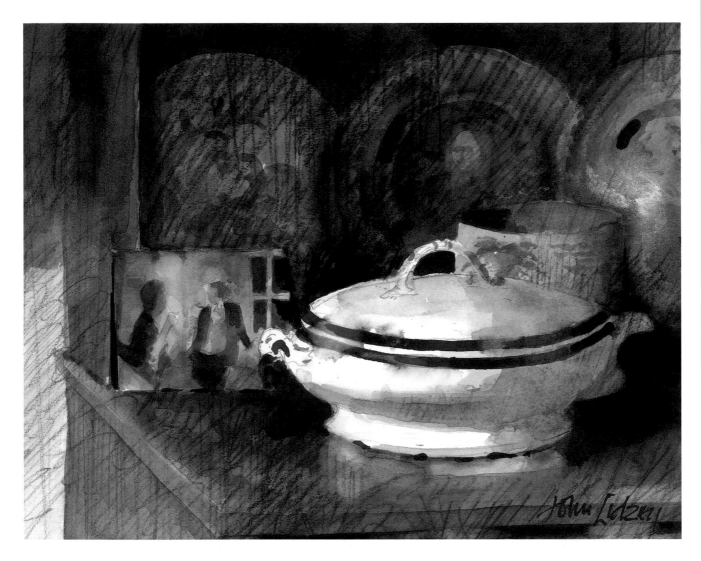

Choose not more than five items of tableware and make an interesting arrangement. Make a careful drawing of the shapes. Be sure to measure all of the shapes and the spaces between them. Strive for accuracy, using your pencil as a measuring tool. When you feel you have achieved a sufficiently accurate result, build up a strong tonal painting over the drawing.

▲ I have kept the background plates dark in tone and have excluded most of the detail on them. This has created depth in the composition. The conté scribble over the background and parts of the woodwork has the effect of concentrating attention on the photograph and tureens. The painting was made with only Yellow Ochre, French Ultramarine, Indigo, Cadmium Red, Aureolin and Burnt Umber.

SELF-ASSESSMENT

✧ When measuring, did you hold your pencil parallel to the subject matter?

✧ Did you transfer your measurements accurately onto the paper?

✧ Did you concern yourself with the overall shape and size of objects rather than any pattern details?

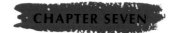

CHOOSING A SUBJECT

We often feel that it is necessary to travel long distances to find something special to paint when, in fact, our own immediate surroundings can offer the best source material. Familiar, and even seemingly dull, subjects can often make very interesting paintings, while picturesque material can sometimes give rise to extremely boring work. A haystack, for example, might not be seen as a very thrilling subject. Yet the French Impressionist, Monet, painted haystacks over and over again, studying the effects of light and changes through the seasons.

Many other artists have been similarly attracted to the countryside and, indeed, it has unlimited opportunities for painting. The inside of your house, too, offers all kinds of subjects. Windows, doors, furniture, even the kitchen sink, are all very paintable. And remember, you can paint inside even when it is raining outside.

▶ *Anna's New Bedroom*, 36 x 25 cm (14 x 10 in). Untidy rooms are often better to paint than tidy ones. The personality of the room's occupant is apparent through items left lying around.

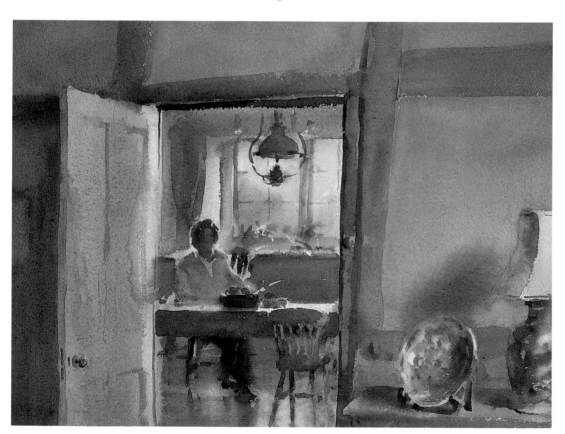

◀ Trevor Chamberlain, *Kitchen Doorway, Upper Wyke Manor*, 25 x 36 cm (10 x 14 in). A simple subject, not specially set up. The chair at the table has not been tidily placed. Such unpretentious subjects as this can make the most compelling pictures.

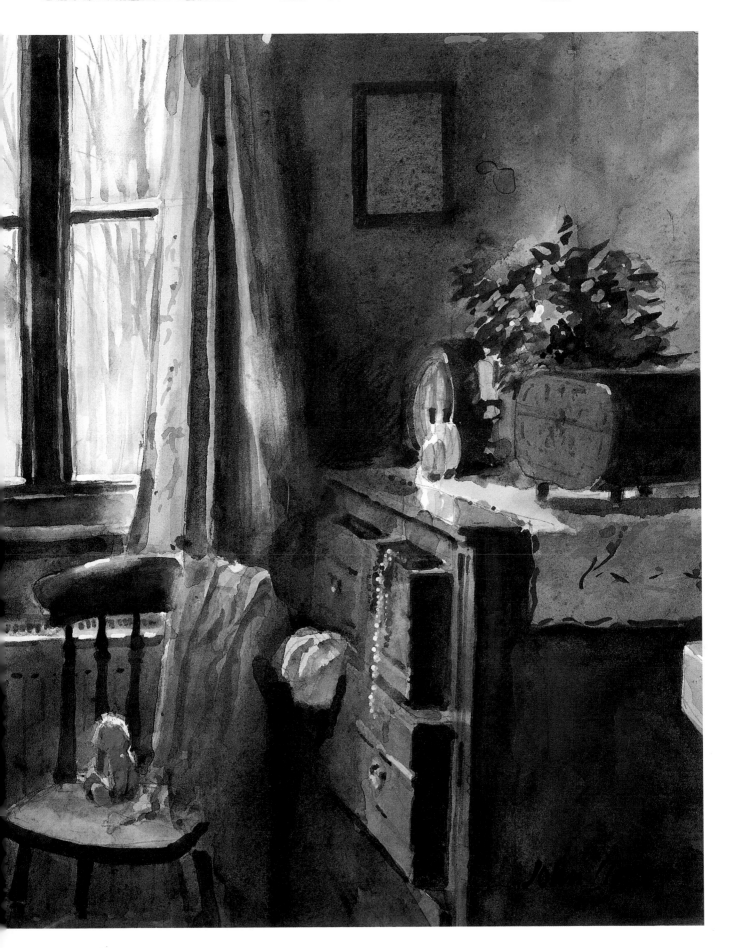

LOOKING FOR SIMPLE THEMES

Try not to make life complicated for yourself. If you are new to painting, work simply. Still life subjects can be ideal. Two flower pots on a bench or table with a garden trowel might be suitable to start with. It is an easy matter to arrange these items in the interests of picture-making and, unlike the painter of landscapes, you will have your material under complete control.

Look for subjects that have a human interest. In the kitchen, the ingredients for making a cake could be used – some eggs, flour, milk and a mixing bowl perhaps. Or try painting an envelope propped up against a vase. Perhaps a part of the letter itself is showing. We are all curious about the contents of letters, and a painting of this simple, yet intriguing, subject would have universal appeal.

UNLIKELY SUBJECTS

We usually want to paint subjects which especially interest us. However, it is often a good exercise to paint something which has, on the face of it, no special qualities at all. To make it successful, you will have to rely on the style of painting, on technique or, perhaps, on being creative, changing colours, bringing in distortion, adding textures, or using a free quality of paint application. You may be able to see that making the subject of secondary and not primary importance will lead you to an alternative attitude. Your work can become more painterly and more interesting, rather than being a copy of a 'pretty' subject.

Take a familar object which you see possibly every day, one so familiar that you have stopped looking at it. A bottle of milk, for example, would make an excellent subject for a painting. Set the bottle down on a sheet of grey paper and light it from one side only. A subject like this has no real emotional appeal, unlike, let us say, a kitten playing with a ball of wool. A bottle of milk is 'boring', but the challenge for the artist is to make it an interesting painting.

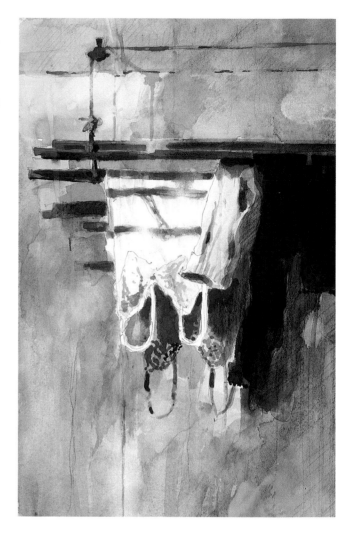

Clothes Airer,
38 x 20 cm (15 x 8 in).
Look for the unusual. A subject like this shows interesting shapes, colours and tones. Yellow Ochre and French Ultramarine were used to suggest a faded and stained room wall. It was painted wet-in-wet, the paint being allowed to run down in streaks for effect.

PAINTING ON LOCATION

Working in the open air can be a great stimulus to your painting. If you enjoy walking and can pack your watercolour equipment and materials into an easily portable form, you may be able to find and paint exciting subjects far from home. However, working on location also means that you can paint just down the lane or even outside your own back door. The important thing is to look around with the eyes of a painter, not just as a casual observer.

IN TOWN

When painting in a town, be constantly aware of your surroundings. Often without noticing, you may pass many paintable things: railings, notices, traffic signs, signals and people.

A simple item like a scrap of newspaper caught in a gutter could be a marvellous subject. Make a note of what you see to remind you when you are stuck for ideas. If you feel confident, take on more difficult subjects, for example, urban sculpture and monuments.

IN THE COUNTRY

On a simple theme in the countryside, try painting the sun shining through trees, or a telegraph pole leaning at an angle (if it doesn't lean, then paint it as leaning). Rustic cottages always make attractive paintings, but even a barbed-wire fence can have a stark beauty. Broken things such as old farm machinery, smashed shed windows and rusty corrugated iron fencing are fascinating to paint, while drainpipes, guttering and old water butts on barns or sheds should not be ignored by the keen subject seeker. If you are looking for more challenging subjects, farm animals or fast-moving water will test your skills.

▲ This old street lamp caught my attention and I made a colour study in line and wash. Many interesting things to paint can be seen above street level, so when searching for subject matter, look up as well as down.

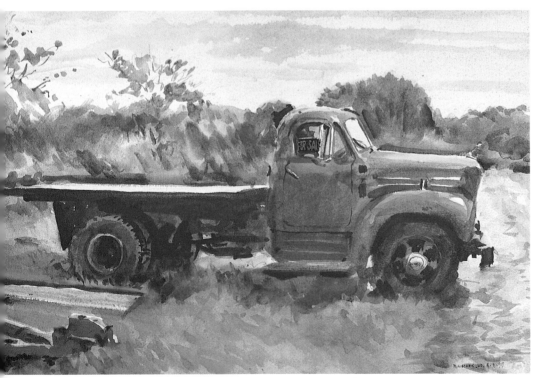

◀ Howard Morgan, *Truck for Sale*, 38 x 56 cm (15 x 22 in). Very old motor vehicles, when set in open countryside, usually make good subjects to paint, especially if they have been overtaken by weeds and grasses. This aged vehicle and its rural setting make an intriguing contrast.

73

WORKING IN PUBLIC BUILDINGS

There are many small country churches which are often deserted for much of the day and which possess lovely architectural features. Not only can church interiors offer the large spaces you would not find at home, but also the quality of light can be unique. If you can find a day and time when the sun shines through a stained glass window onto an interior wall, you have a subject which could make a marvellous painting. Additionally, churches offer a wealth of fascinating interior architectural details for the sketcher and painter.

If you are looking for more secular subjects, many theatres possess fine baroque detailing and decorative features, such as brass rails and arches with drapery. If you feel confident about attempting this kind of subject, the management will often allow you to spend a morning in the theatre when it is not being used. You might even consider asking if you can make sketches of the rehearsal of a play; good studies could be made from one of the boxes close to the stage. For some fine examples of pictures of theatrical performances and theatre audiences, look at the work of the English painter, Sickert. He was particularly interested in the auditorium and stage of the music hall, and produced wonderful drawings and paintings of this subject.

A rehearsal by an orchestra or a chamber quartet can also provide a marvellous subject for the painter. The players remain fairly still for a period of time, and they adopt interesting positions when playing. If you can get quite close to the performers in a small group, you will have a better opportunity of studying them effectively. Work freely and loosely. It is better to capture the essence of what is going on in a sketch rather than attempting to produce a painting of great detail.

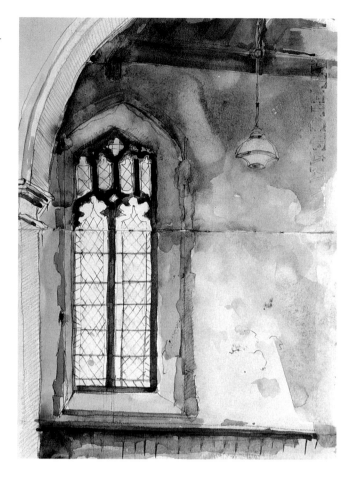

Country churches are good places to draw and paint, and the views inside are often as interesting as the exterior. This beautiful little church is falling into disrepair, with crumbling plasterwork. I used French Ultramarine and Yellow Ochre wet-in-wet to suggest this effect.

▶ *Lyric Theatre, Hammersmith,* 43 x 28 cm (17 x 11 in). I painted this when the theatre was empty from the front row of the Upper Circle. The auditorium was richly ornate, but as time was limited, the decoration was merely suggested and the painting completed later.

PRACTICAL TIPS

Do keep your eyes open for good subject matter at all times and don't just rely on picturesque scenes for painting subjects.

Don't slavishly paint what is in front of you. As Degas said, 'Lie a little.' Don't be afraid to alter for the sake of aesthetic effect.

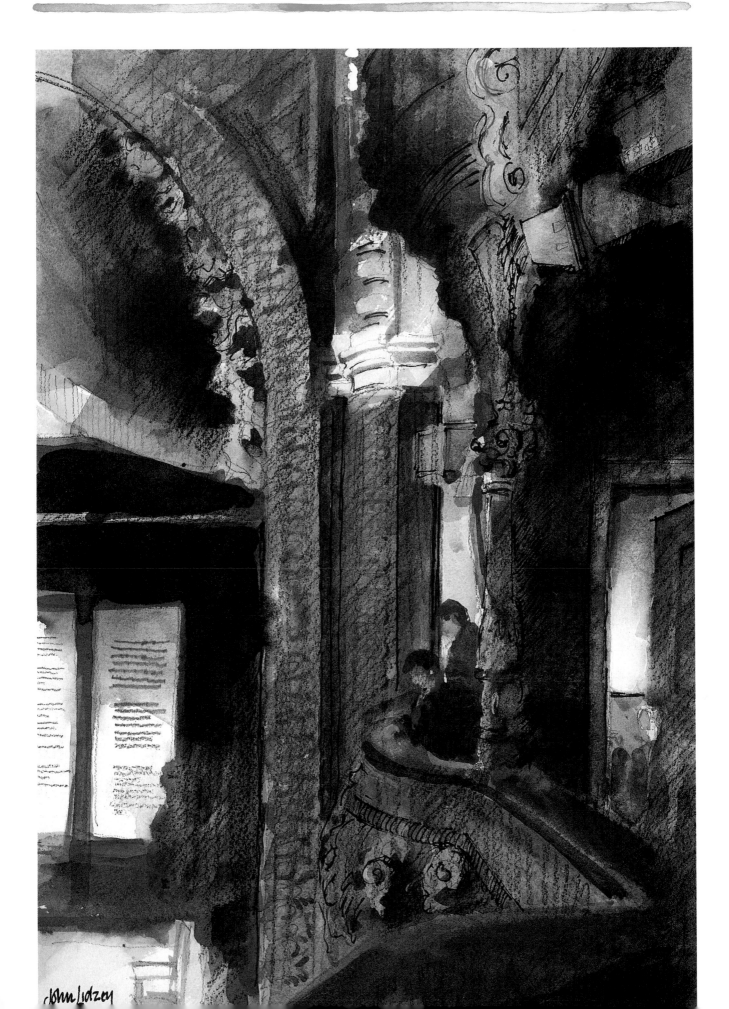

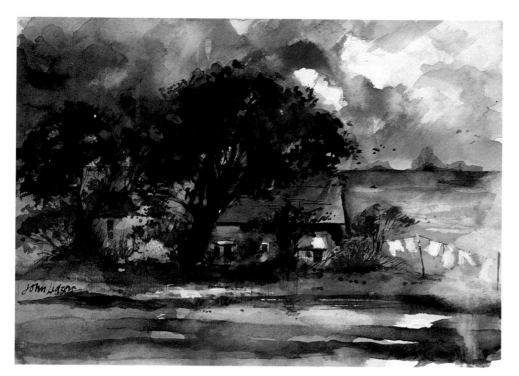

Blustery Day,
20 x 28 cm (8 x 11 in).
An ordinary subject can be given more life by creating certain weather conditions. From a quick sketch made from my car, I produced this small painting. The sky was painted freely in blues and greys. Movement was suggested in the trees, and the washing on the line was painted as though moving in the wind. I kept the brushwork very loose to create a turbulent quality.

THE WEATHER AS A SUBJECT

It is easy to dismiss weather conditions as being entirely separate from the scene that is being painted, but you could turn the weather into a subject in its own right. Many painters have been fascinated by weather conditions and have sought to reproduce them. The English artist, William Turner, is said to have had himself lashed to the mast of a sailing ship during a storm in order to record the effects of wind and mountainous seas. You may feel reluctant to go to such lengths and prefer to remain at home during really bad weather. Even so, much can be observed from a window, especially an upstairs one. On the next stormy day, look to see what possibilities present themselves.

WIND

This is a marvellous subject for painting. You don't actually need a windy day, you can create it by showing washing blowing on the clothes line, trees bowing in a storm, leaves carried along in the air.

To show tree branches moving in the wind, soften their edges and overpaint in a lighter colour but in a very slightly altered position. Experiment and use your imagination.

RAIN

Turn a dry day into a wet one. Make studies of puddles. Look at other painters' versions of wet streets, copying ideas into your sketchbook. Consider how it might be possible to simulate falling rain in your painting. You can suggest rain quite easily by dragging a damp sponge across a painted sky while it is still wet, or by blurring outlines while the paint is wet, using a coarse bristle brush or even an old toothbrush. Why have sunshine in your paintings when you can get a good downpour!

FOG

Gloomy, half-hidden houses and trees, emerging out of a thick fog, can make fascinating subjects. Fog can be patchy, so try introducing fog into just part of your painting with heavily diluted white gouache. Paint laid in as a wash, with a wet-in-wet method of concentrated white dropped into the wash, can simulate an effective mist or fog. Try painting an old shed and allow a wispy mist partially to cover it. Experiment further and see how you can develop this idea.

SUN

The sun is celebrated in much of the work of Turner – it is seen over and over again in his

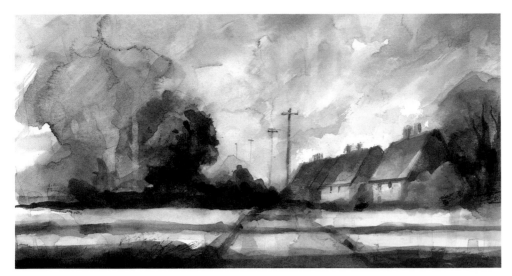

◀ Make studies of the same scene at different times of the day or at different seasons. These houses were painted early one summer morning. What interested me were the long lateral strips of sun and shadow. When the sun is low on the horizon, many fine painting opportunities are available. The low angle of light can provide excellent modelling for various landscape features.

watercolour sketches known as his 'colour beginnings'. In various meteorological conditions, the sun has great potential for painting. It is possible to make it the dominant part of a watercolour scene, a seascape or a landscape.

Where there is sun, there are shadows. Towards evening, when the sun is going down, long shadows can be a subject in themselves. Keep your sketchbook handy to record the pattern of light and shade on buildings, in parks, in streets or in the open countryside.

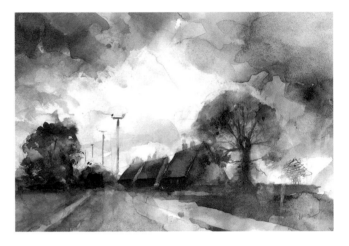

LIGHT AS A SUBJECT

As many other painters have found, a concern with light can be a study in itself. At different times of the day and according to season, the nature of a subject can change dramatically. Try recording these effects in a series of paintings. Either paint close-up, showing, for example, the light falling on a watering can, or take a wider view by demonstrating the appearance of sunlight on a building. Produce three paintings: during the morning, in the afternoon and in the evening. See what alternative effects you can get.

An otherwise unexciting subject can be made to come alive if you create the impression of back lighting. For example, you may have painted a house and trees that look dull and flat. Try lowering your tonal values and introducing a light patch between the trees by sponging an area out with water and clean cotton wool.

▲ Later in the year, the same scene was quickly sketched at mid morning. It was a cold day although the sky was bright. This rather dull scene gains any interest it has from the colours used for the sky.

▼ This sketch was begun in my car and finished off in the studio. Painting at dusk when the paper is barely visible can be an interesting experience. The lack of light forces you to exclude details.

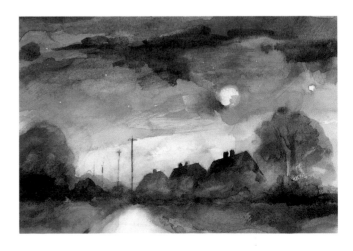

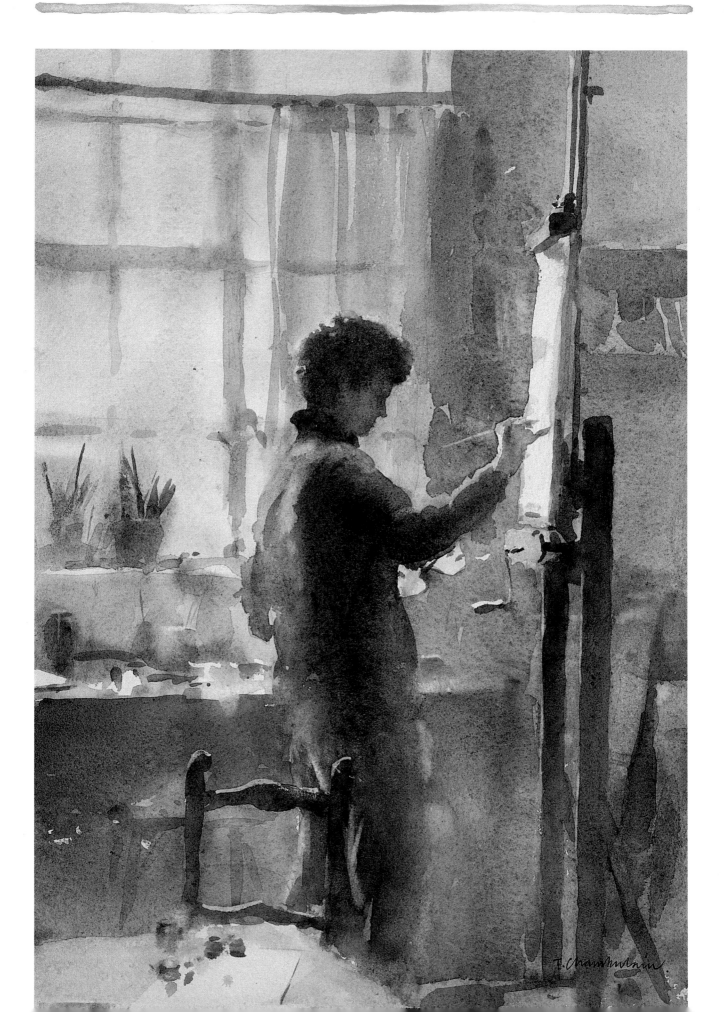

PAINTING YOURSELF

For the aspiring figure painter, you are your own best subject. Start by setting a mirror facing a window so that you can see yourself more or less silhouetted against the light. Don't concern yourself too much with the details of your own features. Treat yourself almost as a piece of furniture in the room. Maybe you can paint the sunlight catching the side of your head, or perhaps a glint of light on your nose. This is the best way to start. As you grow in confidence, you can position yourself so that the light falls across your body. This will give you scope to include more detail in your painting.

▲ A large mirror can be useful if you want to draw and paint figures using yourself as a model. Start with simple drawings, concentrating on shapes and proportions. If you sit against a window in silhouette, you won't become bogged down with details.

◀ Trevor Chamberlain, *In the Studio*, 36 x 25 cm (14 x 10 in). A figure painting in the studio against the light. Drawing or painting somebody involved in an activity where the amount of movement is small can be helpful. In this case, the person at the easel maintained the same position for a length of time. The background has been considerably softened to focus attention on the subject of the painting.

▶ *A Studio Sketch*, 41 x 23 cm (16 x 9 in). A large mirror hangs in my studio. I find it interesting to draw and paint studies of myself on occasion. In this study, I was concerned to suppress detail in the figure and concentrate more on the lights and darks in the scene.

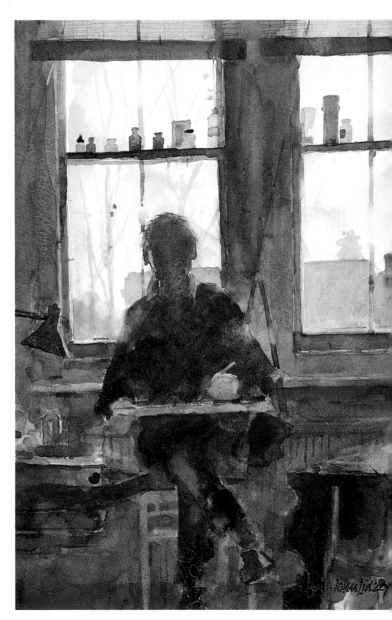

COMPOSITION

Occasionally we come across a ready-made scene just asking to be painted – some trees and a house by a lake, perhaps. We are often attracted to such a view because its composition looks somehow complete; it seems to satisfy something in our psyche which appreciates order, regularity and harmony. Unfortunately, the world does not consist of simple, ready-made compositions. We are surrounded by a chaos of unresolved visual effects and the artist looking for a landscape to paint must consider the possibility of 'adjusting' the view or looking for an alternative vantage point to satisfy the needs of picture-making.

Although there may be no hard and fast rules for painting, there are several composition guide-lines which you might find helpful to begin with. Apply these in your own work, then later, as you become more experienced, you can perhaps break a few of the rules to produce some really original work of your own. But remember that, in order to break the rules, you first have to learn what they are.

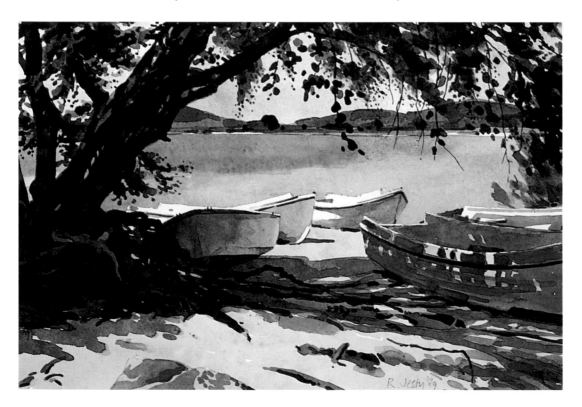

Ronald Jesty, *The Shore, Loch Rannoch,* 24 x 33 cm (9½ x 13 in). The focus of attention here is directed through the boats and shadows, over the water and into the distance. The boats on the right and the foreground shadows point to the left; the tree leans to the right and interest is kept to the centre.

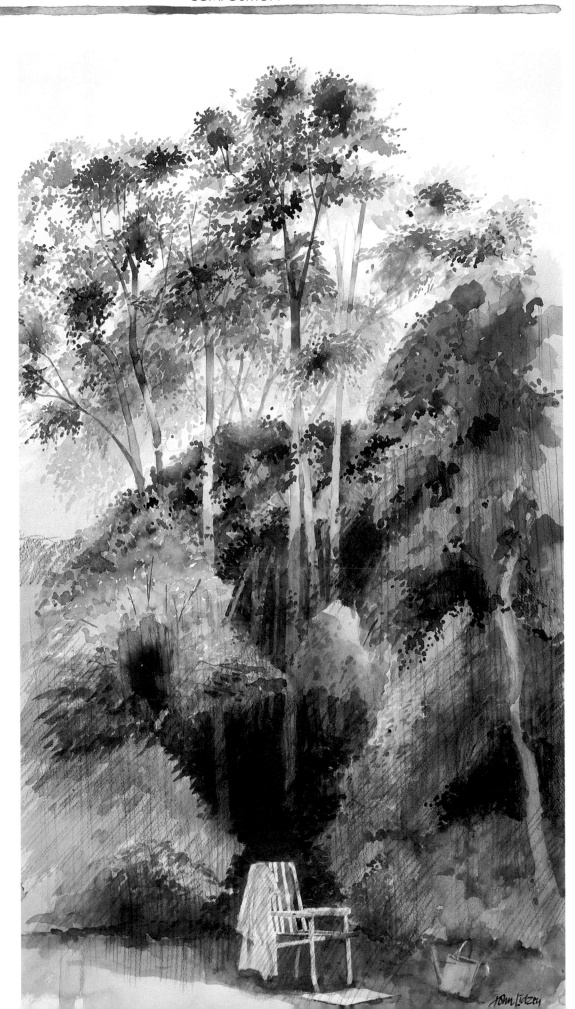

Garden at The Dell, 71 x 40 cm (28 x 16 in). The strong vertical quality of this painting is modified by the changes of tone at the bottom of the trees where the trunks become lost in shadow. The white chair gives a base to the composition. If the chair had been a darker colour, its part in the composition would have been less satisfactory.

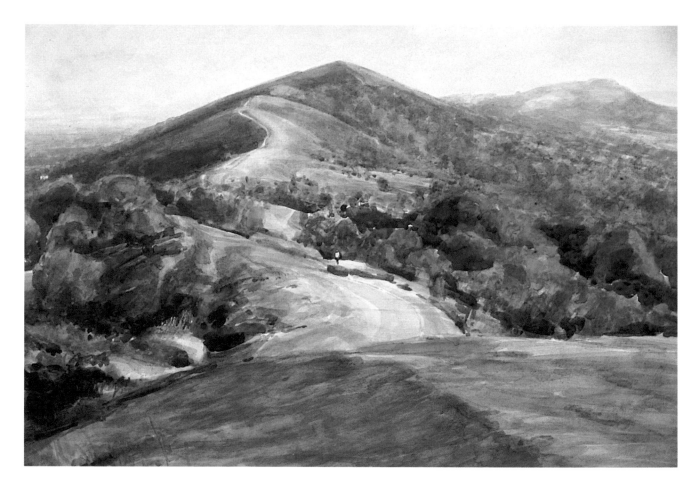

David Prentice,
Malvern Hills Ridgeway,
56 x 84 cm (22 x 33 in).
Many beginners' paintings of
panoramic views do not
come off, usually because a
sense of space is not
adequately conveyed. David
Prentice succeeds
magnificently in this respect.
A sense of the open air
comes about partly through
the large scale of his
painting, but mainly because
of his compositional devices.

CREATING A CENTRE OF INTEREST

Your painting will usually look better if it has a
main focus of interest to which everything else is
subordinate. Always consider whether the
features which make up a painting should be
enlarged, reduced, blurred or even eliminated in
the interests of picture-making. Do not assume
that your centre of interest should be in the
centre of your painting. In fact, doing this could
produce a very static arrangement. By
positioning the main feature of the painting to
the left or right, or high or low, you will create a
sense of tension in your composition which will
help to make your painting look more lively.

Views are very tempting to paint, but they
often provide quite unsatisfactory results. We
are all familiar with the picture postcard view
from a high vantage point. All of the trees and
houses are reduced by distance to a small and
even scale which would make for a very
uninteresting painting. If you wish to paint a
landscape, it is better to look for a feature which

will give the painting a sense of near and far. Distant trees and houses are made to look far off by the introduction of foreground interest. Position yourself so that there is a bush, a gate or farm machinery in the near or middle distance. If you want to introduce a figure in the foreground, a walker perhaps, this will give the painting a human interest too.

The drawings on this page show some of the possibilities for a composition of a house with trees near it. Making small preliminary sketches will help you find the best arrangement for your finished painting.

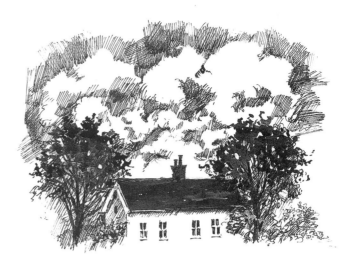

▲ Here the relationship between house and stormy sky is interesting. By positioning the house low in the picture, the sky appears to threaten the house. The chimney silhouetted against the sky is the vertical centre point of the composition, while the two trees on either side provide a regular balance. Symmetry suggests calmness and stability which contrasts with the turbulent sky.

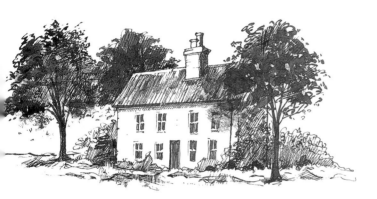

▲ This white house with trees seems to offer a good subject. Taking a three-quarter angle position with the house slightly off-centre allows the foreground tree to obscure the roof and upper wall slightly, which will help to suggest depth in the composition.

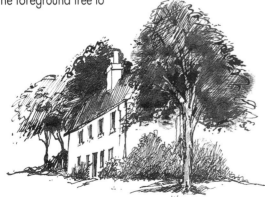

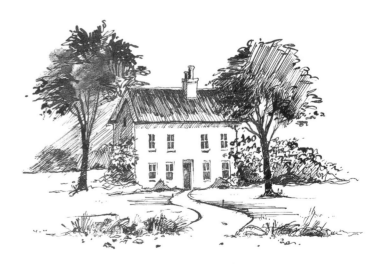

▲ Seen from a lower angle, trees now appear to shelter the house. The steep angle of the roofline is more interesting, too. The trees dominate this composition, obscuring the house rather more and suggesting a harmony between the building and nature. Look out for these psychological features in all your painting.

▲ The path to the front door of the house might be considered as a good foreground lead-in, but in this case it is too centralized in the composition. Together with the trees on either side, the result is, as *you* may feel, too evenly balanced. As a general rule absolute symmetry in picture-making is best avoided, but be careful, there can be some exceptions to this.

Make a viewfinder by cutting an aperture about 13 x 10 cm (5 x 4 in) out of a piece of card. Cut a further strip to change the shape.

USING A VIEWFINDER

A small home-made viewfinder can be very useful for composing your painting. You could make one which will slip into the back of your sketchbook, ready for you whenever you need it. When using a viewfinder, don't forget to change its format if necessary, making the aperture elongated with a further strip of card. A landscape can often work very well in an extended horizontal shape, or sometimes even in a narrow vertical one. A line of trees or a lakeside scene might make a splendid elongated painting. Such extended dynamic shapes often make for very exciting pictures.

As well as being useful outside, I have found that a viewfinder is occasionally helpful for composing interiors too. You might, for example, want to paint a scene in a room. Rather than resorting to moving the furniture about to create a satisfactory arrangement, see if you can make something out of a casual arrangement as found. Setting up an interior composition can result in a false and unnatural look. Use your viewfinder, or even two L-shaped pieces of card, to see if there are possibilities in the room as it is.

This harbour scene at Honfleur in France shows a complicated arrangement of houses, yachts and reflections in the water. In a scene like this, you could use your viewfinder to see which parts of it might suggest a painting.

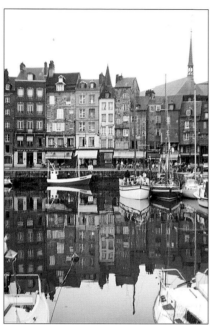

One of the areas that the viewfinder has isolated is shown here. The boat with a red sail and the shops behind form an interesting subject to paint.

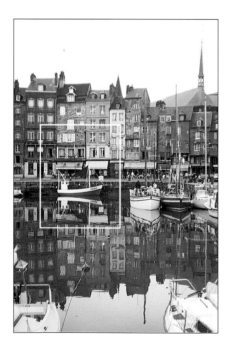

CROPPING TO FIND A PICTURE

In spite of the care you might take in the early stages of composing a picture, it can happen that the finished result is disappointing. This is sometimes caused by errors of judgement in the composition. Perhaps the arrangement in the painting has become complicated. It is easy to put too much in. If you suspect that this is the case, you will find it useful to make and use two L-shaped pieces of thick white card measuring approximately 46 cm (18 in) in each direction. Use these by laying them on your finished painting, in effect producing a temporary, adjustable mask. You can alter the size and shape of your picture quite easily by moving the two pieces of card.

If you feel that a painting has failed because of poor composition, cropping can often produce a small but simple arrangement which works

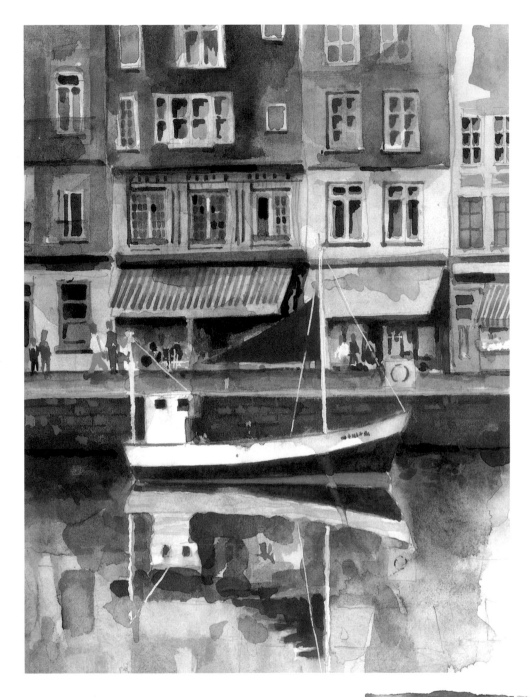

In this colour sketch of the scene opposite, a certain amount of detail has been reduced in the background shops and houses and in the reflections in the water. To make the boat more prominent, the tonal value of the background has been darkened. The reflection of the boat has also been washed over with dilute French Ultramarine. Reflections in still water sometimes need to be weakened to avoid ambiguity in the finished painting.

perfectly. Sometimes you will find that the centre of your painting contains the real subject matter and you could lose certain features on the edge. Alternatively, you can move your mask out towards the edge of the painting and find an interesting composition which starts in the centre and ends on one of the edges.

L-shapes can be used for composition as well as for cropping if you hold them in the same way as a viewfinder. The shape of the rectangle is easily changed by moving the two pieces in relation to each other.

EXERCISES

1 Use your viewfinder to define three views of a window in your home. In your sketchbook, make quick pencil sketches to record your choices.

2 Find a large and complex photograph in a magazine or newspaper. Using your L-shaped masks, see if you can find a subject for a painting. Make a single-colour study no bigger than 15 cm (6 in) in either direction.

USING SUNLIGHT IN COMPOSITION

You can use sunlight as a compositional device in both landscapes and interiors. As an idea for a landscape composition, see if you can find an open space with trees when the sun is low on the horizon. Look for an area where the trees are in near-silhouette and observe the shapes of the trees and the negative space between them, using a viewfinder to try out various compositions which look interesting. You may not find one which looks exactly right, but remember, as a painter you are entitled to make modifications to what you see. Use your sketchbook to fix your ideas.

When painting interiors, sunlight on a wall can provide an exciting composition. Sometimes it is useful to have a camera to hand to record the fleeting moments as sunlight moves across a room, as such references can provide source material for future paintings. Windows are often very effective in interior compositions, providing a strong focal point. The differences between light and shade fix very strong areas of tone, which can form powerful shapes to give your painting an overall structure. If you can, look at the work of the American artist, Edward Hopper. His interiors are masterpieces in the use of light as a compositional device.

The Dell Gate,
53 x 35 cm (21 x 14 in).
On sunny days the pathway up to the gate is always in dark shadow, and the sunlight outside always seems so bright that I feel drawn towards it. I have tried to catch this quality in the painting. The shadow on the trees, shrubs and ground on the right forms an almost complete frame for the sunlit grass and trees beyond.

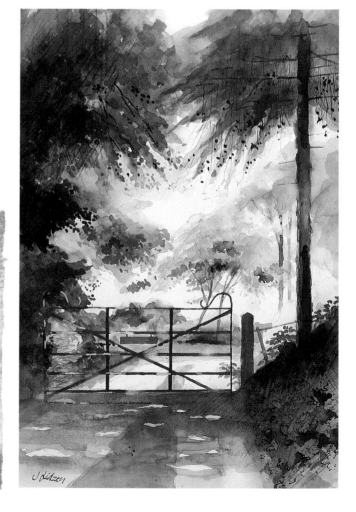

PRACTICAL TIPS

Avoid panoramic views. It is very difficult to create a sense of great space in your painting.

If you don't have a viewfinder with you, the thumb and forefinger of your left and right hand can form a makeshift one.

Don't feel that your paintings should always be standard envelope-shaped. Look at the possibility of using a taller or wider shape.

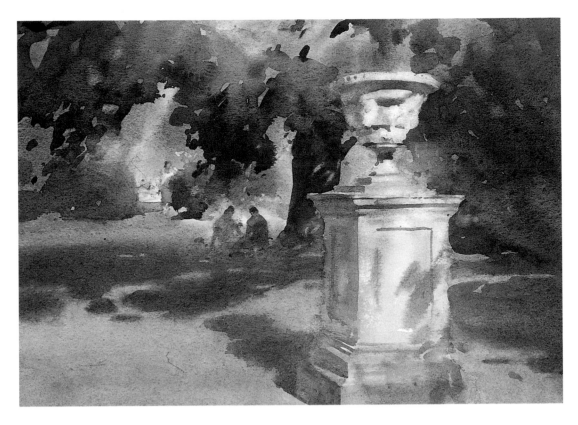

Trevor Chamberlain, *Garden at Newby Hall,* 18 x 25 cm (7 x 10 in). In this painting, the flower urn is bathed in sunlight and is the main focus of attention. It is set against a background of shadow which reinforces its prominence.

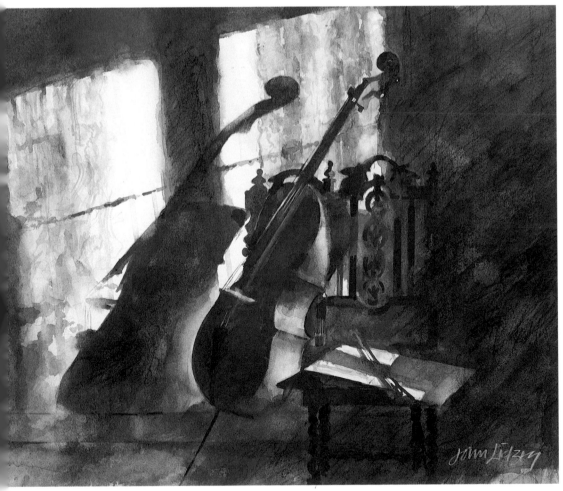

Cello in Sunlight, 35 x 50 cm (14 x 20 in). A cello left out from a practice session the night before gave me an idea for a painting. The angles of light and shade create an unusual chiaroscuro composition. Light can often be used to create strong centres of interest; look out for the opportunities it presents.

PROJECT
COMPOSING A STILL LIFE

✧

Subject
Still life of food items
✧
Medium
Pencil (for sketches)
Watercolour
✧
Colours
Indigo, Aureolin,
French Ultramarine,
Cadmium Red, Yellow
Ochre, Burnt Umber
✧
Size
35 x 25 cm (14 x 10 in)
✧
Paper
Cartridge paper (sketch)
Good-quality watercolour
paper, Not surface (painting)
✧
Equipment
4B/6B pencils
25 mm (1 in) mop brush
for washes
Brushes no smaller than
No. 6 for other work
Damp cotton wool for
mopping out excess colour
✧
Time
One hour each for the
sketches
Five hours for the painting

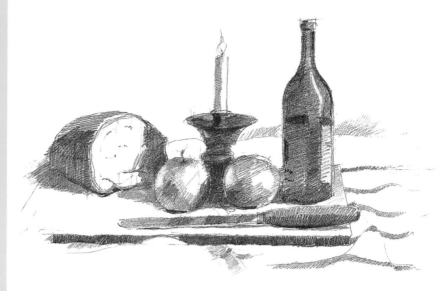

▲ This arrangement is less than satisfactory. The spacing between items is too regular. The candle dominates the composition, creating the wrong emphasis, while the placement of the two apples is too symmetrical. The arrangement also has a poor overall shape.

▼ This arrangement has a good pyramid shape, although including everything on the chopping-board makes it look a little cramped. The candleholder and candle have been given too much prominence by being placed close to the centre of the composition.

From your kitchen select some items connected with preparing a meal. Choose some vegetables, a bag of flour, a bowl, possibly some kitchen scales, a kitchen knife and spoon; also include a bottle or jar of some sort. Make a point of finding items which show contrasting shapes and textures, and which you think might be interesting to paint.

Make at least two arrangements of your chosen items, trying to give them a satisfactory overall shape. Remember that the spacing between items can be made as important as the items themselves. Now prepare a pencil sketch of each arrangement. These sketches are for your own benefit and should not necessarily be highly finished. They should,

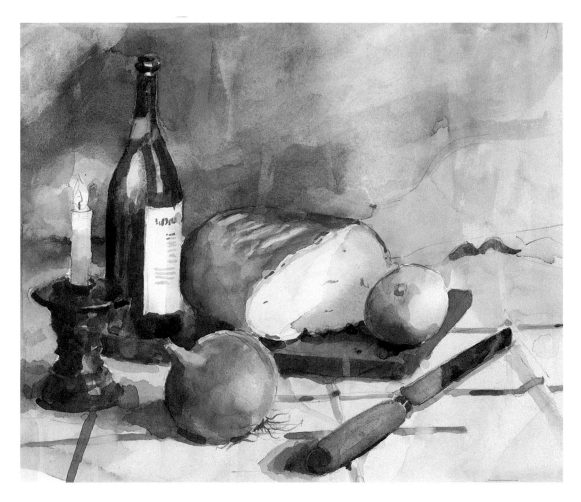

however, show the compositions you intend, the placing and spacing of items, and the lights and darks. Sketching a proposed arrangement will be of more help to you in deciding the effectiveness of a composition than just judging it by eye alone.

Using the drawing with the best-composed arrangement, prepare a finished painting in the colours I suggest.

Another arrangement has been tried here which I think works well. The emphasis is thrown onto the bread, which dominates the composition. The candle is better placed on the left. Bringing items forward off the chopping board creates more space between them. In your painting, consider creating areas of light and dark in the background.

SELF-ASSESSMENT

✧ For your subject, have you selected items of varying shape, size and texture?

✧ Does the overall composition have a specific shape?

✧ Is the spacing between items varied and interesting?

✧ Have you included too many items in your composition? Is it too crowded?

SKETCHING IN WATERCOLOUR

I love to sketch, no matter where I might be, outside or inside, in good weather or bad. I have even sketched in driving rain and when it is almost too dark to see the paper I am working on. It is a private activity. I am not working to sell or to demonstrate anything; I am out recording what I see for the sheer pleasure of it. In fact, many artists make watercolour sketches for their own enjoyment rather than for any specific purpose.

Apart from this, working in a sketchbook holds certain advantages over more formal methods of painting. You are not noticeable; you can tuck yourself away in an odd corner. In a busy railway station, for example, the travelling public will probably not see you, and if they do, they will ignore you. With the minimum of materials you are travelling light, with no easel, boards or stools. This, of course, gives you access to more and perhaps better places to work.

Sketch in watercolour as often as you can; in this way you will develop your skills through working quickly and freely. In addition to this, you can use your sketchbook as a source for paintings to be produced in your home at a later date.

▼ Ronald Jesty, *Shandie*, 10 x 13 cm (4 x 5 in). You can almost count the number of brush strokes that were made to produce this simple sketch of the artist's dog. Painted wet-on-dry with building up of colour on the body, this study was quickly completed.

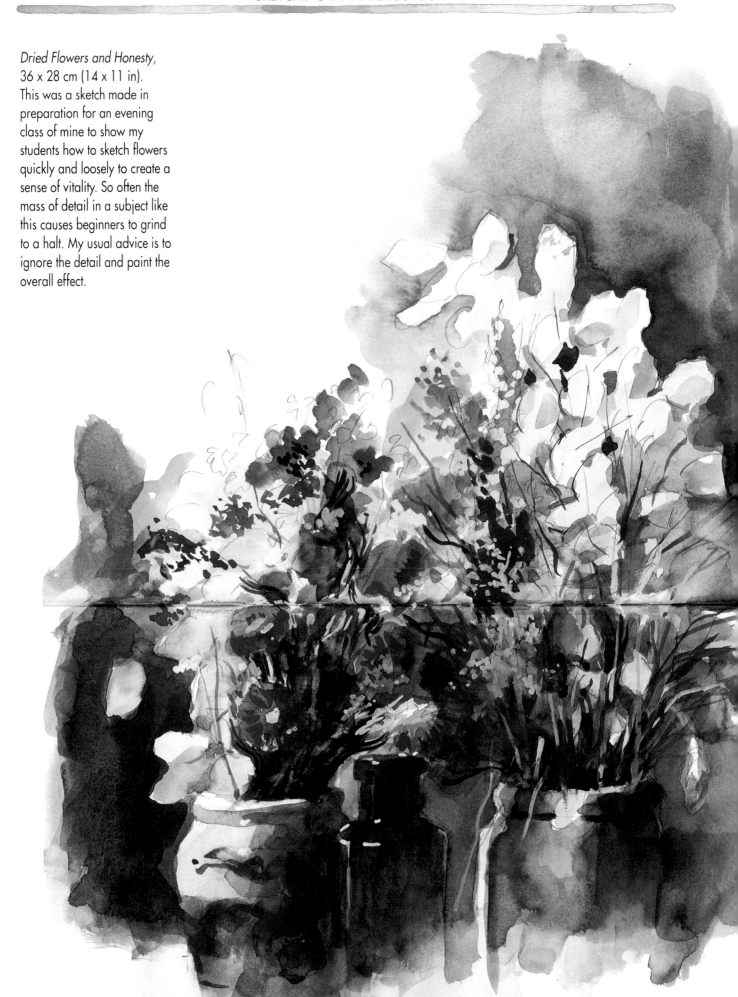

Dried Flowers and Honesty,
36 x 28 cm (14 x 11 in).
This was a sketch made in
preparation for an evening
class of mine to show my
students how to sketch flowers
quickly and loosely to create a
sense of vitality. So often the
mass of detail in a subject like
this causes beginners to grind
to a halt. My usual advice is to
ignore the detail and paint the
overall effect.

SKETCHING EQUIPMENT

It is often useful to set aside some equipment and materials specially for outdoor sketching. If you expect to walk some distance on your expeditions, you will need to keep your equipment and materials both few and light in weight. Even if you are sketching at home or inside, you may prefer to use your special sketching kit rather than items you normally use for painting.

FINDING A SUBJECT

Make a start at sketching in watercolour in your own home by arranging a small still life on a window-sill. Try a wine bottle, an orange, a bowl and perhaps a single flower, placing the items as close to the window as you can, so that the lighting is strong and directional.

Outside the house, restrict yourself to sketching details at first: a watering can and some flowerpots in the garden, perhaps, or a newspaper protruding from a letterbox. If you feel happy with your results, try some watercolour sketches on location. Parks, playgrounds, railway stations or docks all provide good subject matter. If you are nervous about being bothered by the public, try working in the open countryside. But even here, you may find that your sketches will be more interesting if you include some evidence of human activity – a tractor or a farmhouse perhaps.

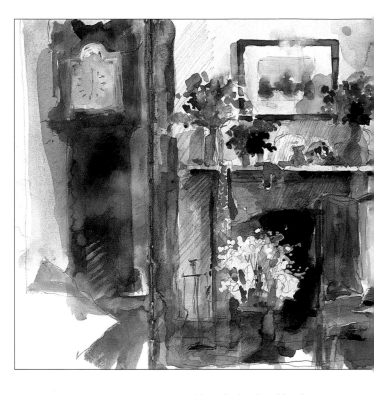

Interior with Grandfather Clock, 28 x 36 cm (11 x 14 in). This sketch was made while looking for a subject to paint. I was concerned mainly with content and arrangement rather than colour or lighting.

Although sketches like these are early stages in the development of an idea, they can be interesting in their own right. We sometimes unexpectedly produce our best work when we are relaxed and not even trying.

EXERCISES

1 Using your sketchbook, make three sky studies in full colour. Choose a variety of weather conditions and times of the day.

2 Spend one hour at your local railway station making pencil studies of standing figures. Draw them as shapes only, trying to record their posture; don't draw facial characteristics or details of dress.

3 Set up a simple still life such as a bowl of fruit. Do three sketches, one in pencil, one in black ink and one in watercolour. In the first two, concentrate on tonal values. In the watercolour, see if you can create the lights and darks you obtained in the first two.

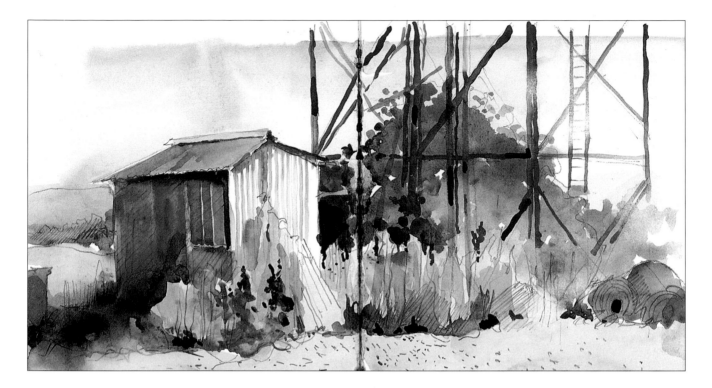

Tin Shed, Flixton,
22 x 39 cm (8½ x 15 in).
Industrial sites are often
marvellous places for
sketching. This sketch took no
longer than 30 minutes.

When you work quickly, it is
important to simplify as much
as you can. The foliage and
weeds were suggested here
with washes and patches of
paint with pencil scribble.

SKETCHING ON LOCATION

There are various minor hazards that you might
occasionally encounter when working on
location, especially in the countryside. Farm
animals on the distant horizon can soon become
close-up, interested spectators of your sketching
techniques, and you may find that the local
insect population is a problem if you sit down
on grass. It is often better to sketch sitting on a
rock or a low wall. In high summer, choose a
shaded position rather than a sunny one; both
the heat and the glare of your paper can quickly
become very uncomfortable. If you can position
yourself near a source of water, this would be
useful too, as you need to change your water
often in order to keep your colours clean. Finally,
be careful about private property. You don't
want to be asked to leave your chosen viewpoint
halfway through a painting.

SKETCHING IN COMFORT

If you have a car, it can become an ideal
sketching studio. The main advantage is that it
allows you to work in all weathers, enabling you
to avoid some of the discomforts of working in
the open referred to above.

However, you will probably discover that it is
difficult to find a good subject from a car;
driving around the streets or country lanes is not
the best way of doing this. Try to do your
research on foot if possible, particularly if you
are sketching in town, as it will be easier to find
a suitable position. You may then be able to park
in the spot you have chosen. In the country you
could find a parking area and then have a walk
around to assess the visual opportunities, and
the suitability of the lighting and the possible
compositions. Remember that, in the country as
in the town, you need to select a site where you
can conveniently position your car for sketching.

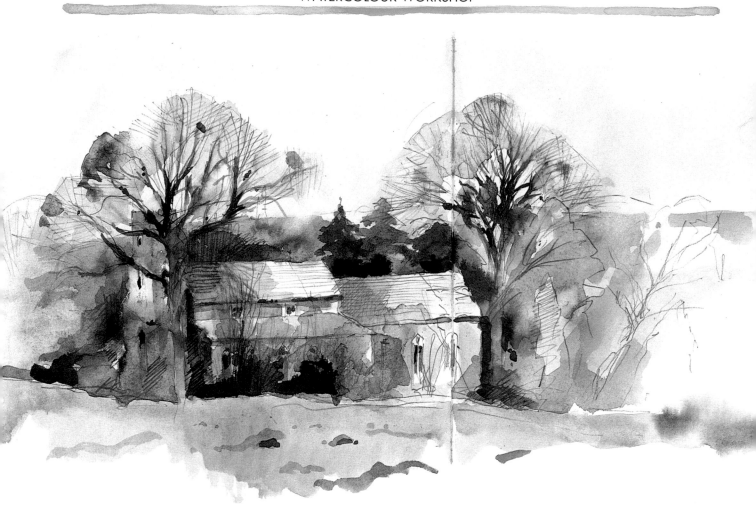

SKETCHING AT DIFFERENT TIMES

Fine summer days are not necessarily the best times for sketching; look out for possibilities at other times of the year too. Autumn will suggest some lovely rich colours and spring is a time of attractive and delicate greens, while winter can have a wonderful melancholy quality that can be caught well in watercolour.

An interesting time to work in winter is when the light is beginning to fade. If you pick your spot and the time is right, you won't have to exclude unnecessary detail in your sketch – it will already have been obscured for you. Once you have lost this detail, you can concentrate on getting the general shapes in your drawing correct; on the basis of this drawing, you can then concern yourself with the nature of the marks you are making on the paper. The washes, the smudges, the stains and the blots can be used not to describe your subject, but to suggest it. Also, capturing the melancholy of a winter's day is a good exercise in creating mood.

Denton Church,
30 x 48 cm (12 x 19 in).
Winter is the best time for sketching. The colours in nature can be surprising, the angle of the sun interesting. It is a time when nature shows its structure. This sketch has the quality of looseness and spontaneity that I often like to include in my paintings.

PRACTICAL TIPS

Work quickly in your sketchbook. Remember that you are not producing a finished painting.

Try sketching from the television. You will have to work fast but it is good practice.

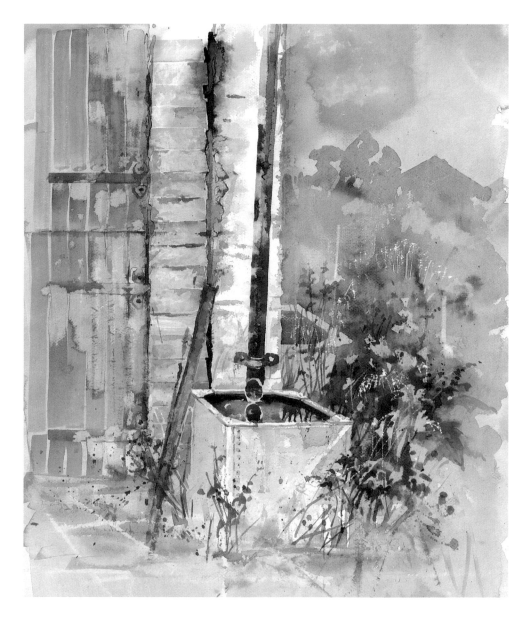

Kay Ohsten,
Water Tank,
46 x 36 cm (18 x 14 in).
This is a lovely sketch, beautifully done and very atmospheric. The tonal values have been kept light except for the drainpipe and the water. By this means, attention is concentrated onto the subject. On the right-hand side, various shapes, dots and lines successfully describe both close-up and distant vegetation.

WORKING METHOD

Begin by making simple drawings of your subject without including too much detail. Try to get the overall proportions correct and show the general arrangement. If necessary, be prepared to work across the whole spread of your sketchbook, right over the fold in the middle. When you paint your initial washes, these should be weak and thinly laid. Don't use a large volume of paint; you may find on a cold day that it will never dry. Build up your washes gradually, increasing the density of the paint as you proceed.

As the painting continues, detailing can be added with either a soft pencil or a small brush.

Sometimes you could try drawing into wet paint; you can drag the paint with the pencil point to obtain interesting textures or even to suggest foreground grass. Work as quickly as possible, allowing some of your washes to run into one another. Blots, stains and smudges will occur in your sketchbook; don't worry about these or about any mistakes you might make. You may think, as I do, that some people's artistic mistakes are more interesting than other people's artistic intentions.

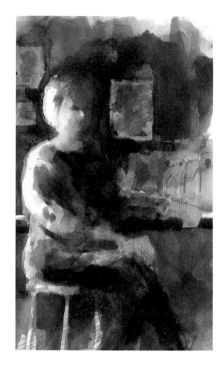

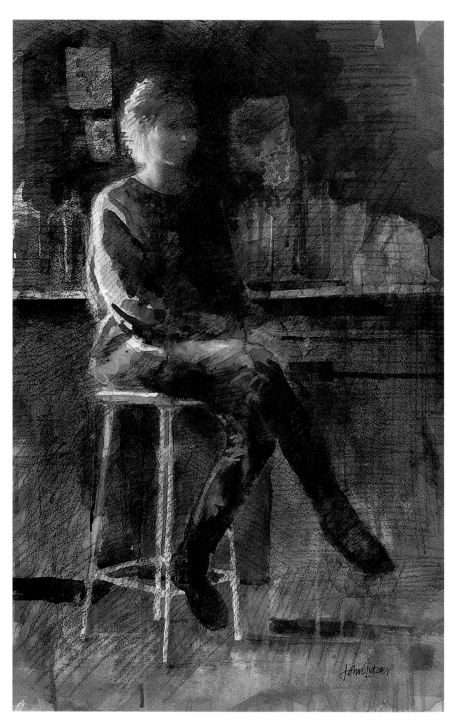

▲ Sketch for *Anna in the Kitchen*, 23 x 14 cm (9 x 5½ in). My daughter, sitting in the kitchen, caught strong light coming through an adjacent window. I made this quick study to see how much definition could be lost on the right of the painting while retaining the sunlight on the left. The colours and tones were simply blocked in and no attempt was made to show any of the details in the figure or in the background.

▶ *Anna in the Kitchen*, 48 x 33 cm (19 x 13 in). In the finished painting, I decided to include the whole of the figure and to change the position. By the use of conté I toned down much of the background colour in order to emphasize the figure in the foreground more.

USING YOUR SKETCHES

It is quite possible to use sketches as a source for finished paintings. One function of a sketch can be to filter out detail. Many paintings made on location show far too much detail and lose their effectiveness because of this. A true sketch will show only the essentials of a subject. If it is used as the basis for a painting, then its qualities are preserved in the finished work.

If necessary, make a number of quick drawings of the intended subject. Initially, use pencil and conté to get the feel of the subject, but try to make one watercolour sketch to use as reference for the finished work. Once back at home, see if you can produce a painting by using your source material. You will be aiming for a different kind of painting from your usual ones – freer, looser and with more zest. Direct your concentration into making your paint look exciting; let the subject matter look after itself.

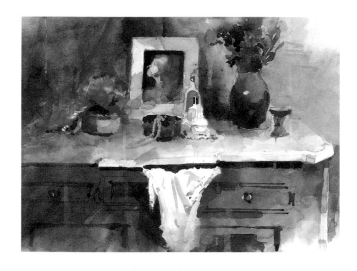

Sketch for *Chiffonier with Beads*, 23 x 32 cm (9 x 12½ in). This sketch shows an assortment of items on a marble-top table. I was interested in the way that the light fell away over the surface from right to left. The item of clothing provided a vertical element in an extremely horizontal composition.

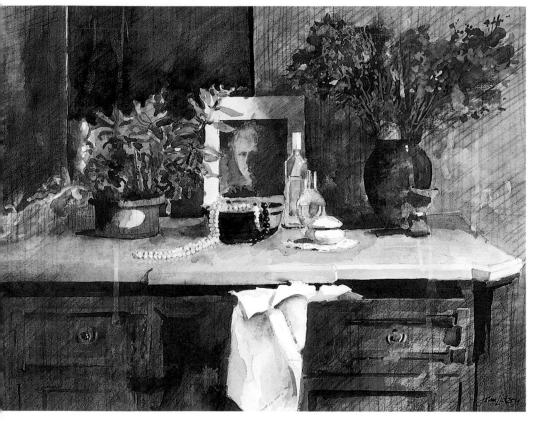

Chiffonier with Beads, 38 x 51 cm (15 x 20 in). The finished painting carries out most of the ideas in the sketch, although the item of clothing has been changed, as have the plants and flowers. More attention has been paid to the detail, but much has been suppressed, particularly the moulding and fittings on the chiffonier.

PROJECT
SKETCHING IN THE BEDROOM

Subject
Your bedroom

Medium
Watercolour

Colour
Six colours of your own choice

Size
Each individual sketch to be approximately 25 x 20 cm (10 x 8 in)

Paper
Good-quality sketchbook

Equipment
12 mm (½ in) mop brush for washes
No. 8 brush for other work

Time
No more than one-and-a-half hours for each sketch

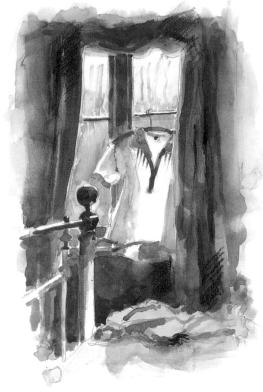

Sketchbook study, *Early Morning*, 23 x 30 cm (9 x 12 in). Sunlight shining through a white garment, especially one made from cotton or muslin, can make it appear quite luminous. Notice how I have reduced the sketch to areas of light and dark without any middle tones.

For this project I would like you to do at least six sketches in your bedroom, even though you may think it is the least interesting room you have. Don't tidy the room up; leave it as it might be in the early morning. Untidy bedcovers, discarded clothes, perfume, make-up and newspapers can make wonderful subjects for sketching. General views of a bedroom can be interesting as well. Often bedrooms are lit by small bedside lamps; low lighting like this can make for particularly atmospheric results. In the daytime, you may find that sunlight creates patterns in the room or reflects off mirrors.

Sketchbook study, *Bedside Table*, 28 x 25 cm (11 x 10 in). I haven't taken great pains with this drawing of a bedside table, nor have I included much detail. The dried flowers have been reduced to a few blots and strokes of colour. Work which has been produced in great haste can sometimes look better than finished paintings which have been laboured over.

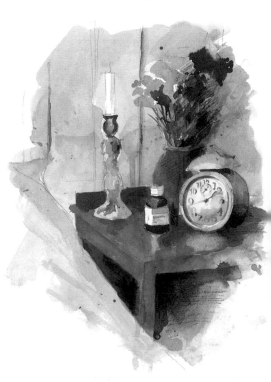

Many painters have produced studies of people in bed. You may feel that you would like to try one yourself (if you can persuade your partner to co-operate!). Don't paint facial characteristics; record shapes and tonal values only. Remember, you are just sketching.

Sketchbook study, *Elsie in Bed*, 36 x 20 cm (14 x 8 in). The subject of this sketch was anxious to be gone; it was therefore completed at great speed. A drawing was made in 6B pencil and colour was applied with a No. 12 brush. There was no time to consider colour; I used only the ones I happened to have to hand. Notice the violet skin tones!

SELF-ASSESSMENT

✧ *Did you work quickly enough?*

✧ *Did you become over-concerned with detail?*

✧ *Do your results have the quality of a sketch, or do they look like finished paintings?*

✧ *Do your sketches show a good range of tones from dark to light?*

LANDSCAPES

There is no doubt that the countryside seems to have an enduring fascination for most watercolourists. I suppose that this is a reflection of the feelings we have for the natural world. The country is ordered and tranquil while cities are chaotic and unstable, and a landscape painting can create for us what might seem to be the serenity of rural life.

But apart from this, I suspect that many people new to painting consider that landscapes are the easiest subject to draw and paint. It could be argued, I suppose, that an error in drawing the nude figure, for example, is usually quite noticeable, but a tree, a bush, a sky or a distant house are not subject to strict laws of proportion, and so errors of drawing and measurement are not immediately obvious. In practice, of course, a conscientious painter should make as much effort in drawing for a landscape as drawing for a nude.

Field Gate, Flixton Estate, 46 x 29 cm (18 x 11½ in). A view of the rural landscape outside the artist's front gate.

▶ I saw this cottage set among trees and was impressed by the way the trees framed the house. The lights and darks around the house were also very interesting. I made a number of on-the-spot pencil sketches, of which this was one example.

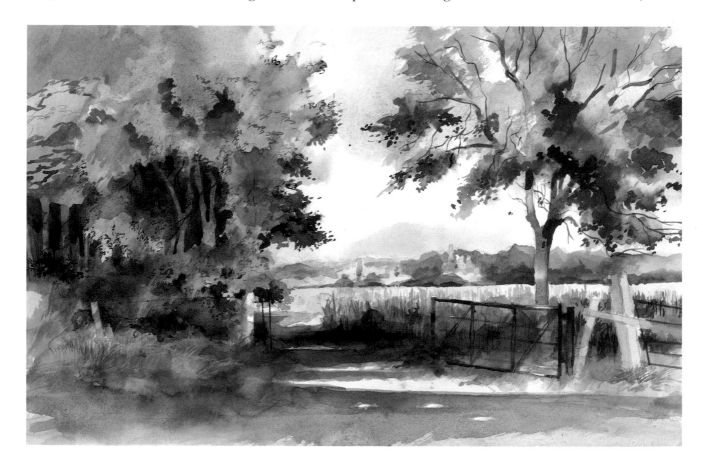

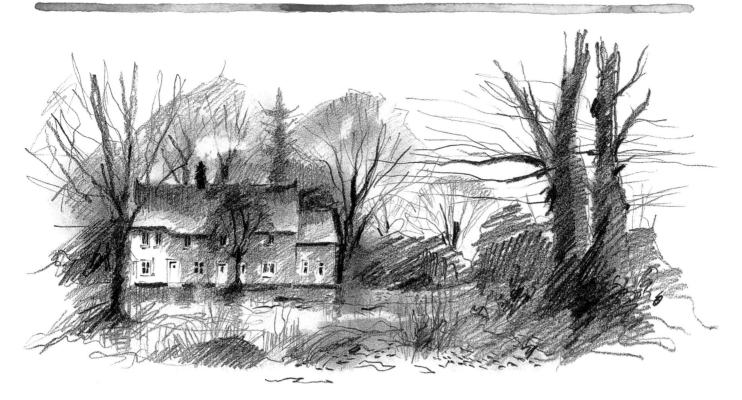

▼ *Cottage at Yaxley,*
23 x 43 cm (9 x 17 in).
This painting was done in the studio from drawings and sketches. I kept most of the background in warm colours and the foreground in cool ones. The foreground shade was emphasized to help establish a pattern of lights and darks. A shaded foreground gives depth to a painting, asking the spectator to step through the shadow into the light.

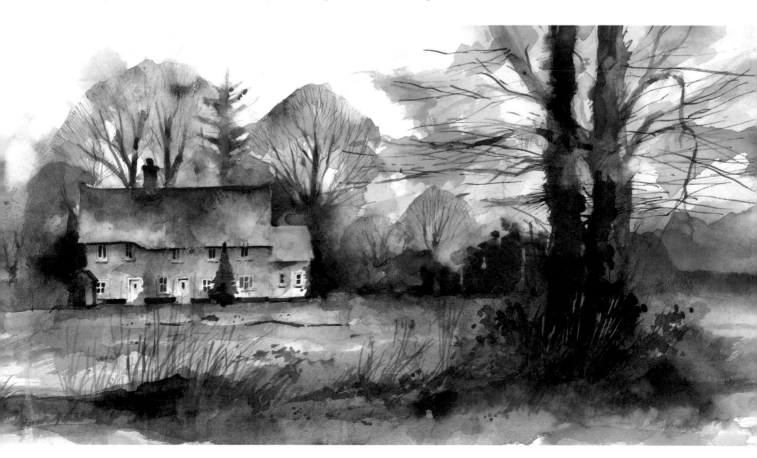

SKIES

Painting skies can be as easy or as difficult as you choose. If you wish to avoid problems, merely introduce a small amount of colour into the sky area with a large brush. The remaining white paper can be left to stand for cloud. You will be surprised how watercolour can, with absolute economy, suggest a very convincing sky. If you are new to painting, this is probably the best way to begin.

SKY STUDIES

Make sky studies as often as possible. Particularly dramatic studies can be created when the sky is stormy or there are unusual weather conditions. In the evening and early morning, skies can be interesting to paint, too. Make notes of the colours and tonal values in cloud formations. If you look carefully, you will see colours in the sky that you would never expect. Try to record these, but if this is not possible, make pencil notes to remind you of what you have seen. Your studies can be worked up later in finished paintings.

CREATING A SKY

Even for small paintings, use a large brush for general washes. A 25 mm (1 in) squirrel-hair mop brush would be ideal. Have a good supply of cotton wool, some blotting paper and plenty of *clean* water for lifting out paint (see page 28). There are no 'best' colours for skies, but if you are new to painting, begin with a simple palette of French Ultramarine, Monestial Blue, Yellow Ochre, Cadmium Red, Indigo, Cadmium Yellow and Payne's Grey.

Plan out the kind of sky you want. Don't necessarily accept the sky that is available to you at the time of painting. You may be able to produce a more interesting result by creating an alternative cloud composition or even by changing a stormy sky for a cloudless one. Try to relate the cloud shapes and colours to the landscape below. High trees, for example, might be shown against a background of white cloud. A low-intensity blue sky might complement a landscape of ochres and browns.

▲ Lay two washes, French Ultramarine at the top and Yellow Ochre at the bottom, letting them just touch.

▲ With damp cotton wool, blot out cloud shapes as you wish. Reinforce the French Ultramarine above the clouds.

▼ Darken the lower cloud shapes with mixtures of Indigo, Yellow Ochre and French Ultramarine.

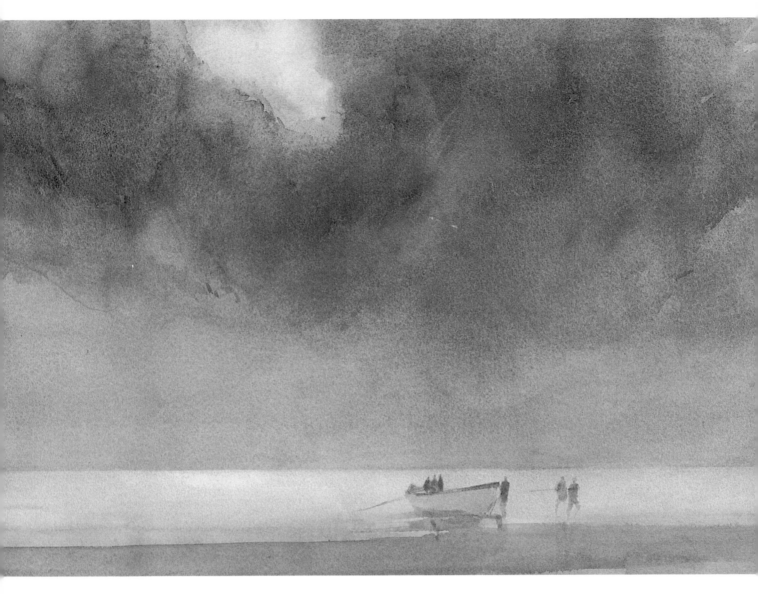

Richard Wills,
*Seascape with Small Boat
and Some Figures,*
71 x 51 cm (28 x 20 in).
This is a painting which at
first looks monochromatic,
but on closer inspection
reveals different kinds of
blues, violets and indigo,
creating a wonderful sense of
atmosphere. The small boat
and figures give a sense of
scale to the powerful sky. The
white cloud at the top of the
painting links up with the
pale-coloured sea to unify
the composition.

A pencil study of a tree in winter. Many trees are covered with ivy on the main trunk, often climbing up to a considerable height. The branches become progressively thinner towards the outside of the tree. Outer growth can be suggested by a light pencil cross-hatching.

TREES & FOLIAGE

Because they are very complicated, trees are not easy to paint. In winter they are a mass of branches and twigs and in summer a confusion of foliage showing an intricate pattern of light and shade. To paint trees successfully, a high degree of simplification is usually called for.

WINTER TREES

Look for the overall shape of a leafless tree. Take careful note of the direction of the branches and study their thickness relative to the main trunk. You won't be able to paint all the small branches and outgrowth. A pale ochre wash over the perimeter of the tree can suggest these.

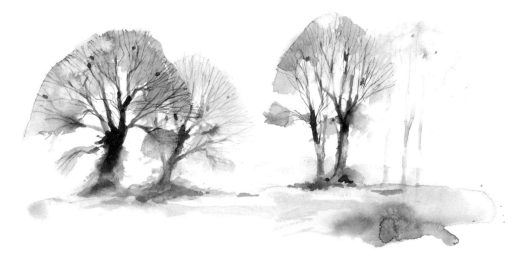

In your sketchbook, make quick colour studies of trees. The structure of a tree is most easily seen in winter. Don't be over-fussy about the colours you use; concern yourself more with tonal value. Notice that trees with a blue colour cast will appear to sit further back in the picture than those in full-strength, realistic colours in the foreground.

EXERCISES

1 In summer, at sunset or sunrise when trees can be seen against the light, make some pencil or watercolour sketches showing the foliage of various trees in silhouette.

2 Find a leafy tree in the middle distance at midday, partly in sunlight and partly in shadow. In your sketchbook record the effects of light and shade as a simple drawing.

SUMMER TREES

To be able to capture the appearance of a tree in summer, it is often useful to view it through half-closed eyes. Doing this will kill off detail and reduce what you see to broad masses of light and shade. You can suggest the texture of leaves by using a sponge to apply the paint.

DISTANT TREES

As with all other receding features, trees should become both paler and slightly bluer as distance increases. Also, detail should be shown to diminish to a corresponding degree. In the far distance, a tree might be simply indicated by a suggestion of the trunk and main branches with an uneven wash to suggest the foliage.

Catch the effect of foliage seen close-up. Use pen and Payne's Grey watercolour to draw the leaves. When the pen work is dry, use colour and tone to suggest areas of light and shade.

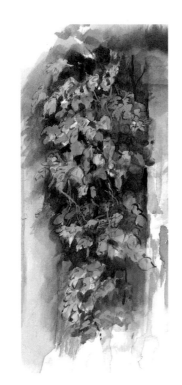

▼ The foliage in some small trees seems to divide into bunches, each bunch catching the light in a particular way.

CLOSE-UP FOLIAGE

Foliage seen in close-up shows more detail than that in the middle distance. The use of a pen can be useful to suggest the harder and sharper edges of close-up leaves. But once again, a degree of simplification is advisable. If you attempt to paint everything as you see it, the result can become tedious and overworked. Try to give your painting depth by showing foreground leaves in detail and defining the foliage further away less clearly.

LIGHT ON FOLIAGE

In many trees, leaves appear to form bunches which overlap each other. Notice how the light falling on one bunch casts a shadow which falls onto the bunch below. The sun can provide interesting contrasts of light and dark, and you will find it useful to make a series of studies of the same subject affected by direct sunlight at different times of the day. Shadows cast by trees on a wall, for example, move quickly and change shape. If you work fast and have a good visual memory, you could try to produce a small painting in one session to record these shadows.

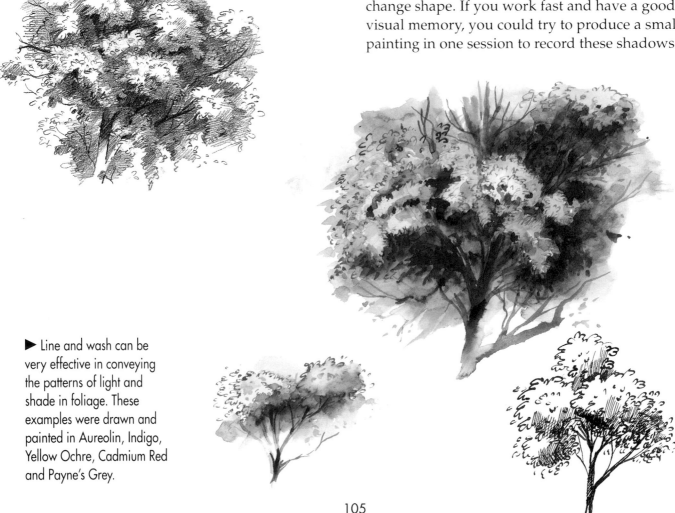

► Line and wash can be very effective in conveying the patterns of light and shade in foliage. These examples were drawn and painted in Aureolin, Indigo, Yellow Ochre, Cadmium Red and Payne's Grey.

Winter Trees

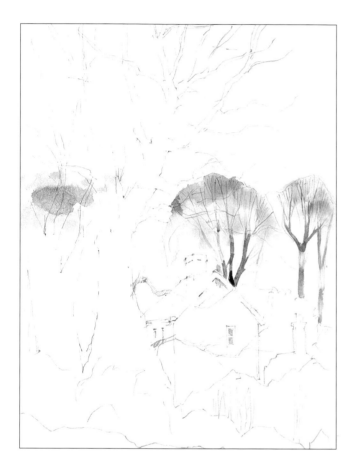

▼ STEP 2

To avoid completely flat areas of colour, I often lift out paint when wet with damp cotton wool, as I did here.

▶ STEP 3

A soft wash of Cadmium Red, Yellow Ochre and French Ultramarine was brushed over the house. The roof and chimney stack to the right were painted in a lighter tone of French Ultramarine and Crimson Alizarin. The background foliage was filled in using Indigo, French Ultramarine and Payne's Grey, while weak washes of Aureolin and Indigo were brushed in the foreground.

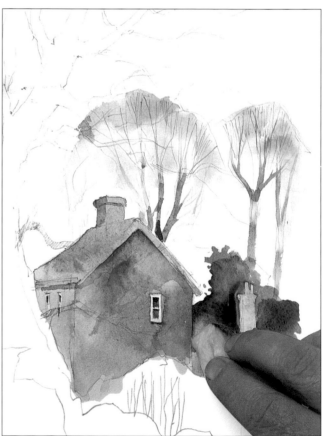

▲ STEP 1

I prepared an outline drawing of the trees and houses using a 4B pencil. Only the trunk and main branches of the tree in the foreground were drawn; fine detail was left for inclusion later. Weak French Ultramarine and Yellow Ochre washes were brushed over the distant trees using a 25 mm (1 in) mop brush; the main trunks and branches were filled in with a No. 8 brush. It is important to keep the tone of background trees light in order to achieve a sense of recession.

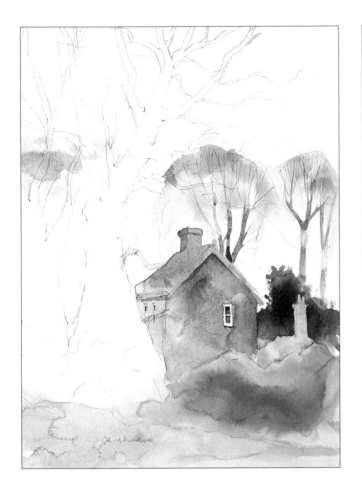

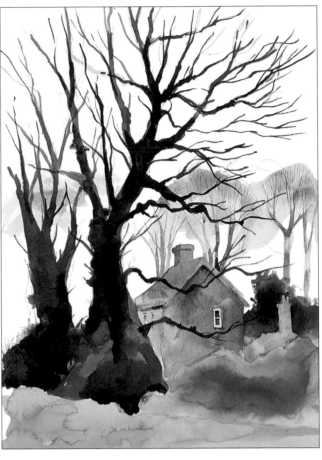

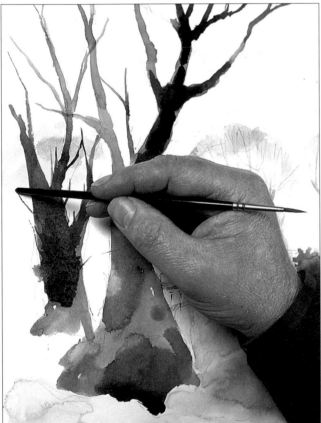

◀ STEP 4

The 'wrong end' of a paintbrush is often useful for pulling wet colour away from a wash. In this case, I used it to suggest some minor branches growing away from the tree trunk.

▲ STEP 5

I painted in the main parts of the foreground trees. Notice how I have used a slightly bluer hue for the left-hand tree, which is a little further back in the picture plane. The colours for this tree were French Ultramarine, Monestial Blue and Indigo, while for the right-hand tree I mixed Indigo, Aureolin and Payne's Grey. Cotton wool was used to lift out some colour on the trunks, and strong mixtures were dropped in wet-in-wet. Some of the smaller branches were drawn in with a broad steel-nib pen.

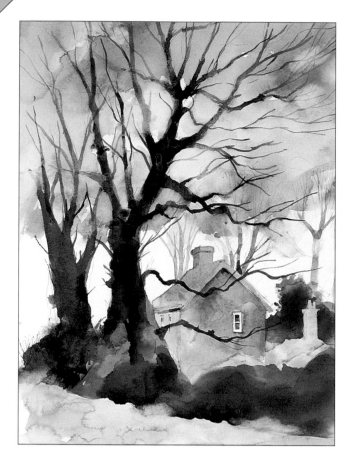

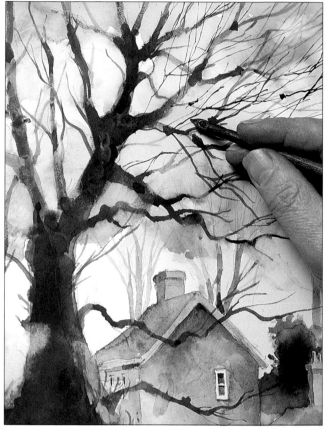

▲ STEP 6
I lowered the tone of the foreground undergrowth with a mixture of Indigo and Carmine, dropping a really concentrated mix into the base. Next I applied washes made up from Yellow Ochre, Cadmium Red and French Ultramarine over the top of the tree. Initially, I used wet-in-wet methods to achieve soft results, but then I added some extra washes in places using wet-on-dry.

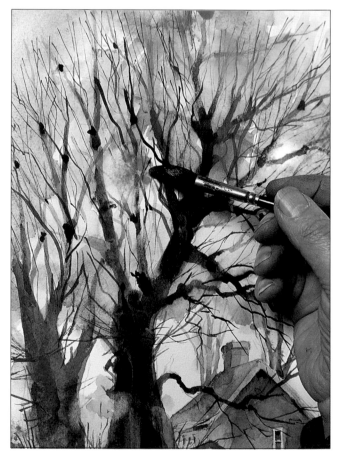

◀ STEP 7
I added fine work to the foreground trees with a steel-nib pen. For this, I used a strong mixture of Payne's Grey and Yellow Ochre, feeding it into the pen with a watercolour brush.

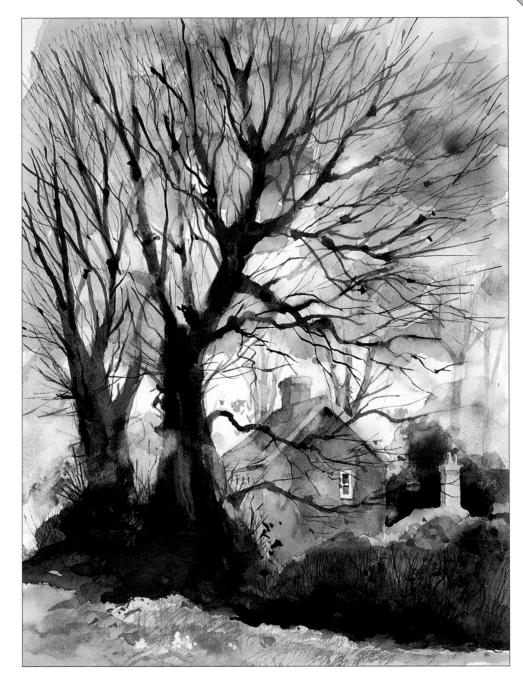

◀ STEP 8
Here I am adding uneven washes of Yellow Ochre and Cadmium Red over the uppermost branches. By doing this, I am lowering the tones at the top of the picture and directing the viewer's attention downwards towards the house.

▲ STEP 9
On top of the washes, additional branches were drawn in, again with a pen. By using this method, I achieved the effect of some branches being soft and weak while others were clear and sharp; this creates a sense of depth within the tree. Further pen detail was drawn onto the foreground shrubs.

COLOURS USED:
French Ultramarine
Yellow Ochre
Cadmium Red
Crimson Alizarin
Indigo
Payne's Grey
Aureolin
Monestial Blue
Carmine

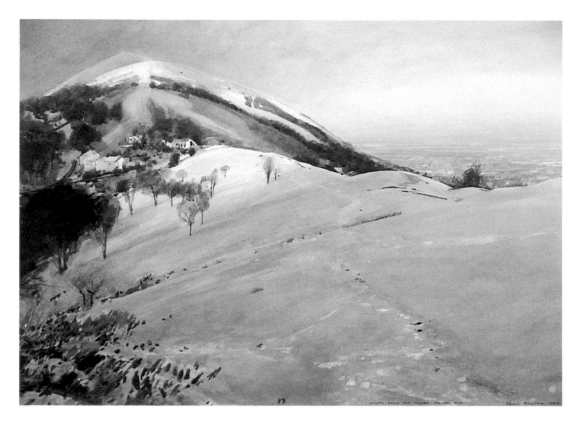

David Prentice, *Winter Above the Wyche-Malvern*, 58 x 86 cm (23 x 34 in). A wonderful painting which shows how snow should be painted. The foreground has few features, yet interest is maintained by the changes in tone and colour in the snow and by the lifting of colour to suggest the play of light on the surface.

LANDSCAPE FEATURES

Think carefully about your painting while you are working. Sometimes it is necessary to take liberties with realism in the interests of picture-making. If you attempt to paint details exactly as you see them, rather as though you were attempting to produce a painted photograph, you may find that the results are rather flat. It is often better to reduce the features in a landscape to their essentials, using as simple a painting technique as you can achieve. For example, a piece of farm machinery might be successfully painted using just a few economical brushstrokes. By working both carefully and simply in this way, you can make your painting seem effortless and exhilarating.

FOREGROUND TREATMENT
Many otherwise successful paintings are spoiled by unsatisfactory treatment of the foreground. This is a common problem which relates to poor drawing, or more particularly, to poor measurement. Remember that foreground grass, for example, will often need to be shown taller than a house in the middle distance. Make sure that you measure these differences carefully when making your preparatory drawing. Also, look carefully at how the scale of objects diminishes over distance.

HILLS AND MOUNTAINS
Wild, mountainous country can often make for impressive paintings. When viewed from the middle distance, the shape and scale of these features create exciting possibilities. The texture of rocks, stone and wild grass can be well expressed by the use of masking fluid, lifting out and spatter (see Chapter Three).

PRACTICAL TIPS

Look for details to paint in a landscape as well as more distant scenes, for example, grasses, foliage, stones and rocks.

There are many kinds of green in nature. This should be reflected in your paintings.

FIELDS

If you are considering painting an expanse of meadow or cultivated land, you will need to devise a method of creating a sense of recession. This can be achieved by using a diminishing scale of textural marks into the distance. For example, a stubble field might be suggested by a spaced system of dots in the foreground which gradually become smaller and closer together as they recede.

Brighter colours in the foreground and paler colours further back in the picture plane will help the effect. The suggestion of a cart track receding into the distance can also convey depth in the painting. It could be painted strongly in the foreground, but diminish both in tone and perspective until out of sight.

BUILDINGS

Houses, agricultural buildings and other constructions are normally very much part of the landscape and can often form the focal point in the composition of a painting. Unusual or derelict buildings make interesting subjects to paint, too.

How you treat buildings will normally depend on their distance from the spectator. Far-off houses can be shown in little more than silhouette, with a minimum of architectural detail. As the distance from the house decreases, more detail, such as drain-pipes and guttering become evident. But in most cases you should paint less than you see. Remember that supression of detail is one of the principal methods by which the painter suggests distance.

You can bring interest to a landscape by suggesting evidence of habitation: a smoking chimney, a clothes line with washing or perhaps a figure or two. A sign on a wall, partially obscured by ivy, might make a good subject, and even 'ugly' things like discarded farm implements can be of interest to the painter.

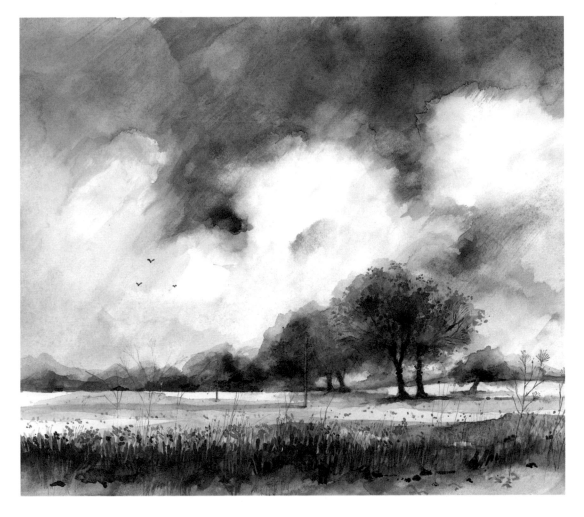

Fields and Trees, Wortham, 30 x 36 cm (12 x 14 in). The depth of tone in the sky and foreground has been increased to exaggerate the sunlit quality of the fields. Always look at the possibility of lightening or darkening parts of your painting. This method will help you to focus the attention of the viewer on specific areas.

Three simple washes of overlapping colour can suggest the sea. The changes in hue and tone suggest recession. Use a 25 mm (1 in) mop brush to lay the washes, letting the colour dry between applications.

A more complicated pattern of washes becoming narrower towards the horizon suggests deep recession. The dark-toned foreground contributes towards this. The weak sun on the horizon is the result of a drop of clean water falling on the almost dry paint – a happy accident. This is always a possibility with watercolour.

By spattering white gouache with a discarded toothbrush and painting white and grey gouache on the wave-tops, I have created the impression of an uneasy sea.

WATER

Water may be encountered in a landscape in many ways, from a puddle in a field to a lake in the mountains. Water may be moving or still; it may be shallow or deep. In each case, you will need to experiment to suggest the kind of water you are featuring in your painting.

TONE AND COLOUR

Water acts like a mirror and, if seen from eye-level, it will mostly reflect light from the sky. If there are clouds, the tonal values on the surface of the water will vary. These tonal changes can often be suggested by overlaying weak tonal washes, and by gradually building up the dark areas. But be careful to keep the washes clean and thin in the lighter areas, otherwise the water might start to look muddy. For dramatic effect you can often exaggerate changes in tone over the surface of the water, making shadow areas very dark indeed.

Water will reflect the colour of the sky as well as its tone. Don't just assume that water should be painted blue. Water can be green, or even brown in shady areas, showing reflections from the surrounding landscape.

STILL WATER

Water at rest will normally call for washes of flat colour. If your painting is small, flat washes can be laid without much difficulty providing you use a sufficiently large brush. If, however, you are embarking on a large painting with an extensive area of still water, you will need to be very careful in laying washes (see page 26). Avoid runbacks, as this can ruin the effect of a flat water surface.

Reflections of trees or houses in still water might actually look pin-sharp in detail, but it is often a good idea to suggest a small amount of movement by introducing a slight 'shiver' to the image. This will reinforce the watery look you wish to create.

MOVING WATER

Loose, fluent brushwork added over flat washes can be used to describe moving water. Careful

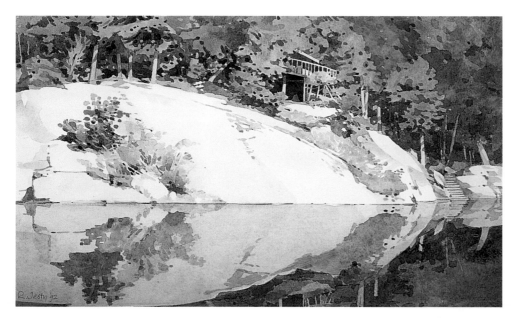

Ronald Jesty,
Holiday Cottage, Ontario, Canada,
29 x 49 cm (11½ x 19¼ in).
In this simple, yet beautiful painting, the artist shows the capacity of watercolour to describe absolutely still and mirror-like water. Notice how he has nicely judged the colour and definition of reflections in the water.

Yacht under Sail,
36 x 71 cm (14 x 28 in).
The houses behind the sails of the yacht were sunlit, but it was necessary to darken them considerably to create sufficient contrast between the sails and background. Similarly, the foreground of the water was darkened to concentrate attention towards the boat. The water was deliberately made to look rough to give the impression of a windy day.

observation of your subject is called for, but it is usually impossible to record every movement of the water. Look for ways of simplifying what you see. You may be able to describe motion by short staccato brushmarks or long sweeping ones which follow the flow of the water. Where the water is turbulent, gouache paint can be effective in describing spray and foam. Spatter techniques can also be incorporated to give the impression of really rough water.

As wet-in-wet methods produce soft, indefinite marks, paint wet-on-dry if you want sharper results. Using Rough paper, which breaks up the paint surface, will also help to suggest the movement of water. If the sun shines on moving water, it will reflect off ripples on the surface, creating a pattern of highlights. These can be suggested by the use of masking fluid, wax resist or by scraping out the paint with a very sharp knife or scalpel.

PROJECT
CREATING AN INTERESTING SKY

Subject
Evening sky with setting sun

Medium
Watercolour

Colours
Crimson Alizarin, Yellow
Ochre, Cadmium Red,
French Ultramarine, Indigo,
Cadmium Yellow

Size
20 x 25 cm (8 x 10 in)
maximum

Paper
Good-quality watercolour
paper, Not surface

Equipment
25 mm (1 in) mop brush
for washes
Brush no smaller than
No. 8 for other work
Damp cotton wool for
mopping out excess colour
Mask to create the sun

Time
Maximum of one hour for
each painting

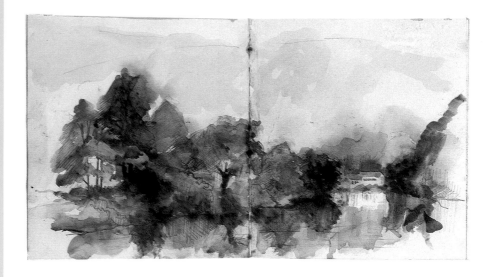

The watercolour sketch and painting of a river landscape illustrated on these pages show how it is possible to create interest in what might otherwise be a somewhat lacklustre scene.

The sketch was made in some haste on a damp and chilly evening as the light was beginning to fade. However, the painting, which was based on the sketch, has been given luminosity by the creation of a hazy sun placed asymmetrically above a distant house and a middle-ground boat with figures.

Using the techniques shown in this chapter and on page 28, I would like you to create your own evening sky with a setting sun over the horizon. Try working on a small scale and produce three paintings, varying the height of the sun over the horizon in each one. Use a paper mask to give a good shape to the sun.

▲ There was very little detail discernible in this subject. The centre of interest is the distant house, but even this is not a particularly strong feature.

▶ *Sunset over Symonds Yat*, 35 x 53 cm (14 x 21 in). In this painting, based on the sketch above, the sun, house and boat have been positioned in line to create a vertical in what is essentially a horizontal composition. The introduction of a sun into a sky can really enliven a landscape, as here, or, depending on treatment, can produce a melancholy, even mysterious quality.

114

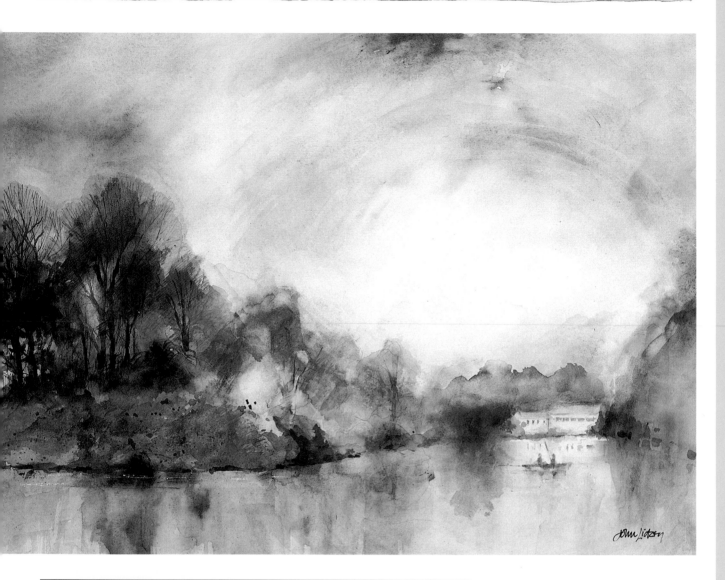

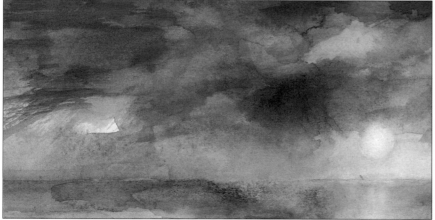

This small painting of a sky also includes a partially cloud-covered sun, which was created by using a paper mask. By freely manipulating the paint, as shown here, you can often produce striking and dramatic effects. Only one successful painting, however, might come about for every four or five which are failures.

SELF-ASSESSMENT

✧ *Were your colour mixes for the first sky washes too dark and too bright?*

✧ *Were you able to keep control of the colour?*

✧ *Did you manage to create a wide range of tones in the sky?*

✧ *Did you cut a clean, round hole for your sun mask?*

INTERIORS & STILL LIFE

In painting an interior, you are producing what could be a fascinating record for future generations of how we live now. The corner of a room or a view through an open door can provide a glimpse into people's lives, their interests and activities. But apart from this, a still life of a few domestic items or even a single subject like a vase of flowers on a table can be a joy to paint irrespective of its associations.

Traditionally the painting of interiors is identified with oil painting, but watercolour, too, can precisely capture the quality of an interior. It can wonderfully suggest the play of light through windows and curtains, and can convey the delicacy of the lightest fabrics while giving luminosity to the deepest shadows. With watercolour it is possible to work quickly and spontaneously, giving an interior scene a quality of life and zest. But it is also possible to work slowly and methodically, building up colours layer by layer for a more considered or planned result. A last point to note is that the painter of interiors has no necessity to travel and need not contend with rain and wind.

▶ *Anna's Room*, 53 x 33 cm (21 x 13 in). A window in sunlight will always give interest to an interior. In this case, the room has been given a feeling of warmth and comfort.

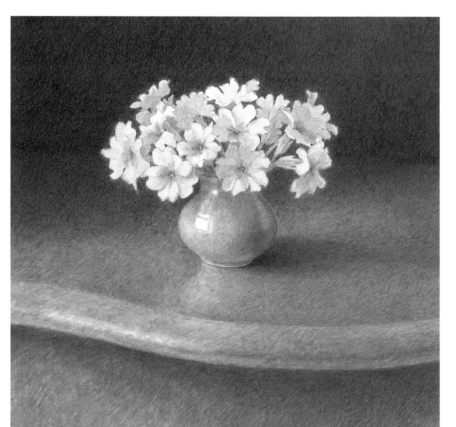

◀ Janet Skea, *Primroses*, 20 x 20 cm (8 x 8 in). Janet Skea normally paints small-scale still lifes concentrating on very fine detail. She begins with thin washes, building up colour with small brushstrokes.

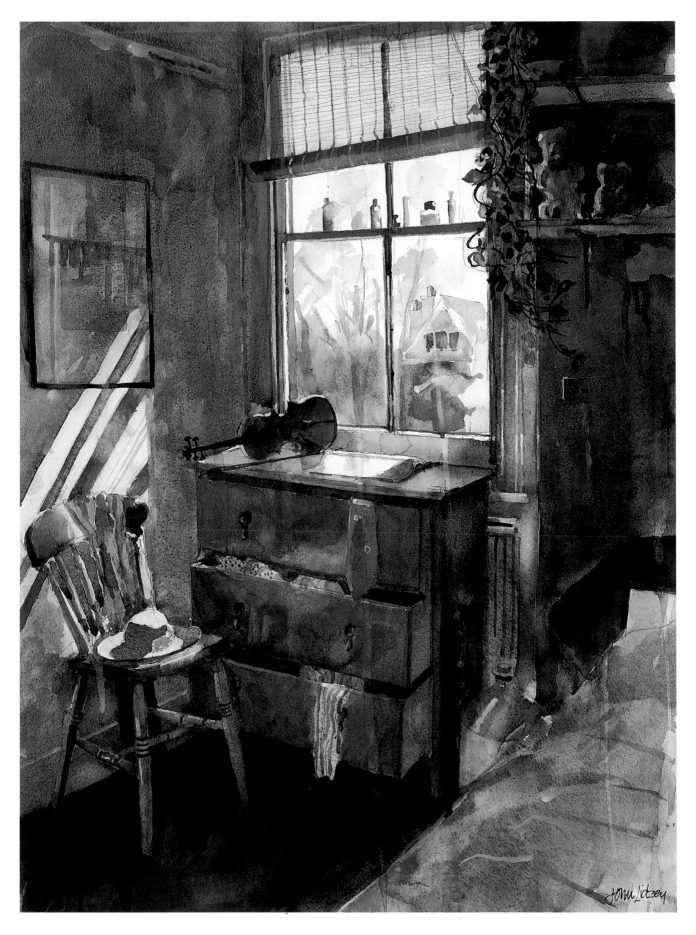

Hat with Purple Ribbon I,
22 x 22 cm (8½ x 8½ in).
A mirror stands behind this
still life, reflecting parts of it.
The ribbon and cloth hanging
over the table edge are
nearly as dark as the wood.
Even white objects in shade
can be very dark, and
beginners often paint them
too light. Study tonal values
very closely.

▼ *Hat with Purple Ribbon II,*
20 x 14 cm (8 x 5½ in).
An alternative study of the
same subject as above. A still
life in strong artificial light
can be very satisfying to
paint. The tonal range can be
very wide with extremes of
light and dark. Such contrasts

make for a dynamic result.
While building up the
colours, allow the paint to
flow freely rather than
keeping it under tight control.

▶ Elizabeth Jane Lloyd,
Summer Pears,
56 x 76 cm (22 x 30 in).
A lovely example of wet-on-
dry technique in a still life.
There is a contrast of free,
almost casual, brushwork
and strong graphic control;
compare the lines on the
table-cloth with those on the
bowl. The colours are kept
very pure, and the artist has
made use of complementary
colours (i.e. orange and blue)
to create a dazzling effect.

STILL LIFE

If you haven't painted inside before, don't be too
ambitious to begin with. Start, perhaps, by
painting a series of small still lifes. As you
become more confident and develop your skills,
gradually increase the range and size of the
subjects you choose.

Still lifes can range from the simple, for
example, a single flower in a jug placed on a
table against a white wall, through to an
elaborate set-up showing fruit, bottles, plates
and baskets, such as Cézanne might have
painted. For a natural effect, it is best to look for
an existing subject rather than to set one up; in
spite of your best efforts, this can look contrived.
Use your viewfinder (see page 84) to identify
possible arrangements. Good examples could
be: a bathroom basin still life showing soap,
toothbrush and toothpaste; a cup and saucer
with a packet of biscuits; a bottle of cough
mixture, a spoon and a handkerchief; or a
broken cup and a tube of glue. Such subjects
often tell a little story which will give your
painting an added interest.

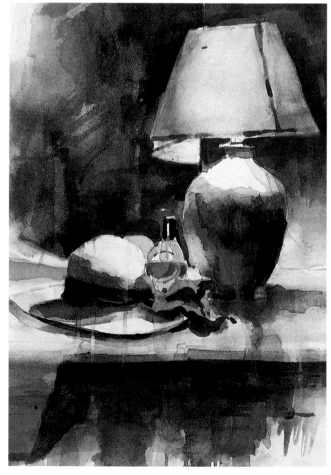

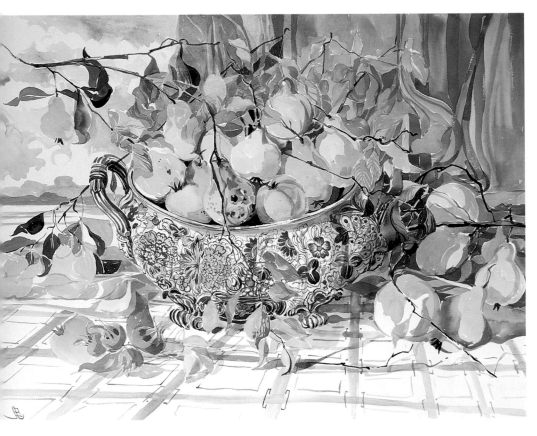

▼ Kay Ohsten, *Crowded Dresser*, 38 x 30 cm (15 x 12 in). This shows the effects that can be achieved when a painting is done quickly. Wet-in-wet and wet-on-dry techniques were used, some of the colour being allowed to run and blot to produce some very painterly effects. Pen and watercolour line was incorporated to provide definition and structure in the painting. Although a static subject, the finished result exudes life and vitality.

If you want to create a more formal still life arrangement, take some trouble in considering the composition of your subject. Make sure that there is variety in the shapes of your objects. Try to arrange interesting intervals of space in the composition; balance large against small. Let some items overlap others – don't just place objects in a row. See if you can contrast the texture of one item against another, for example, a bottle of wine and a loaf of bread go very well together. Your still life should be resting on an interesting surface. Old furniture can produce some subtle reflections and provide a mature effect, while a draped cloth can be a very attractive base, especially for chinaware and porcelain.

Once your arrangement is complete, it is wise to check it with your viewfinder, even if you feel happy with it. You may find that, by slightly adjusting your proposed painting position, you will considerably improve the result. Before you start painting, make some initial studies. You will be surprised at how your final painting will be easier to do if you have completed some preliminary work of this kind.

DOORS & WINDOWS

Closed doors can be interesting subjects to paint, yet when they are fully or partially open they tend to be much more compelling. A half-open door into a room will always create an unsatisfied curiosity. In life, we could walk through the door and inspect what lies beyond; in a painting we never can. Because we are left guessing, such paintings can be very intriguing.

Your own home could contain many possibilities for this kind of painting. Examine the views through your own doors, fully open or half-closed. Don't give too much away, just a hint of what lies beyond.

The light shining through a window into an interior can make a splendid painting subject. Look out not just for ordinary domestic windows, but for others which might be interesting, for example, those made up from patterned or coloured glass. The resulting bright colour contrasts can give you lots of marvellous painting opportunities. Ordinary windows with light, flimsy curtains also offer possibilities of painting coloured and reflected light.

Windows can be painted showing the outside world in full detail. However, if you want to focus attention on the window itself, it is best to leave the view outside the window either unpainted or very indistinct.

▲ *Interior with Hat and Scarf*, 53 x 33 cm (21 x 13 in). This room was poorly lit, yet it was possible to create interest by exaggerating the contrast of light between the bottom and top of the wall. Another room is glimpsed through the open door, creating a sense of space in the picture.

▶ *Bedroom at The Dell*, 33 x 53 cm (13 x 21 in). In sunlight, windows can be marvellous subjects. Most curtains will obscure light from outside, but in this case the lace curtains seem to radiate light. On the right of the painting, the darkness of the room reinforces this effect. The highlights on the glass jar were painted in white gouache, which was also used to suggest the filminess towards the base of the lace curtains.

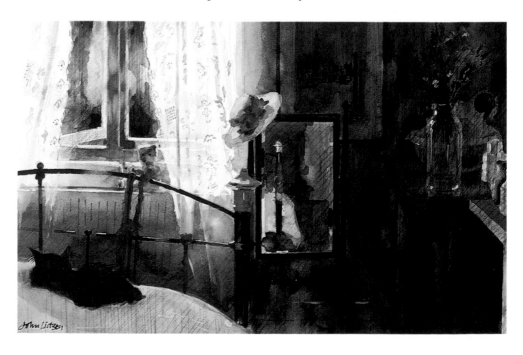

INTERIOR SPACES

An interior might extend from a few items of furniture in the corner of a room to a much larger area like a library or a dining room with a more specialized use. It is best to give your interiors a 'lived-in' look, rather as though somebody was recently in the room but has just walked away. Untidy rooms are often better to paint than tidy ones, so look at the possibility of including everyday objects in your interior. Sights like cupboard doors left open or spilled food containers can often disclose more about people than they could tell us themselves.

You could include a figure in your interior, but it need not necessarily be the dominant feature. In a room setting, for example, you could pose somebody, a member of the family perhaps, a little distance into the picture space. It might be best if they were doing something rather than being just passive, possibly sitting at a table reading a newspaper.

A perfectly satisfactory interior with a figure can be painted where the facial features of the sitter are obscured or merely suggested. This is particularly the case where the figure is positioned in the middle distance. If you are uncertain about painting people's faces, arrange for your sitter to be half-turned away from you, or set them in silhouette against a window.

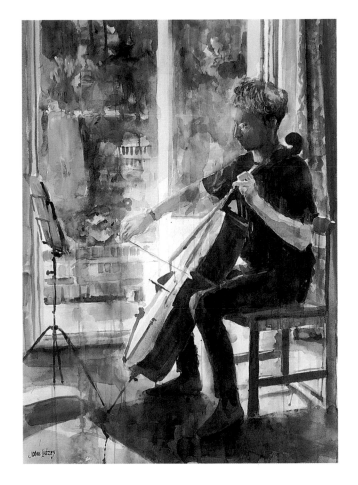

▲ *David Playing the Cello*, 71 x 56 cm (28 x 22 in). A figure playing the cello creates a study of interesting lines and angles. The pose in itself is expressive of music. The instrument is, of course, beautiful, and light and shade have been used to focus attention onto it.

Girl on a Bed, 30 x 46 cm (12 x 18 in). This room is a favourite of mine, and by re-arranging the furniture I can create a wide variety of interesting subjects. The white covers on the bed provided a wonderful setting for the figure and cat. To create an appropriate atmosphere, many of the forms in the room have been ghosted or partially dissolved. In most cases, this was achieved by rubbing out some of the colour after the painting was finished.

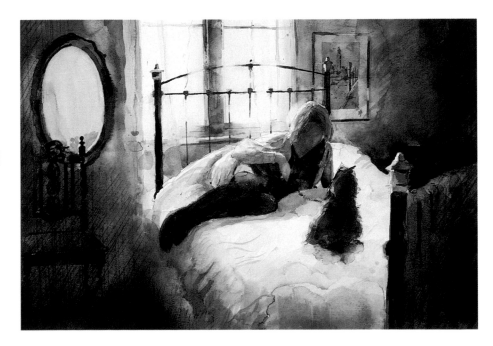

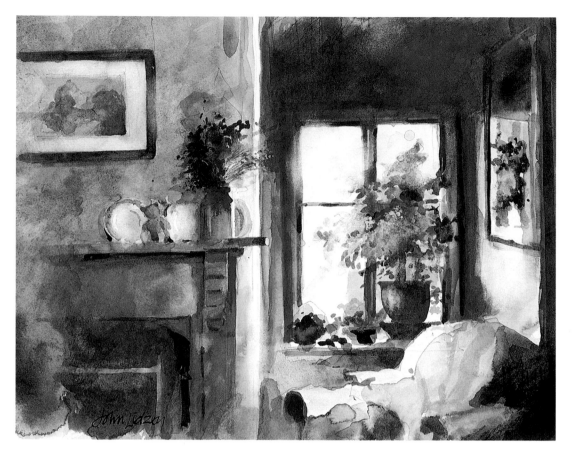

Interior at The Dell, 30 x 36 cm (12 x 14 in). This was painted quickly in a limited range of colours. First, colour was lightly washed in with a big brush. After this, it was applied by dabbing on and wiping off, mainly wet-in-wet.

GETTING THE BEST RESULTS

Having decided what you want to paint, you could begin by making a number of small scale studies of the subject. These need only be quite rough, but they will help you to select the best arrangement. The size of paper you use for the finished painting is important. Don't work on too small a scale. A piece of paper measuring 28 × 38 cm (11 × 15 in) is the smallest you should use. Less than this and you might find your work becoming rather cramped. Use Hot Pressed or Not surface paper to begin with. Rough surface paper might give you inappropriate paint textures.

It is also important to match your setting to your drawing skills. If you are inexperienced, avoid subjects with perspective problems. However, a slight rearrangement of a piece of furniture can make your drawing simple rather than complicated. Avoid becoming bogged down with drawing detail. Door catches, handles and mouldings are better merely suggested than laboriously drawn and painted.

LIGHTING

Interiors are normally much less flatly lit than landscapes. Illumination from one or more windows produces extremes of darks and lights; create these in your painting. A wall facing a window can be described in the palest of tones, while the shadow under a chair might be a rich, dark tone. Details in shadows might almost disappear. The legs of a table, for example, can be lost in the darkness underneath.

PRACTICAL TIPS

Don't over-complicate your still lifes. The simplest arrangements can be the most effective.

Don't be too concerned about detail; many interesting paintings are very broad in their treatment. Allow the viewer of the painting to do some work also.

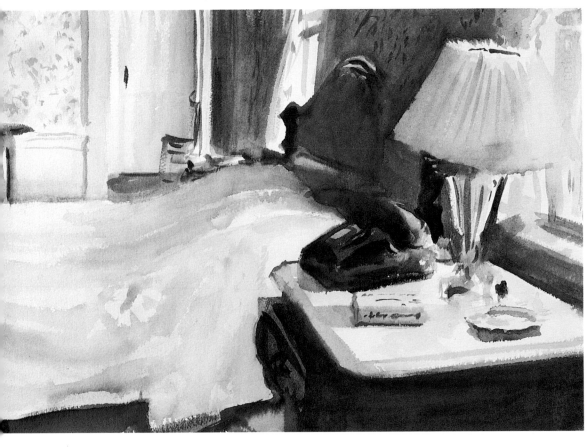

Howard Morgan, *Bedroom Scene*, 37 x 56 cm (14½ x 22 in). This picture is painted in a mixture of wet-in-wet and wet-on-dry. The strong lighting produces a wide range of tones which makes an effective pictorial structure.

SUNLIGHT

Sunlight streaming through the window onto a wall or piece of furniture can make a striking picture, especially early or late in the day when the sun is low on the horizon. Strong shafts of light can sometimes penetrate deep into the interior of a room. It does mean, however, that you can only paint for a limited time during the day. Take a photograph of the subject when the sun is in the best position. In this way, you will then be able to paint at different times or on a cloudy day.

HIGHLIGHTS

In most interiors, the light will catch the edges of objects and furniture in the room. These are highlights and are hard and sharp. They are best picked out in white gouache, or even scratched out with a sharp knife when the painting is finished (see Chapter Three). In most cases, painting round highlights or stopping them out with masking fluid is unsatisfactory, because you will find it difficult to attain a sufficient degree of definition.

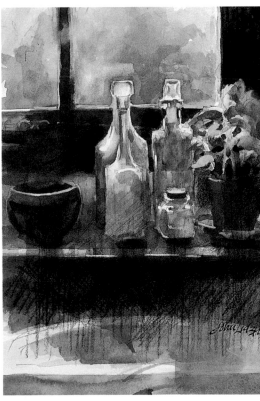

Four Glass Bottles, 33 x 24 cm (13 x 9½ in). Painted on the dullest of dull days, this picture shows that even in bad lighting conditions painting can still be a possibility. The highlights on the bottles were picked up from light coming in at the top of the window, creating interest in a scene which is otherwise very flat.

Hallway at Night

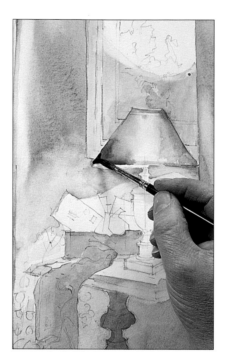

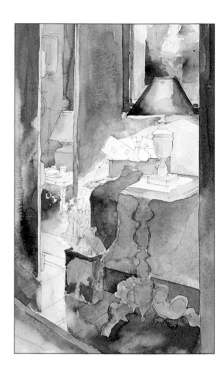

▲ STEP 1

I made a drawing from the subject, carefully showing the size, position and spacing between the various items. Some of the drawn details were obscured in the finished painting, but at this stage I wasn't sure exactly what would be kept in or out of the finished result. Following this, light washes of colour were brushed over most of the picture area, made up from Yellow Ochre, Crimson Alizarin, French Ultramarine, Burnt Umber and Cadmium Yellow Deep.

▲ STEP 2

Although at the early stage of a painting I lay flat and fairly weak washes of colour, I also try to include some really dark areas of paint to establish a strong tonal contrast. For the low tone which is being painted here, I used Indigo and Payne's Grey, while the rest of the lampshade was painted in a weak wash of Aureolin and Indigo.

▲ STEP 3

To achieve a convincing appearance of illumination, it is necessary to paint strong contrasts of light and dark. To do this, I began to lay concentrated washes of colour where I wanted the painting to be low-toned. The letters and the table-mat I left unpainted.

► STEP 4
I had built up the tonal values quite strongly now. The lamp in the foreground and the one in the background were in balance, but I wanted to push the tonal contrast even further. Because of the colour of the lampshade, the shadow areas had a slight green tinge which I tried to keep in my painting.

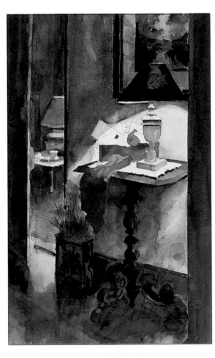

▼ STEP 6
I also introduced yellow-green onto the upper left-hand wall. This colour is not naturalistic, nor is the Cadmium Red at the base of the picture, yet they benefit the painting and this is sufficient justification for their inclusion in this case. The dried flowers were painted in white gouache, but with no detail. I wanted attention to be focused upwards towards the lamp, scarf and letters. I used black conté crayon on the top left-hand corner of the painting to lower the tone.

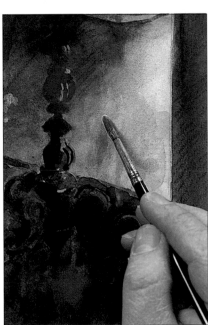

▲ STEP 5
I painted concentrated Aureolin on the wall underneath the table. The result is exaggerated, but this didn't concern me. I was keen to make this part of the painting interesting in terms of colour rather than producing a result which was photographically correct, yet visually dull.

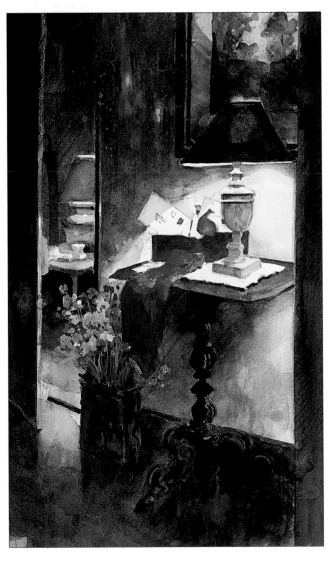

COLOURS USED:
Indigo
Aureolin
French Ultramarine
Payne's Grey
Burnt Umber
Carmine
Yellow Ochre
Crimson Alizarin
Cadmium Yellow
 Deep
Cadmium Red
Vermilion
Monestial Blue
Titanium White
 (gouache)

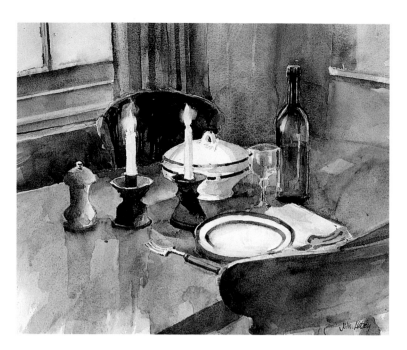

◄ *Table Setting,*
44 x 53 cm (17½ x 21 in).
This is a painting of hard
edges and bare surfaces. The
result suggests an atmosphere
of austerity despite the
candles and wine! The
creation of a pool of light on
the table surface round the
base of the candles would
have given a softer effect.
Darkening the window and
walls would have further
changed the overall mood.

MOOD & ATMOSPHERE

The mood of your painting can be evoked by
the painting techniques you use. A subject like
an untidy corner might be effectively painted
with a free and loose brush technique, while a
clean-lined architectural subject might require
tighter, more controlled brushwork. Be prepared
to experiment to achieve the results you want.

COLOUR AND MOOD
To create a bright and cheerful mood in your
interiors, keep your colours clean. Yellows, reds
and oranges suggest optimistic and extrovert
qualities. To create an atmosphere of peace and
tranquillity, use cool greens, blues and violets.

TONE AND MOOD
The overall lightness or darkness of your
interior will tend to describe the mood of the
painting. If you wish to preserve a fresh, active
quality in your work, keep your tones light. By
contrast, overall dark tones will convey an
atmosphere of melancholy and stillness.

DEFINITION AND MOOD
Hard, linear paintings tend to create a sharp,
clinical feel. On the other hand, soft muted lines
and dissolving forms will conjure up an air of
romance or mystery.

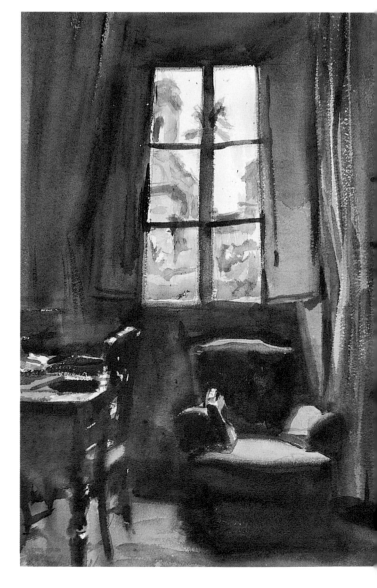

► *Old Bathroom*, 61 x 37 cm (24 x 14½ in). The less-than-new, or even the slightly dowdy, can often be good subjects for the watercolourist. This is especially the case with interiors.

◄ Howard Morgan, *Keats' House*, 33 x 53 cm (13 x 21 in). Morgan's low-key palette and diffuse technique combine to give marvellously moody interiors. This one, painted in reds and violets, creates an air of quiet opulence. The rich drapes and hangings are suggested with a few brushstrokes.

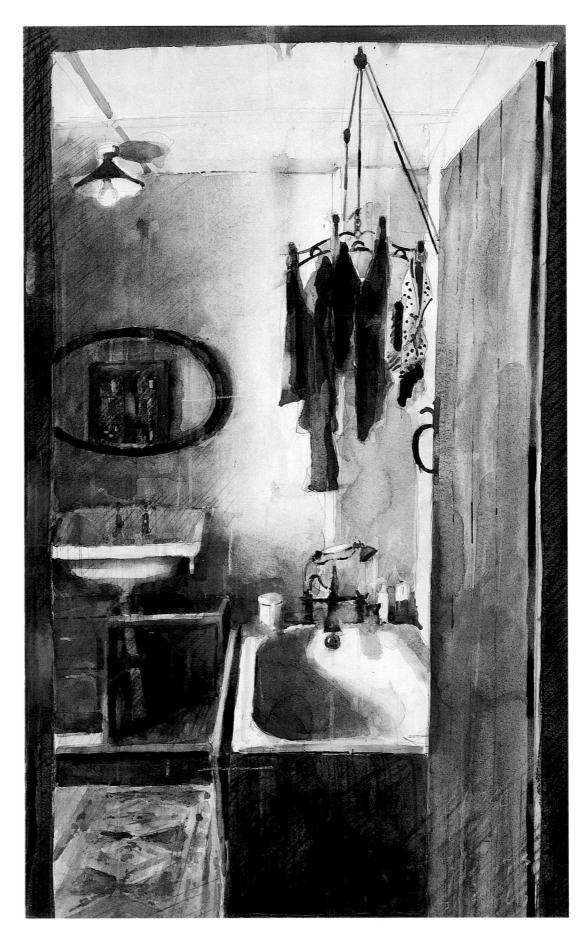

PROJECT
CAPTURING LIGHT IN A WINDOW

✧

Subject
Domestic window scene

✧

Medium
Watercolour

✧

Colours
Either a six- or twelve-colour palette as suggested on page 14
Titanium White gouache

✧

Size
43 x 33 cm (17 x 13 in)

✧

Paper
Good-quality watercolour paper, H.P. or Not surface

✧

Equipment
25 mm (1 in) mop brush for washes
Brushes no smaller than No. 6 for other work
Damp cotton wool for mopping out excess colour
Conté crayon

✧

Time
Six hours

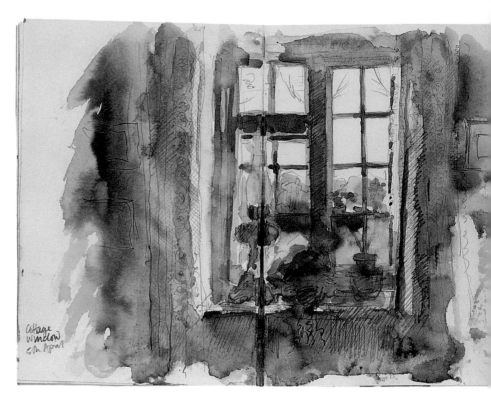

Windows are always pleasing subjects to paint. If you work from the inside looking out, you will be painting against the light. Depending on the angle of view, this could mean that much of what you see will be in shadow, with highlights catching the edges of surfaces.

Make an interesting painting by placing items in or under a window. Choose objects which might suggest the personality of the user of the room, but don't make your subject look too cluttered. Do some preliminary studies before you begin your main work.

To capture light effectively, you will need to build up some good low tones and to contrast these with pale and delicate washes in the areas of light. Try some experiments using conté to darken areas of low tone.

▲ This sketch of a cottage window preceded a larger painting. All detail in the scene was excluded in order to direct attention towards the light shining through the top half of the window.

▶ *Interior with Teddy Bear*, 28 x 43 cm (11 x 17 in). I tried to capture the interesting lighting in this scene. The chair and coat are in silhouette. The curtains are the lightest part of the composition and not the outside of the window as might be expected. Painting against the light has produced here a series of interesting horizontal highlights, which are in contrast to the vertical chair. I have positioned the chair out of centre in the picture to make the overall spacing more satisfying.

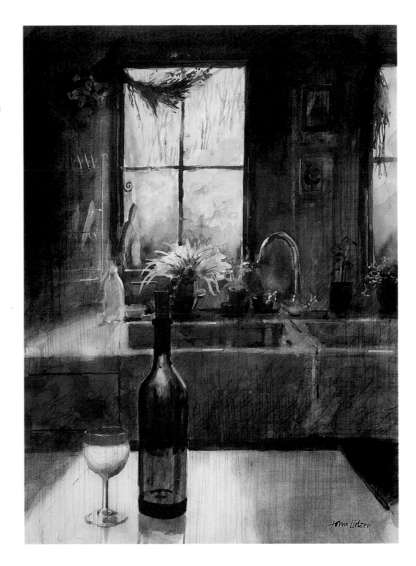

Kitchen Window,
61 x 46 cm (24 x 18 in).
The walls of this kitchen are, in reality, very light in colour, but they were darkened in the painting to create a strong impression of light. The foreground bottle and glass create a sense of depth in the painting. Notice that the bottle, as painted, is actually taller than the window.

SELF-ASSESSMENT

✧ *Did you manage to get the balance of light correct between the inside and the outside of the window?*

✧ *Did you paint your shadow areas dark enough?*

✧ *Did you keep the light areas of the painting clean and not too overworked?*

TOWNSCAPES

Amateur artists are often reluctant to draw and paint in towns or cities. Many who live in built-up areas feel that houses, commercial buildings and traffic are dirty and ugly, and they can't wait to escape from them. It is often the case, however, that city streets can provide subject matter that is both atmospheric and beautiful. Early in the morning in misty sunshine, buildings can have a quality that is completely magical. After rain, wet streets can provide unusual effects of glistening light and shadow.

Apart from any aesthetic considerations, there can be historical value in painting aspects of your town or city. Many impressive nineteenth-century commerical and industrial buildings remain in inner city areas. Paintings of wharves and warehouses with old cranes can make an interesting record of the architecture of a previous era. Also, future generations will be fascinated to see how urban areas looked in the last half of the twentieth century. Paintings that show this can only grow in value as the years pass.

▶ Dennis Roxby-Bott, *Venetian Backwater*, 33 x 22 cm (13 x 8½ in). Good painting always begins with good drawing. Notice the perspective on the left-hand wall and the accurate windows. This painting shows the transparency of watercolour beautifully.

▶ *The Temple*, 37 x 46 cm (14½ x 18 in). The stark severity of the buildings has been softened by the foreground tree painted with barely controlled washes of very wet paint. Although a lot of the detail in the subject has been omitted in the painting, there is sufficient to describe the characteristics of the scene.

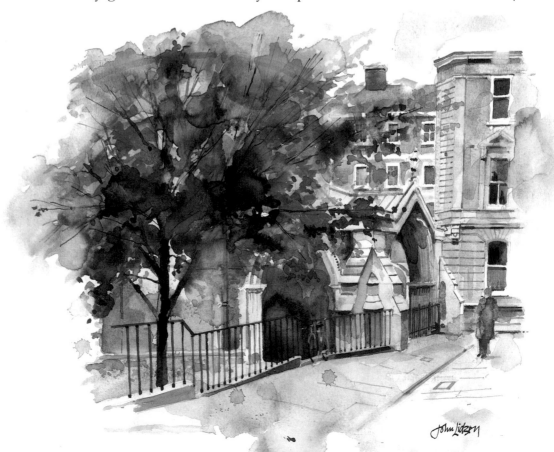

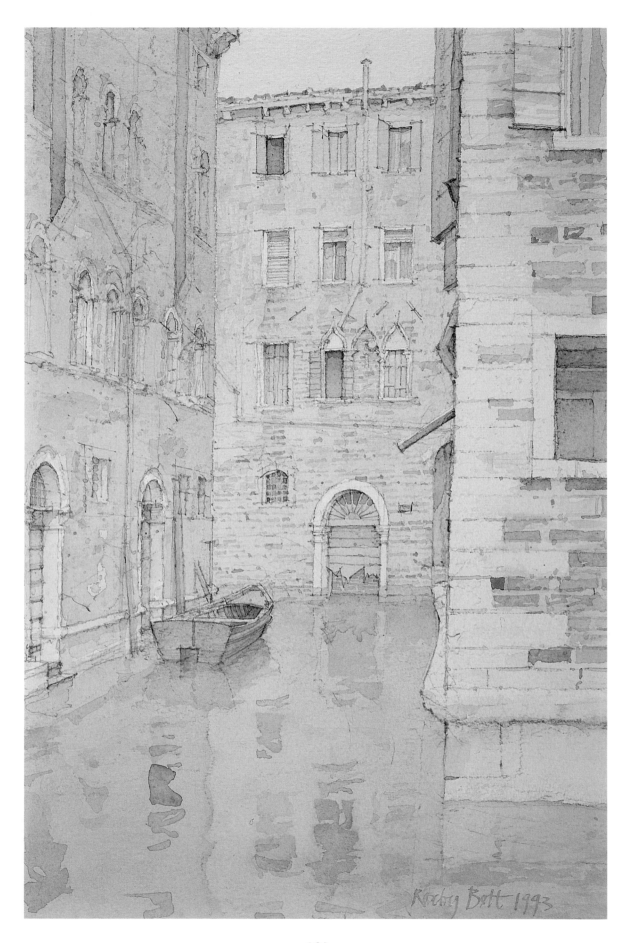

Botesdale,
23 x 30 cm (9 x 12 in).
This village street was drawn
from the top of a small hill.
The higher vantage point
meant that the horizon line
was also high, i.e., level with
the guttering of the first house
on the left. There is enough
information in this sketch to
produce a painting.

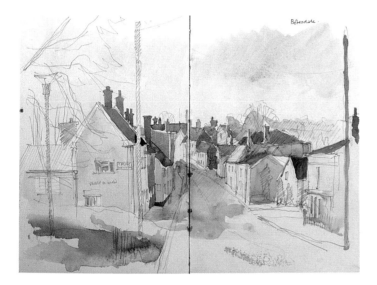

PAINTING ON LOCATION

Many painters of townscapes prefer to work at home or in the studio from photographs. However, working on location can make your paintings freer, looser and more dynamic.

Before you set out to paint on location, you should bear a number of practical points in mind. It is probably better for you to work sitting rather than standing. You will be able to balance your board on your knees; paints and water pot can be placed on the ground and be near at hand. Keep your materials simple – remember that you may find a position to paint where there is little room. Watercolour paper measuring 28 × 38 cm (11 × 15 in) taped to a piece of hardboard is probably the largest paper you would need; you could even work slightly smaller than this.

If you find yourself in a very cramped position, you will probably find it more comfortable to work standing up, drawing your subject in a sketchbook and making colour notes in the margin together with other necessary data. You can then work from these sketches (and photographs) at home.

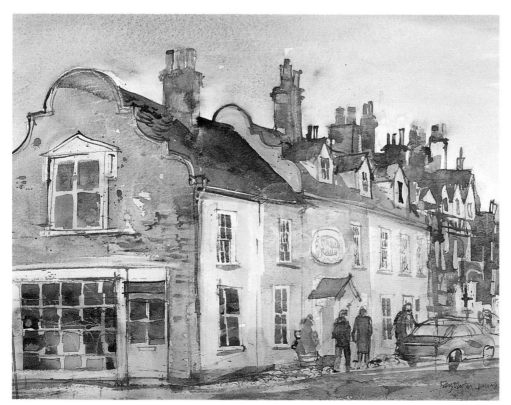

Kay Ohsten,
Earsham Street, Bungay,
51 x 38 cm (20 x 15 in).
A good example of the use of
line to describe buildings.
Because the penwork is soft
in colour and not over-used,
it is not obtrusive. The
apparently casual technique
gives a sense of vitality to the
painting which belies the
careful structuring of the
underlying drawing. Look at
the economy with which the
facing wall has been painted.
Just a few lines and marks
suggest its construction and
state of repair.

CAPTURING THE MOOD

The mood of a city street can change dramatically during the course of a single day. Before you even consider embarking on a painting expedition, you will find it useful to spend some time looking at a number of possible locations at alternative times of the day: in the early morning, at midday and in the early evening. For example, at twilight when the street lights have just been lit, some places can have a melancholy look, while at midday they might be centres of vibrant activity. If you are interested in painting at dusk, you might have to work for short periods at the same time on successive days to catch the exact quality of the light. Take note of your location in various weathers, even when, or especially when, it is raining. Streets shiny with rain can be particularly well caught by the watercolour medium.

Remember that colour affects mood. Experiment to see how you can change the character of a scene by the range of colours you use. If your subject is bright and bustling with activity, consider using warm colours; if it is melancholy and deserted, use cool colours.

EXERCISES

1 Take your camera to photograph lights reflected in a wet street. Use your photographs as references for a painting.

2 Produce a simple sketch in colour showing buildings close-up and far-away. Use definition and tone to create a sense of distance.

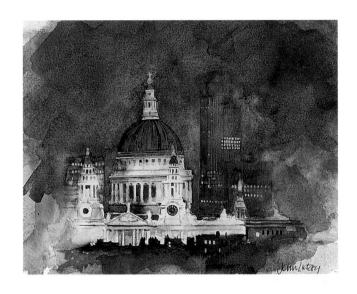

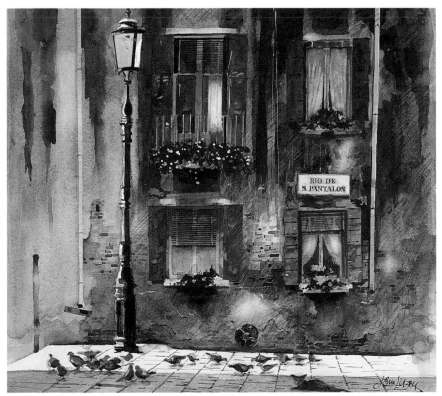

◀ *Rio de S. Pantalon*, 48 x 43 cm (19 x 17 in). A picture of romantic urban decay – a good subject for the watercolourist.

▲ *St Paul's at Night*, 36 x 41 cm (14 x 16 in). Before painting, this subject was carefully drawn. The colours were applied with a large, soft mop brush and plenty of water. The definition was kept soft to produce a hazy, radiant look.

Market Scene

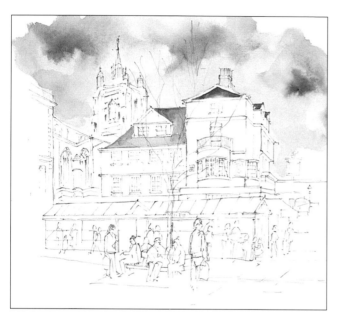

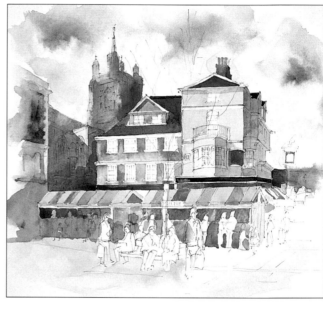

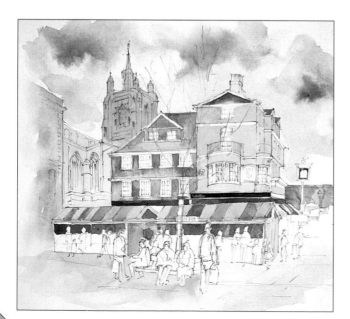

▲ STEP 1
I first made a pencil drawing of the subject, clearly defining the detailing of the two buildings behind the market stalls. The background church was loosely drawn with only a few architectural features shown. Foreground figures were lightly sketched in at this stage, showing their position and scale. A light sky of Yellow Ochre and French Ultramarine was brushed in using wet-in-wet techniques.

◄ STEP 2
I laid in light washes of colour over the principal areas of the painting. The market stall canopies were bright and cheerful, so I used pure colours on these. The church in the background was painted in pale blue colours to create a sense of recession. The foreground paving looked a pale, warm green in the sunlight. I used a mix of Aureolin and Monestial Blue with plenty of water for this.

▲ STEP 3
The next thing to do was to strengthen my colours by overpainting where necessary, and to give some form to the buildings by adding shadow areas. Because I wanted to keep the focus of attention on the foreground and middle distance, I was concerned not to make the background too sharply defined; I therefore painted shadows wet-in-wet. To keep the pink building on the right clear and sharp, I painted hard shadows on the right-hand side.

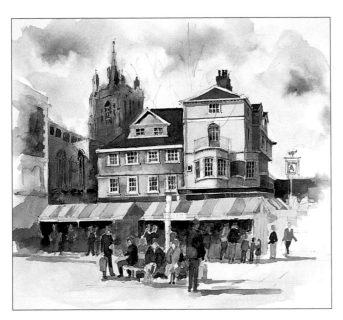

◀ STEP 4
The shadow areas throughout the painting were strengthened and most of the details I wished to include in the foreground and background were defined. The church, however, was kept weak and diffuse. The figures were blocked in and the tones were deepened under the market stall awnings.

COLOURS USED:
Payne's Grey
Yellow Ochre
French Ultramarine
Aureolin
Monestial Blue
Cadmium Red
Indigo
Crimson Alizarin
Cadmium Yellow Deep
Permanent White (gouache)

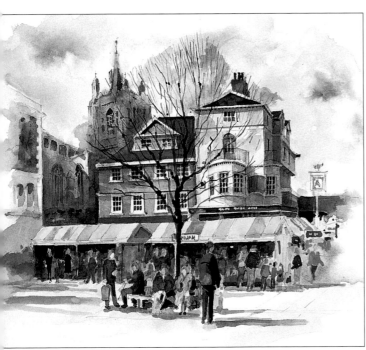

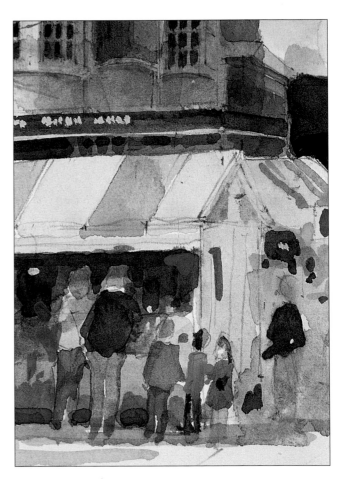

▲ STEP 5
Further detailing was added to the right-hand side of the painting, but kept loose and weakly defined. I felt that the sky needed darkening slightly to create a contrast with the light pink buildings, so I washed weak Yellow Ochre on the area just above the two roofs. Following this, I painted in the tree, using a brush and steel-nib pen. Further splashes of Yellow Ochre and light green were added to the outer branches. Finally, I developed the shadows in the painting, increasing them to the left of the market stalls and deepening them on the side of the red-brick building. This last piece of painting completed the picture.

▲ DETAIL
Figures can be suggested by simple strokes of colour. Painting them freely and loosely can create a feeling of movement and activity. Spots of white gouache and pure Cadmium Red suggest interior details of the stall.

135

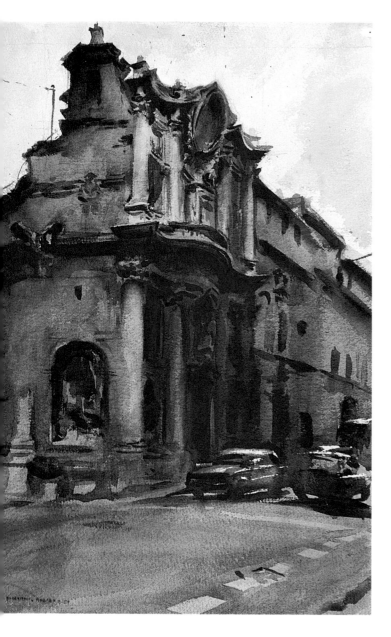

BUILDINGS

It is best to take a little trouble with the drawing of buildings, especially those that are close to you. Some features are worth special study. The rules of perspective apply to doors, windows and roofs, especially if viewed from an oblique angle. Take careful note of the angles of sills, guttering and ledges.

Roofs normally vary in colour and tone over their surface. Paint your roof in the apppropriate flat colour, and while the wash is still slightly wet, drop in the darker tones where appropriate, for example, where a chimney stack casts a shadow. Remember that a chimney stack does not sit on top of the roof; the base slopes down. One side of the stack faces the light source; paint this lighter in tone and even exaggerate the contrast to achieve a three-dimensional effect.

If you are painting a brick-built house, don't be tempted to paint every brick that you see. If you are some distance away, a flat wash will be all that you need. If the wall is quite close to you, paint just some of the bricks, possibly in groups of three or four, while suggesting the changes of tone which inevitably show across the face.

The building you are painting may have drain-pipes and exterior service pipes. Don't include these if you think they disfigure the building. If you do include them, keep them fairly light in tone – grey perhaps, certainly not your darkest black.

The entrances to buildings can sometimes be as interesting as the buildings themselves. Wrought-iron gates with delicate metal tracery can be good subjects. Sometimes such gates are old, rusty and falling into decay. Even domestic entrances can be worthwhile to paint. Throw the focus of attention onto the gate, gateposts and any foliage, making the background fuzzy and ill-defined.

Period public buildings often have figurative sculpture in or around them; such subjects can make an unusual painting in themselves. When painting sculpture, the underlying drawing is very important. Make this as accurate as you can, but don't become bogged down by recording excessive detail.

Howard Morgan, *S. Andrea al Quirinale*, 38 x 56 cm (15 x 22 in). This painting shows how modern technology has devalued the exterior of great buildings of the past. The artist has not chosen to leave out the traffic signals seemingly attached to the wall of the church, nor the road markings running diagonally across the front right of the picture. The vehicles he has painted speed past: this effect is achieved by placing the highlights on each car slightly out of register with its bodywork.

Sculptural material can be all kinds of colours depending on the light, the age of the statue and its state of preservation. Don't be tempted to try and mix a stone colour with your paints just because you know that the figure is carved in stone; paint only the colours that you see.

AERIAL PERSPECTIVE

This term refers to a situation where the effect of atmosphere and haze causes features to become progressively less distinct. They become paler and usually bluer as distance increases. You can make use of this effect to give a real sense of space in your painting. Paint distant buildings first, and work progressively forward, making your foreground buildings clear and sharp in stronger colours.

PRACTICAL TIPS

Paint townscapes early in the morning, when cars and commercial vehicles are less likely to be using the street.

Don't make window glass the same tone all over. Windows often pick up light from the sky or details from other buildings.

Begin painting townscapes by positioning yourself at an upstairs window. The view is often interesting and you can paint without being overlooked by strangers.

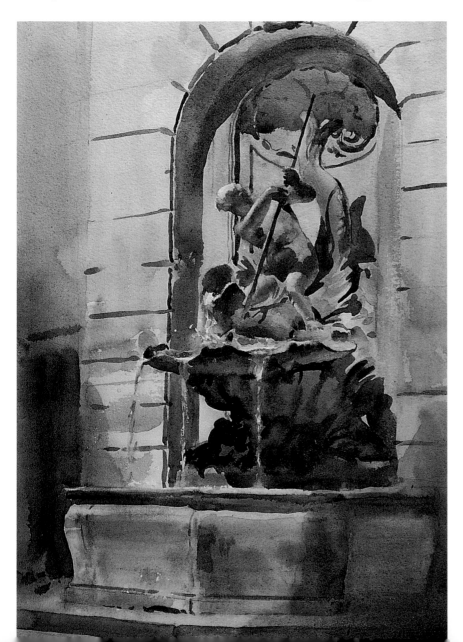

Trevor Chamberlain, *Viennese Fountain*, 34 x 23 cm (13¼ x 9 in). Sculpture can be very rewarding to paint. In this case, Trevor Chamberlain has produced a lovely painting of a figure and stonework bathed in sunshine. This painter is very interested in the effects of light, which he has used splendidly to describe the modelling of the sculpture and fountain.

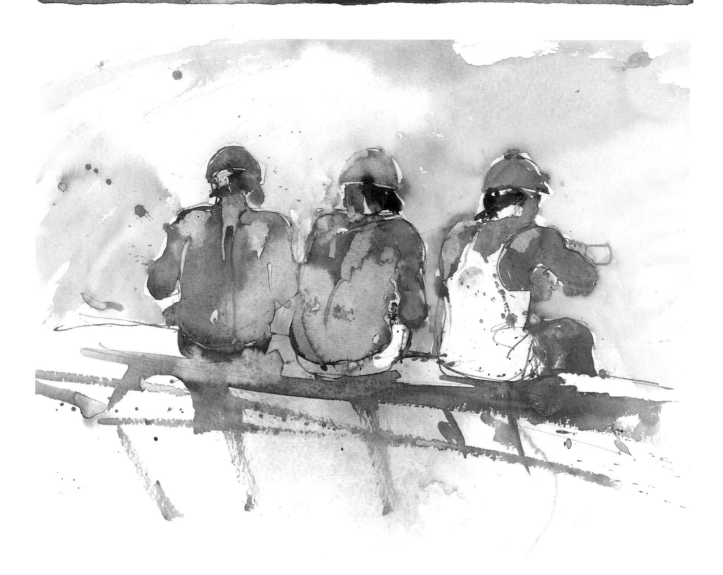

FIGURES

A painting of a scene showing shops and commercial buildings without figures could look thoroughly false. On the other hand, if you wish to convey a still atmosphere in a painting, for example, a view of cathedral cloisters, it might benefit from no figures being shown at all. A good general rule is to be guided by how many and what kinds of people are about while you are doing your sketching or painting. If you paint early in the morning in a market-place, for example, there may be a few street cleaners about. If so, include them in your painting.

You don't need to paint figures in any great detail. Often a few simple marks of paint might be all that you need. Don't copy your figures from photographs, which normally show people in frozen motion, often in untypical attitudes.

Kay Ohsten,
Building Workers at Rest,
30 x 41 cm (12 x 16 in).
A very quick study using Kay Ohsten's favourite method of line and wash. Detailing of the figures is almost non-existent and facial features have been supressed, yet there is subtlety in the shapes of the workmen's bodies. 'Five-minute studies' like this can be good sketching practice, but remember that you should work on a generous scale.

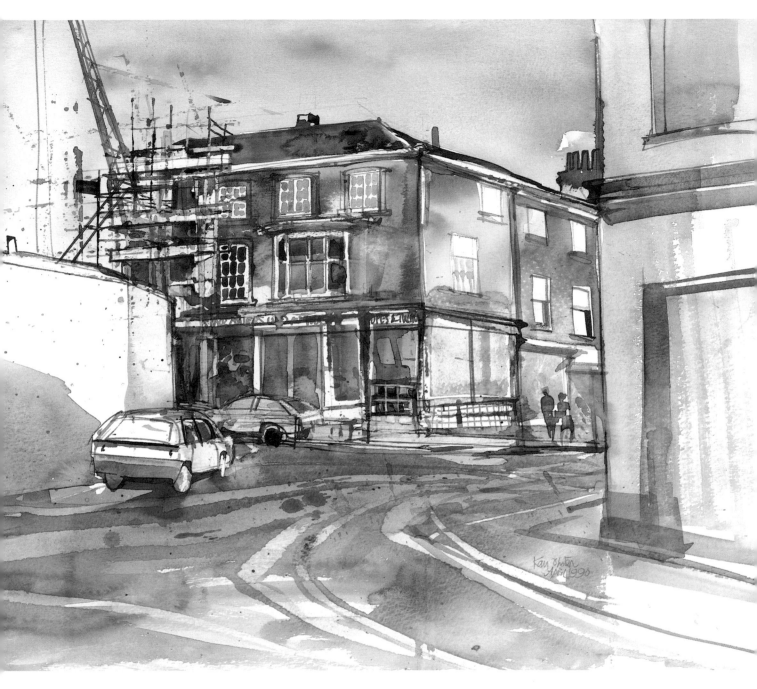

TRANSPORT

It is an unfortunate fact that cars and commercial vehicles of all sorts are spoiling the look of many city centres; and yet paintings which totally exclude them can often look incomplete. If you wish to paint a scene with shops in an ordinary street, you will normally need to include a motor vehicle in order to make it look true-to-life. Even if you position cars in the distance or middle distance, this can provide your painting with a quality of realism.

Kay Ohsten, *Building Site*, 37 x 46 cm (14½ x 18 in). Another of Kay Ohsten's exhilarating paintings! The marks made on the wet roadway, which many painters would exclude, provide an interesting and effective foreground texture. The scaffold poles have been 'printed' by painting the edge of a ruler and pressing it down onto the watercolour paper. Notice how the figures have been painted as loose silhouettes with no attempt to give them realistic form.

PROJECT

CREATING A PORTRAIT OF YOUR OWN TOWN OR VILLAGE

Subject
Buildings or parts of buildings, signs, street furniture or anything of interest in your own town or village

Medium
Watercolour

Colours
Six-colour palette as suggested on page 14

Size
38 x 56 cm (15 x 22 in) overall (but no individual painting to be more than 20 x 18 cm (8 x 7 in)

Paper
Good-quality watercolour paper, H.P. surface

Equipment
No. 2, No. 4 and No. 8 brushes

Time
One to two hours for each sketch

Dominating the centre of my local town stands the figure of Justice. I painted this against the light, losing much of the detail in the figure. The sword and scales were painted in a dark tone to emphasize the nature of justice.

For this project, create a composite picture of the town or district in which you live. If you live in the country, choose a nearby small town.

Produce a series of small paintings similar in size to the ones shown here, i.e., the size specified on the left. Instead of painting them on separate pieces of paper, paint all of your subjects on a single large piece of paper, in the same way as I have done. You will probably be able to fit five or six small paintings onto a single sheet.

I suggest you first make sketches of what you want to include, and repaint these on your paper at home. By working in this way, you can plan out your paintings so that

▶ Just a few houses painted quickly and loosely. In your own painting, keep groupings of houses as compact as you can, but allow the edges of the painting to be uneven and not squared up.

▶ Doors and windows are always interesting to paint. Let the selection of subjects in your own painting be as wide as possible, mixing street scenes with details.

they fit together well on the paper. Occasionally, the paintings can be made to overlap each other slightly, so that the work will have the look of a large sketchbook page.

SELF-ASSESSMENT

✧ Was your choice of subject matter as wide as possible?

✧ Did you fit your individual paintings in together?

✧ Was each small painting well-composed?

✧ Were your paintings overloaded with detail?

INDEX